02|20 Southwark Council

JOHN HARVARD LIBRARY
211 Borough High Street
London SE1 1JA

www.southwark.gov.uk/libraries

 @SouthwarkLibs

Please return/renew this item
by the last date shown.
Books may also be renewed by
phone and Internet.

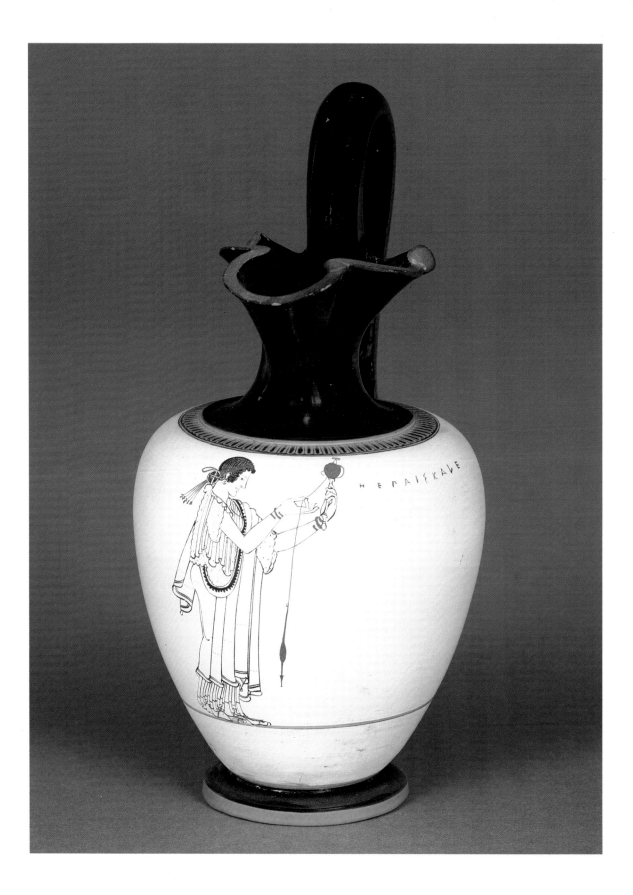

THE BRITISH MUSEUM BOOK OF
GREEK AND ROMAN ART

Lucilla Burn

Published for the Trustees of the British Museum
by British Museum Press

FRONTISPIECE White-ground *oinochoe* (wine-jug), decorated with the figure of a woman spinning. In her left hand she raises the distaff with its load of unspun wool; between the thumb and forefinger of her right hand she draws out a thread that twists itself round the weighted spindle hanging just above the ground. The inscription alongside may be translated as 'the girl is beautiful'. The spinner may be intended as an Athenian housewife, a prostitute, or one of the Fates, spinning the thread of some hero's destiny. Made in Athens about 490–480 BC; attributed to the Brygos Painter. From Locri (southern Italy). Ht 22.3 cm.

This book is dedicated with affectionate admiration to Reynold Higgins, a pioneer in the production of readable scholarship, whose energy, friendship and enthusiasm are a continuing inspiration.

ACKNOWLEDGEMENTS

Many friends and colleagues in the Departments of Greek and Roman Antiquities and of Coins and Medals at the British Museum have consciously or unconsciously contributed to the production of this book, through their generous provision of expertise, their exhibitions, their own publications, and their general support and encouragement: I take this opportunity of recording my gratitude to Donald Bailey, Roger Bland, Andrew Burnett, Brian Cook, Lesley Fitton, Ian Jenkins, Ellen Macnamara, Martin Price, Louise Schofield, Judith Swaddling, Veronica Tatton-Brown, Hafed Walda, Susan Walker and Dyfri Williams. The line drawings and maps were supplied by Sue Bird with her customary speed and skill, while the photographs of British Museum objects, many shot specially for this publication, are the work of P.E. (Nic) Nicholls and Thomas Cochrane of the British Museum Photographic Service, whose professional dedication and obliging attitude made all the difference. Special thanks are also due to Roger Bland, Brian Cook and Susan Woodford, who very kindly read and improved earlier versions of the text, and to the editor and designer, Nina Shandloff and Behram Kapadia, who made its transformation into book form a remarkably painless and efficient process.

FRONT COVER Marble bust (fig. 163).

BACK COVER Bronze figurine (fig. 41).

© 1991 The Trustees of the British Museum
Published by British Museum Press
A division of British Museum Publications Ltd
46 Bloomsbury Street, London WC1B 3QQ

British Library Cataloguing in Publication Data
British Museum
 Introduction to Greek and Roman art in the British Museum.
 1. Greece. Roman Empire. Visual arts
 I. Title II. Burn, Lucilla
 709.3

ISBN 0–7141–1297–6

Designed by Behram Kapadia

Set in 10 on 12pt Palatino and printed and bound in Italy by New Interlitho SpA, Milan

Contents

Preface 6

1 Greece in the Bronze Age 8

2 The Emergence of Greece: The Geometric and Orientalising Periods 24

3 Archaic Greece 40

4 Classical Greece: Sculpture in Bronze and Marble 56

5 Classical Greece: The Minor Arts 74

6 The Greeks in Southern Italy and Sicily 91

7 Monumental Sculpture in Lycia and Caria 112

8 The Hellenistic World 127

9 Cyprus 144

10 Italy Before the Romans 159

11 The Roman World: Sculpture, Coinage and the Emperor 178

12 The Roman World: The Decorative and Minor Arts 195

Suggestions for Further Reading 212
Maps 215
Glossary 218
Illustration References 220
Index 221

PREFACE

Greek and Roman antiquities have been an important part of the collections of the British Museum since its foundation under the terms of the will of Sir Hans Sloane in 1753. The present-day collection in the Department of Greek and Roman Antiquities is one of the finest in the world. It spans over three and a half thousand years, starting around 3200 BC with the Early Greek Bronze Age and ending in AD 313 when Christianity was decreed the official religion of the Roman Empire. The Greek material comes not only from the Greek mainland and the islands of the Aegean, but also from other areas around the Mediterranean, including Asia Minor and Egypt in the east and south, and Italy and Sicily in the west. The civilisations of Cyprus, Lycia and Caria, originally independent but eventually assimilated into the Greek or Roman worlds, are also represented. The collection of material from pre-Roman Italy starts in the Bronze Age and illustrates several Italic peoples, most notably the Etruscans. Objects from most parts of the Empire are found among the Roman material: later Roman antiquities are housed in the Department of Medieval and Later Antiquities, those from Roman Britain in the Department of Prehistoric and Romano-British Antiquities. Greek and Roman coins belong in the Department of Coins and Medals, where they are a major part of the collection.

From 1753 onwards, Greek and Roman antiquities entered the British Museum as gifts or bequests, as purchases or as the result of excavation. One of the earliest major acquisitions, in 1772, was of Sir William Hamilton's great collection of Greek, Roman and Etruscan antiquities; these were mostly vases, but bronzes, glass, terracottas, lamps, jewellery and other small objects were also included. Many more and finer vases were brought to light in the early nineteenth-century excavations of the great Etruscan cemeteries of Vulci and Cerveteri, and the Museum made the most of its opportunities to purchase choice examples at the sales of such great collections as those of the Chevalier Durand (1836) or the Prince de Canino (1843). Meanwhile, the bequest of Richard Payne Knight in 1823 had greatly increased the Museum's holdings of fine bronzes, along with coins, seal-stones and other items.

The first major collection of Roman sculpture bought for the Museum was that of Charles Townley in 1805. In 1816 the Townley collection was joined by the Greek sculptures acquired by Lord Elgin, and the sculptures of the Parthenon were displayed to the first of many generations of enthusiasts and admirers. The sculpture collections were further enriched in the mid to late nineteenth century by a series

of archaeological expeditions, mainly to the west coast of Turkey: Xanthos, Halicarnassos, Ephesus, Cnidus and Didyma were among the sites from which monumental sculpture and architecture were shipped back to Britain and the rapidly expanding Museum.

Opportunities for acquisition were diminishing towards the end of the nineteenth century, largely because countries such as Greece, Italy and Turkey passed laws restricting the export of antiquities found on their soil. A number of excavations were, however, conducted on British-ruled Cyprus in the 1890s, and the material found forms the basis of the Museum's Cypriot collection. In recent years opportunities for purchase have been further limited by general acceptance of the principle that an object's context is of great and irreplaceable value; if the primary aim of archaeologists is to learn as much as possible about the society they are studying, they must interest themselves as much, if not more, in the circumstances of an object's discovery as in the intrinsic character of the object itself. To purchase an object on the international antiquities market is not only to condone its almost certainly illegal export from its country of origin, but also to promote the divorce of other antiquities from their proper context and so to impede the advancement of knowledge.

While new acquisitions may be limited, work continues on sorting, classifying and studying the collection, and on making it accessible to children, scholars and the general public through exhibitions, talks and lectures, and publications. The civilisations of Greece and Rome lie at the foundations of Western society, and to increase our understanding and appreciation of them at any level can enhance and enrich our lives. This book is written not for the specialist, but for anyone curious about Greek and Roman art–perhaps a casual visitor to the Museum, perhaps a student, perhaps someone returning from a holiday in Greece or Turkey. The purpose of the book is to introduce the British Museum's collection of Greek and Roman antiquities, to which the author enjoys the privilege of free and unrestricted access, and at the same time to provide a general introduction to Greek and Roman art and culture. If readers are inspired to look again at actual examples of Greek or Roman art, this book will have achieved its aim.

1 Pottery collared jar with a sea-urchin-shaped body and incised herring-bone decoration. Made in the Cyclades about 3200–2800 BC; from Antiparos. Ht 18 cm.

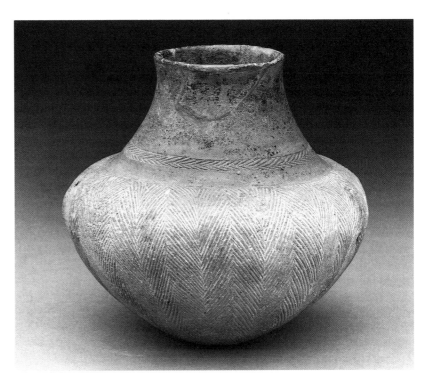

Cyclades, and all were exploited from earliest times. Bronze, which is an alloy of copper, appears to have been very scarce in the earlier phases of the islands' history, but in the Keros-Syros culture it seems to have become relatively plentiful. Tools and weapons were cast from high-quality copper alloyed with arsenic; moulds and the remains of furnaces have been found on Syros. In the British Museum's collection is a group of ten axes and chisels known until lately as the Kythnos Hoard; recent research has shown that they were in fact part of a larger hoard found on Naxos. The tools were probably used for wood-working: the large axes with socketed handles for felling trees, the flat axes for wedges and the chisels for finer operations. Lead and silver were also worked; lead was used to make models and figurines, while silver was beaten into brace-lets, beads and pins, and occasionally vessels.

The rock of the Cyclades is basically marble, and the quarries on Paros and Naxos supplied the Greek world with marble throughout ancient times; even in the Early Bronze Age, marble was an immensely important element in the Cycladic way of life. To make their distinctive marble vessels and figurines, Cycladic sculptors would scarcely have had to quarry their raw material, since large marble pebbles were read-ily available on the beaches. Many beautiful marble vessels survive, ² among them the so-called *kandiles*, one of the most elegant shapes pro-duced on the islands. These vases vary in height from 7 to 37 cm; they have bodies shaped like sea-urchins, with a conical foot and neck, and four horizontally pierced lugs. These vases must have been both diffi-cult and time-consuming to create, and it is scarcely surprising that

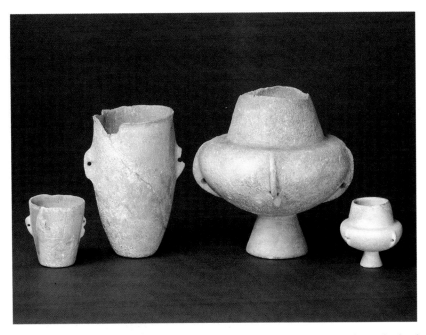

2 Four marble vessels (two beakers and two *kandiles*). Made in the Cyclades about 3200–2800 BC; all from Antiparos except the second from the left (of unknown provenance). Ht (of left-hand vessel) 10 cm.

many of them are very thick-walled, as though their makers lacked either the patience or the confidence to make them any thinner. Other marble vessels included trays, goblets, and spool-shaped *pyxides*, their sides scored with horizontal lines. The elegance and precision of these marble vessels is all the more remarkable in view of the limited range of tools at the craftsman's disposal. Most tools would have been of stone – emery for hammers, obsidian for fine incising and smoothing, pumice for polishing and shining; later some bronze tools may have speeded up the processes, but not by much.

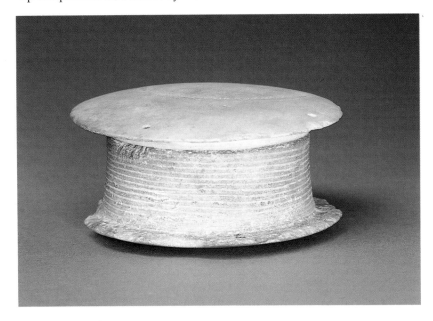

3 Spool-shaped marble *pyxis* (lidded box) with grooved sides. Such boxes may have contained jewellery or cosmetics. Made in the Cyclades about 2700–2200 BC; from Syros. Ht 5 cm.

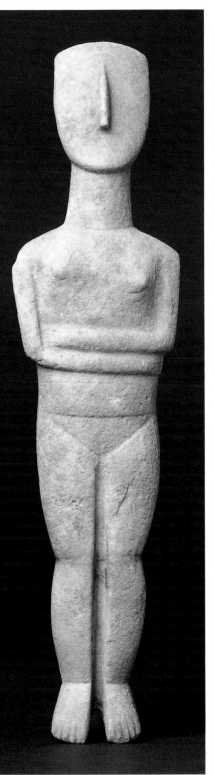

The same tools would have been employed on the most character-istic products of Cycladic art, the marble figurines. These come in two 4 basic types, schematic and naturalistic. Most of the schematic pieces are chronologically early; they are sometimes little more than large pebbles, and do not always have very clearly defined features. One schematic type is violin-shaped, barely recognisable as a human form. The finest pieces are the more naturalistic products of the Keros-Syros culture. Although there are representations of groups and of figures engaged in specific activities including musicians, drinkers and oc-casional warriors or hunters, the most characteristic figures are female and stationary; generally their arms are folded across their chests and they are represented lying down. In these figures the human form is reduced to a few key components: head, neck, torso, arms and legs; these are the figures whose 'great, elemental simplicity' was so admired by the twentieth-century British sculptor, Henry Moore. The finest Cycladic figurines are very striking in their restraint and quiet power. Though much progress has been made in the identification of certain canons of proportions, in the distinction of stylistic groups and even in the identification of individual hands, much about these figures remains enigmatic. Who made them, and for whom, and for what purpose? Do they represent their owners, or a goddess? Since the majority are female – some are pregnant and the genital area is often strongly marked – it is reasonable to suppose that they are in some way associated with fertility, but exactly how they were used will probably always remain a mystery.

Towards the end of the Early Bronze Age, around 2000 BC, the Cyclades were coming increasingly under the influence of Crete, in common with the rest of the Aegean. Unlike the settlements of the Cyclades in the Early Bronze Age, those of Crete in the Middle Bronze Age can properly be described as a civilisation; here at last are the great public buildings and the evidence for complex social structures and political institutions that justify the use of the term. Among the most distinctive features of this Cretan civilisation were the monumental palaces, most of which were established by about 1900 BC. It was the largest and most important of these that Sir Arthur Evans made famous by his excavations at Knossos four thousand years later. What he revealed was a huge, multi-storeyed and richly decorated building which he called the 'Palace of Minos', after its legendary ruler; and so the civilisation of which he had found the centre was christened the 'Minoan'. There were other, smaller palaces at Phaistos and Mallia 5 which were largely destroyed by fire, probably connected with an earthquake, around 1700 BC. After this they were rebuilt on a grander scale, along with new palaces including one at Zakro.

The period from about 1700 to 1500 BC was the greatest period of Minoan wealth and influence. Energetic traders, the Minoans estab-lished outposts throughout the Aegean, while the whole of Crete appears to have been united into a sort of confederacy under the over-all control of Knossos. It was perhaps to record their business trans-

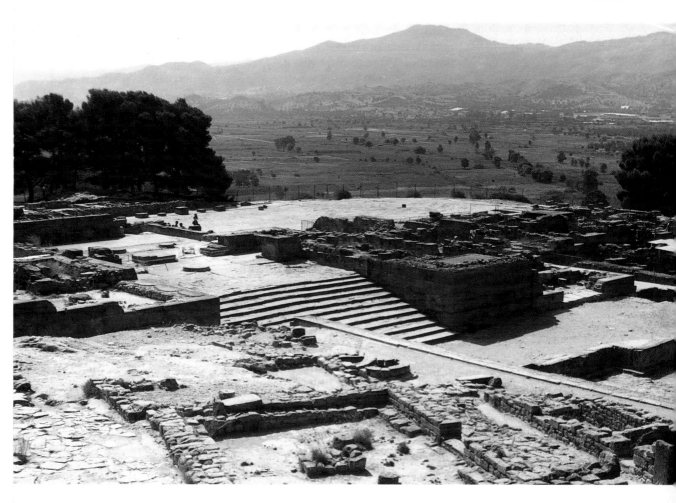

actions that the Minoans developed a form of writing, known today as Linear A. Although this has not been deciphered, it seems to be a syllabic script – that is, one in which separate syllables are each represented by a unique, individual symbol. Around 1450 BC all the palaces except Knossos were destroyed again, most probably by invaders from the mainland; these, the Mycenaeans, established a centre in Knossos and appear to have been in control there until a final destruction took place, through unknown agents, around 1375 BC.

Technically and artistically, the Minoans were a highly accomplished people. The remains of their palaces, towns and villas demonstrate their architectural and engineering abilities, and they were the first in Greek lands to build on a grand scale. Their art shows the influence of Egypt and Syria, yet at the same time is extremely distinctive and highly idiosyncratic. The Minoans have left behind evidence of their talents for many different forms of art. Their wall-paintings combine imaginative design with accurate execution, the subject-matter affording fascinating glimpses of Minoan life, from the physical appearance of the people to their dress, architecture,

5 ABOVE View of the Minoan palace of Phaistos from the north-west. The monumental staircase led up from the courtyard to the main reception rooms.

4 OPPOSITE Marble figurine representing a female figure with arms folded over her stomach. The lyre-shaped head, straight profile and unseparated legs are features characteristic of the Late Spedos stylistic group to which this figurine has been assigned. Made in the Cyclades about 2600–2400 BC. Ht 49 cm.

7 Agate seal-stone, engraved
with a scene of a man leading
a bull with a rope or fillet
round its horns; the rounded,
powerful flanks of the bull
and the folds of skin over its
chest are vividly rendered.
Made in Crete, about
1450–1200 BC. Ht 2.2 cm.

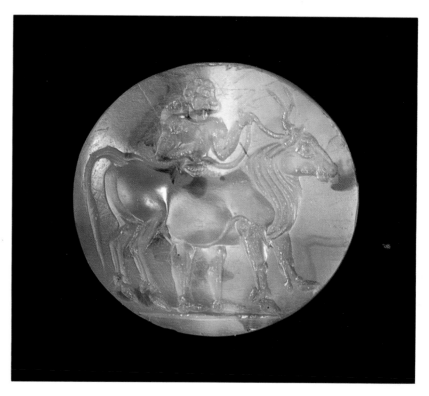

ried as ornaments or amulets rather than for practical use. The carving
is rather impressionistic in style, and the designs are generally symbols
such as spirals or double axes. The designs on the stones intended to be
used as seals include linear patterns, swirls and spirals, pastoral and
hunting scenes, birds, fish, plants and animals, both wild and do-
mestic. The designs have a fluidity of line and a bold stylisation that
seems extraordinarily vivid considering the tiny field and limited tools
at the artists' disposal.

In 1892 the British Museum purchased the Aegina Treasure, a collec- [8]
tion of Minoan jewellery and plate said to have been found in a tomb
on the island of Aegina. The exact circumstances under which it was
discovered have eluded the most diligent investigations, but it appears
to have been found in a Mycenaean tomb, where it had been hidden by
ancient tomb-robbers and for some reason never reclaimed. The
Aegina Treasure is astonishing in both extent and quality. The most
impressive object is the 'master of animals pendant', perhaps designed
to hang from a large dress-pin. It represents a Cretan god standing in a
field of lotus flowers, holding a goose by the neck with each hand.
Behind him are two strange curved objects, possibly sacred bulls'
horns or composite bows. Five gold discs suspended from the bottom
may represent the sun. Equally striking is a large pectoral or chest
ornament, a long, curved plate of gold on which the head of a sphinx
with curling hair looks out at each end. There are two pairs of large
gold earrings, circular hoops in the form of double-headed snakes

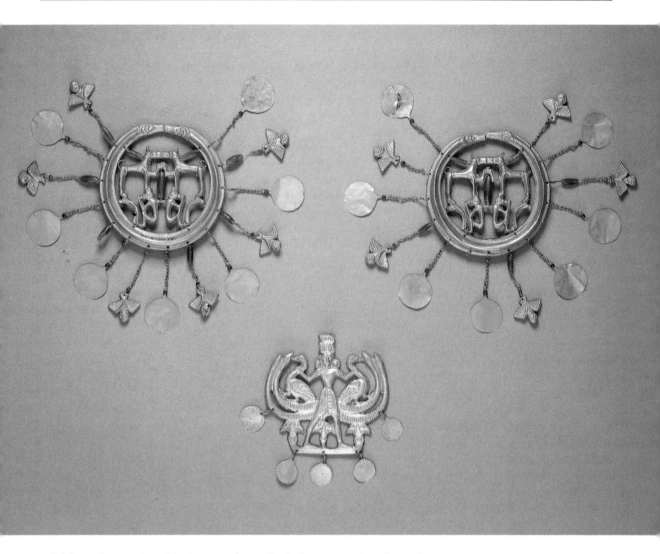

which enclose pairs of facing greyhounds; below are pairs of monkeys set back to back. From the circumference hang fourteen pendants on gold chains, seven in the form of little owls and seven discs. Red cornelian beads threaded on gold wire in several places add a contrast of colour and material. There are strings of gold, jasper, cornelian and amethyst beads, bands of sheet gold, bracelets, rings, a shallow gold cup with spirals and a rosette in the centre, and fifty-four identical gold discs pierced for attachment to a dress or shroud. Cretan parallels suggest that the Aegina Treasure was made between about 1700 and 1500 BC. It displays all the virtuosity of the Cretan goldsmiths, who were equally at home working sheet metal over moulds, linking tiny loops of fine gold chain, or rolling gold wire.

The Minoan civilisation was by and large a peaceful one. Cretan palaces were unfortified; their courtyards were open to welcome visitors. This made them vulnerable to attack from their mainland

8 Two earrings and the 'master of animals' pendant from the Aegina Treasure. The Aegina Treasure was made either in Crete or by Cretan emigrants in Aegina about 1700–1500 BC, a time when Cretan jewellery was at its finest. Ht (of pendant) 6 cm.

neighbours, the Mycenaeans. The Mycenaeans were temperamentally very different from the Minoans; they built themselves fortresses and forged weapons, they invaded and conquered Crete and other places, and in classical times they were chiefly remembered as warriors, the Greeks who fought at Troy.

The Early Bronze Age on the Greek mainland had been a relatively quiet and prosperous period, with the inhabitants, like those of Crete, largely influenced by the culture of the Cyclades. Around 2200 BC this peace was rudely interrupted by invaders, possibly from Anatolia, who destroyed the indigenous settlements and established their own. Their civilisation was at first relatively poor and unimpressive, but by around 1600 BC increased contact with Crete was inspiring the greater prosperity of the Late Bronze Age period, the Mycenaean Age proper, which lasted for some four to five hundred years. Around 1450 BC the Mycenaeans overran Crete and began to establish a widespread trading network that spanned the Mediterranean from Italy to Egypt and the Levant. The Mycenaean palaces whose ruins survive today, notably Mycenae, Tiryns and Pylos, mostly date to the thirteenth century, when the Mycenaean civilisation seems to have been at the zenith of its influence and prosperity. In the course of the twelfth century BC many of the palaces and fortresses were sacked, and there appears to have been a gradual and general collapse of government and of the social structure, ushering in the period of confusion generally termed the Dark Ages.

Although Mycenaean art owes a great deal to that of Crete, it has a robustness and vigour all its own. Where Minoan architecture was quietly luxurious, that of the Mycenaeans tended to be grand and imposing. The Lion Gate at Mycenae, for example, even in its ruined state, makes a far more impressive entrance to a palace than does the main approach to Knossos. Again, the tholos or beehive tombs, whose form was adopted from Crete, were constructed on the mainland on a grander scale: the finest of these to survive is the so-called 'Treasury of Atreus' at Mycenae, of which sections of architectural decoration are preserved in the British Museum. The tomb is a circular domed chamber about 15 m in height and width. It is approached by a long passage, at the end of which stands a monumental doorway. This was originally decorated with coloured stone, elaborately carved. The British Museum has parts of the green marble columns, carved with striking zigzag patterns, that once flanked the doorway, and of the friezes of green and red marble that topped the lintel. Above these friezes a blank triangular space was left to relieve the lintel of weight; this was masked by a facing of red marble decorated with rows of running spirals, sections of which are also in the British Museum. Two fragments of gypsum reliefs depicting bulls, one walking and one charging, are probably part of the original decoration of the walls of the side chamber of the tomb.

Mycenaean pottery was greatly influenced by that of Crete, although the Mycenaeans did evolve their own distinctive shapes. For

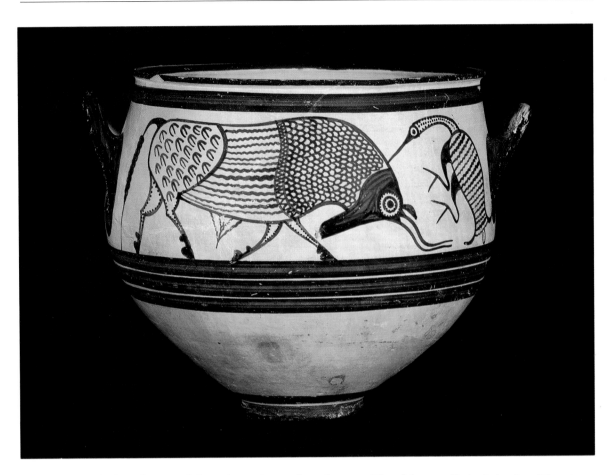

storing liquids they favoured the stirrup-jar, a closed vase with a false mouth (said to resemble a stirrup) and a separate spout beside it. Larger *kraters* (mixing bowls) were designed for preparing the wine and jugs for pouring it out, while the favourite drinking-cup was extremely elegant in shape, with a shallow, delicate-handled bowl set at the top of a high, slender stem. Some of the most interesting Mycenaean pottery dates from the period when the Mycenaeans took over at Knossos, where a fusion of Mycenaean and Minoan ideas resulted in the spirited Marine Style already mentioned, but between about 1400 and 1200 BC this was simplified and stylised beyond recognition. One interesting group of Mycenaean vases appears to have been made for export to Cyprus. These vases, mostly *kraters*, are distinguished by their designs of both animals and human figures. Bulls are particular favourites, with the British Museum's scene of a bull being groomed by an egret affording a particularly pleasing example; representations of chariots pulled by elongated horses and manned by caricatures of warriors are very numerous too and well represented in the British Museum's collection. Also of fired clay are the terracotta figurines found on many Mycenaean sites. The two most common types both represent female figures, perhaps goddesses or worshippers; they are

9 *Krater* (wine-bowl) bearing a scene of an egret picking parasites from the neck of a charging bull. The bull's hide is rendered in various stylised and highly decorative geometric patterns. Mycenaean, probably made on the Greek mainland about 1300–1200 BC; found at Enkomi on Cyprus. Ht 27.2 cm.

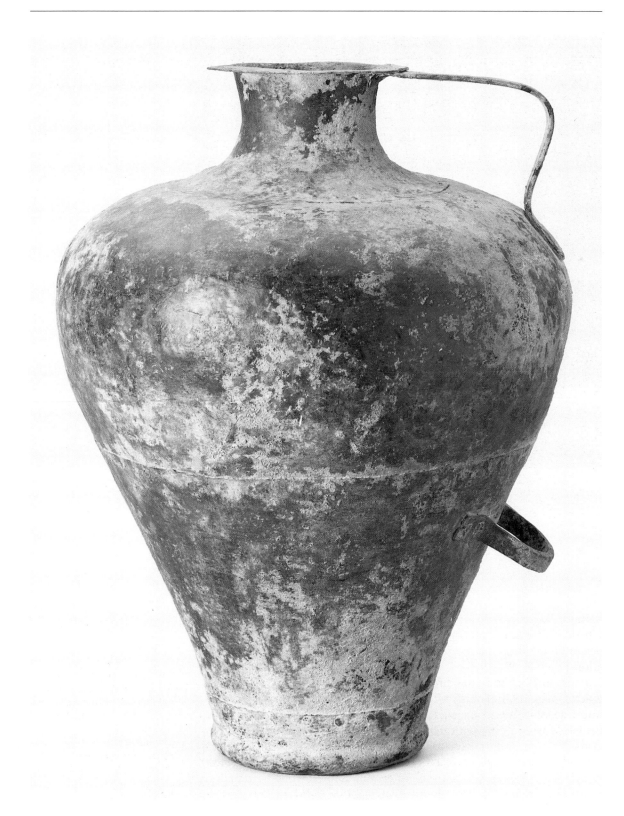

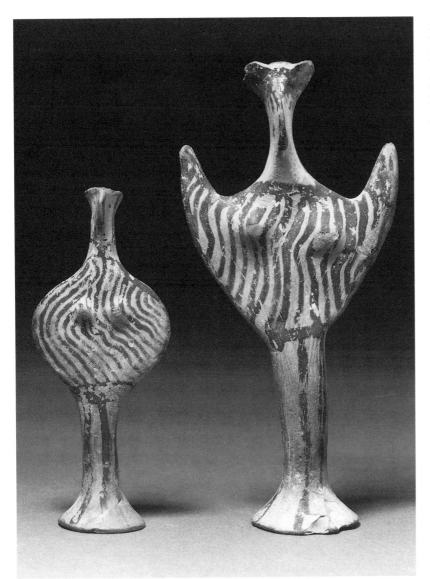

11 LEFT Terracotta 'phi' and 'psi' figurines. These stylised versions of the female form have beak-like noses and prominent breasts; the wavy lines may indicate garments, the gestures prayer or adoration. Mycenaean, 1400–1200 BC; from Melos. Ht (of left-hand figurine) 8 cm.

¹¹ named 'Phi' and 'Psi' types after the letters of the Greek alphabet whose shapes they resemble: the 'Phi' type seems to have her arms wrapped in her garment, while the 'Psi' figure raises hers in prayer or adoration.

Their trading activities brought the Mycenaeans plenty of metal, gold from Egypt and copper from the East, which they worked skilfully into fine vessels and jewellery. Of an extremely elegant shape is the ¹⁰ British Museum's copper pitcher, beaten from sheet metal in four sections that were then riveted together, the handles made separately and riveted in place. Gold and silver cups were favoured, some decorated with designs beaten in repoussé, others left plain. Jewellery, including beads and rings, is also plentiful; it is often hard to distinguish,

10 OPPOSITE Copper pitcher, made from four pieces of sheet metal hammered to shape and riveted together; few of the surviving examples of Mycenaean copper vessels are equally well preserved. 1500–1300 BC; said to be from the Peloponnese. Ht 54.5 cm.

12 Clay tablet with a Linear B inscription recording the allocation of olive oil to a goddess and various officials. Most Linear B signs represent individual syllables, but there are pictograms for such commodities as oil; the oil pictogram (⅄) occurs three times on this tablet. About 1450–1400 BC; from Knossos; presented by Sir Arthur Evans. L 6.2 cm.

however, between what is Mycenaean made under Minoan influence, and what is a Minoan import. In their engraving of seal-stones, too, the Mycenaeans followed very much in the tradition of the Minoans, and again it can be hard to distinguish which is which.

One of the most interesting and distinctive features of the Mycenaean civilisation was its use of writing. In his excavations at Knossos, Sir Arthur Evans discovered over two thousand clay tablets inscribed with a form of syllabic script which, though it shares certain formal similarities with Linear A, is quite distinct from it, and was apparently in use during the Mycenaean occupation of Knossos. Only in 1952, after tablets from both Knossos and Mycenaean palaces on the mainland (notably Pylos) had been closely studied, did it become apparent that the language of Linear B is an early form of Greek, written in syllables rather than letters. This discovery afforded convincing proof of the theory already proposed on other grounds, that the Mycenaeans shared the language of the Greeks of the historical period, and indeed were Greeks themselves. Since the initial breakthrough, translations of the Linear B tablets have revealed fascinating glimpses of the conditions and activities of daily life in and around the palaces in the late Mycenaean world. Most of the tablets are lists – of numbers of slaves of different occupations and nationalities, of fighting men, of armour and equipment, of food supplies, and so on; both in Crete and on the mainland they reveal traces of a highly organised bureaucracy that appears to have controlled both economic and military affairs with great precision.

Greek legend associated the Mycenaean civilisation with the sack of Troy, and it is clear from the Linear B tablets that the Mycenaeans were accustomed to roam the Mediterranean, sacking cities and bringing their inhabitants back as slaves. The Homeric poems of the *Iliad* and *Odyssey*, which reached their final form some time in the eighth century BC, are generally thought to retain echoes of the Mycenaean civilisation, although these are mixed in with references to the intervening centuries through which the poems had been passed down in the oral tradition. That Mycenae deserved its Homeric epithet of 'rich in gold' was made clear by the large quantity of gold discovered by Heinrich

Schliemann at Mycenae; and certain objects mentioned in the poems, such as ox-hide shields and boars' tusk helmets, have been identified either among the excavated material or in wall-paintings of the Mycenaean period. So did the Trojan War itself take place? Excavations at Troy, undertaken first by Schliemann and later more scientifically by an American archaeologist, Carl Blegen, have revealed that though the settlement of the appropriate date does not appear to be of the scale and grandeur evoked by Homer, the city was indeed sacked at the end of the Mycenaean period. Moreover, Hittite documents have revealed that there certainly were Mycenaeans in the area at the time, behaving in an aggressive manner. It has been suggested that the Mycenaeans overreached themselves on the Trojan expedition, and that this contributed to the fall of their own civilisation. This is of course unprovable. All that is known for certain is that the twelfth century was a time of restless movement in the Aegean, on the part of the Mycenaeans as well as others. Some of the Linear B tablets from Pylos seem to refer to the massing of troops to defend the outlying territory, but at Pylos and elsewhere the defences seem to have failed. The end probably came differently in different places; whether the attacks came from within or from outside, the twelfth century BC saw the great palaces abandoned or destroyed, sometimes taken over by squatters. A period of cultural poverty ensued; the arts, including that of writing, were forgotten, and Greece as a whole entered a Dark Age from which it was not to emerge for several centuries.

13 RIGHT Large pedestalled *krater* (wine-bowl) decorated with a range of geometric patterns including meanders and zigzags. Made on Rhodes in the Middle Geometric period, about 800–750 BC; from Camirus, Rhodes. Ht 55.5 cm.

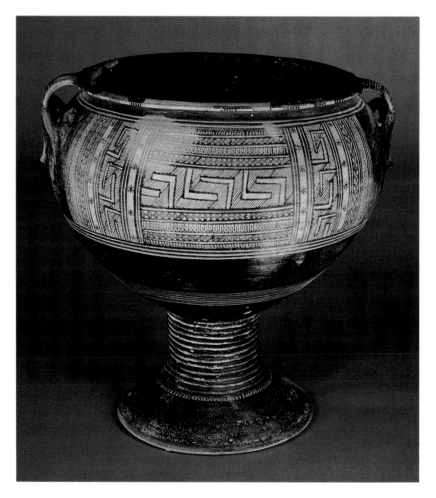

14 OPPOSITE Pitcher (wine-jug) with a figured scene showing women mourning at the biers of two dead people. The shrouds are lifted up to reveal the corpses, and while one mourner waves a branch towards the bier, the others raise their hands to their heads in a ritual gesture. Made in Athens in the Late Geometric period, about 720–700 BC. Ht 44.3 cm.

rituals are portrayed, their formality enhanced by the formulaic, patterned rendering of the figures. Mourners conventionally raise both hands to their heads, perhaps tearing their hair; occasionally they offer branches. The dead person, lying on the bier or wagon, is covered by a patterned shroud, which is raised above the figure to reveal its form. The fight scenes are equally impressive; usually rendered as a series of duels, they show warriors arriving for battle by chariot, equipped with a variety of shields, spears and swords. There are also sea-battles, with the dead and wounded plunged among the fishes. One of the most striking representations of a ship is found on a large *krater* in the British 15 Museum: the vessel is manned by two banks of rowers, possibly intended to represent the port and starboard oars. Beside it stand a man and a woman; the man is about to board the ship and grasps the woman's wrist as though trying to take her with him.

This unusual and interesting scene provokes one of the perennial questions posed by Late Geometric art. Do such figure scenes represent the activities of Late Geometric people, or are they, rather, evocations of the heroic past? It is known that the epic poems of Homer,

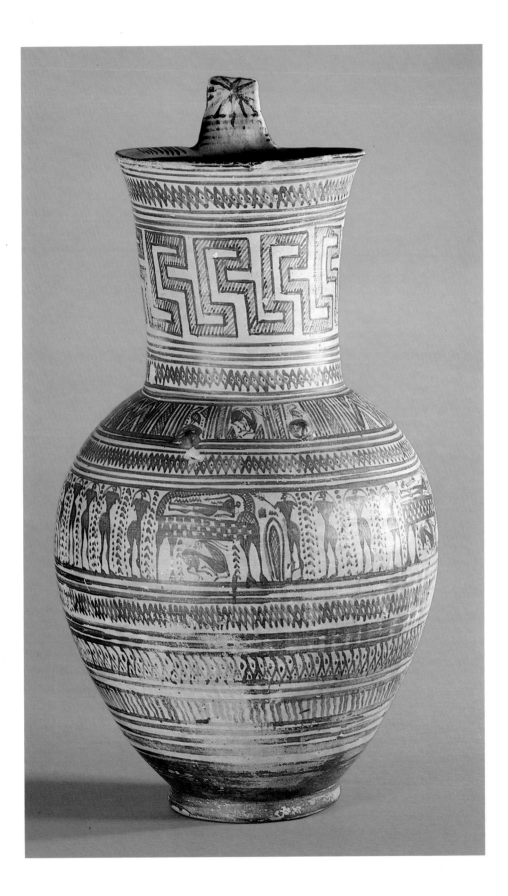

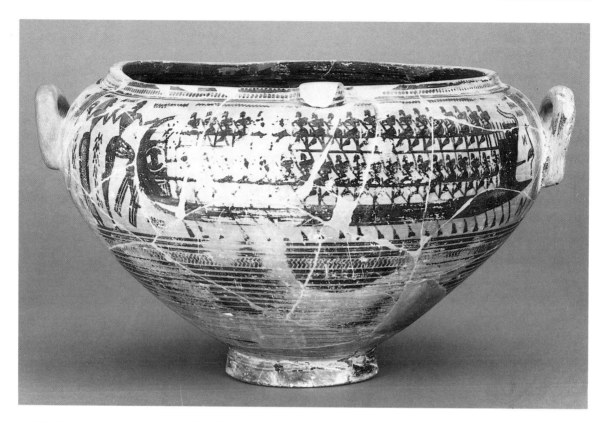

15 The figured scene on this spouted *krater* (wine-bowl) shows a large ship with two rows of oarsmen; the man and woman to the left may be mythological figures such as Theseus and the Cretan princess Ariadne. Made in Athens in the Late Geometric period, about 730–710 BC. Ht 30.9 cm.

the *Iliad* and the *Odyssey*, were reaching their final form in this period. Archaeological evidence suggests veneration of certain Mycenaean tombs at this time, surely an indication of respect for and interest in the heroic past. The establishment of shrines in honour of particular named heroes dates to the same period: one example is the Menelaion at Sparta, where the Homeric hero Menelaos was revered. It is, however, difficult to be certain about representations of myths and legends in Geometric art. Such aspects of Geometric decoration as the so-called 'Dipylon' shields, the large, impractical-looking objects like two arcs of a circle, that leave the bearer totally unprotected at the waist, are endlessly discussed: are they imitations of the Mycenaean figure-of-eight shields, or a stylised representation of a type of shield actually in use in the Geometric period? Do certain 'Siamese twin' figures represent a pair of Siamese twins mentioned in Homer, the Aktorione-Molione, or are they simply two warriors standing rather close together? It may not be impossible that these scenes represent the beginnings of the idea of narrative art, of representations of the myths; if only the possibility is recognised, then the British Museum's ship *krater* may show Theseus, accompanied by Ariadne with the 'clue' that guided him through the Labyrinth, embarking on the journey home from Crete.

Although vases were the most spectacular legacy of the Geometric period, other forms of art have also survived. There are various terra-

cotta models, including model granaries and pomegranates, and fig-
urines such as the horses already mentioned. There is also a range of
small figurines cast in bronze. Most of these were found in sanctuaries,
which were becoming more important in the Late Geometric period:
traditionally, the first Games held in the sanctuary of Zeus at Olympia,
for example, were dated to 776 BC. The small bronze horses are particu-
16 larly fine, like their terracotta counterparts but with exaggeratedly slim
waists, long tapering legs and alert expressions. A small amount of
bronze and gold jewellery also survives from the Geometric period.
The British Museum has a fine collection of Middle Geometric jewel-
17 lery, found in tombs in and around Athens by the agents of Lord Elgin,
which includes rings and gold *fibulae* (brooches), their catch-plates
engraved with figures of stags, horses and lions, very finely worked in
a delicate, miniaturist style anticipating that of the Orientalising
period.

From the middle of the eighth century BC onwards, trading contact
between Greece and such great Near Eastern civilisations as Phoenicia,
Syria, Assyria, Urartu and Egypt increased significantly. Trading posts

16 Bronze horses like these
were a common form of
dedication at shrines and
sanctuaries in the Geometric
period; the example on the
right was found in the
Sanctuary of Zeus at
Olympia. Such dedications
may have served as a mark of
the votary's wealth or status.
800–700 BC. Ht (of the right-
hand horse) 9 cm.

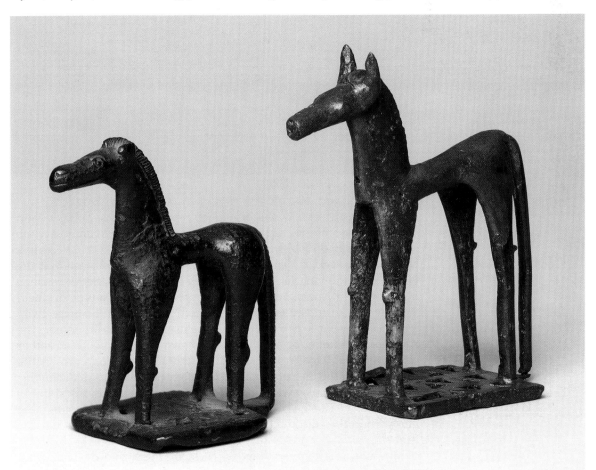

17 Two gold earrings and two *fibulae* (brooches) from the Elgin jewellery. The earrings are decorated with intricate granulation, while the catchplates of the *fibulae* bear incised designs of animals and geometric patterns. Greek, from tombs in and around Athens; eighth century BC. D (of each earring) 3.2 cm.

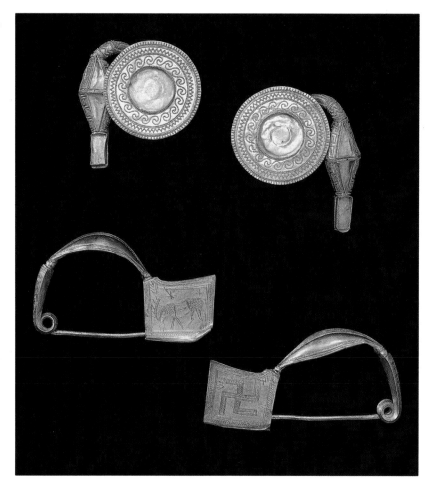

were established, one of the best known and most important being Al Mina, at the mouth of the River Orontes in northern Syria (now in Turkey). It was probably at Al Mina that Greek merchants came into contact with the Phoenicians, from whom they borrowed the Phoenician alphabet, adapting it to fit the needs of their own language and so regaining the literacy lost with the fall of the Mycenaean kingdoms. From the East the Greeks learned new techniques of working with bronze and with precious materials such as gold and ivory; they also ¹⁸ adopted new eastern motifs, including naturalistic plants and animals as well as exotic imaginary beasts such as griffins and winged lions. Many of these motifs may have entered Greek lands in the form of woven textiles. Absorbed into the Geometric repertoire, they breathed new life into a system that had reached a peak of excellence from which, left to itself, it could only have declined; a new freedom dissolved the rigid formality of the Geometric style, releasing artists from the abstract conventions that had hitherto shaped their work. In this way a new style of art was born, one which owed much to the East and yet was as distinctively Greek as the Geometric style itself.

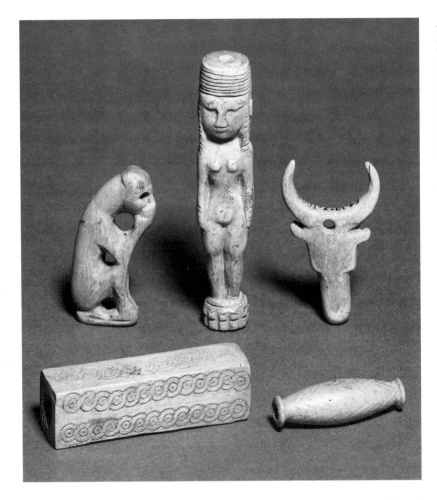

18 Ivory monkey, double-sided female figure, bull's head and two beads found in the excavations of a well in the precinct of the temple of Athena at Camirus, Rhodes. Although they were almost certainly carved locally, in both subject and style these pieces show the influence of Near Eastern and Egyptian art; about 750–700 BC. Ht (of monkey) 3.5 cm.

'Orientalising' influence is immediately evident in pottery styles. A
19 beautiful jug made in the Cyclades has a spout in the form of a griffin's head; on the shoulder are panels containing other oriental motifs: a lioness bringing down a stag, and two grazing horses. The way the griffin was adopted and adapted by Greek artists is typical of the Orientalising movement. Griffins of various types were found in Near Eastern art, but in Greece a distinctively Greek type evolved, with a lion's body, eagle's beak, hare's ears and a knob or spike on the brow.
20 In Athenian vase painting the Geometric style visibly relaxes; so on
21 an *amphora* painted around 700 BC, geometric patterns still fill the lower zones of the vase, but the panel on the neck bears the typical 'oriental' motif of a lion bringing down a deer; the chariots circling the body of the vase show no great change from their Geometric predecessors, though the filling ornament of hooked swastikas and 'N's is new and there is an attempt at perspective with only one wheel of each chariot showing; the grazing deer around the shoulder of the vessel, however, really seem to lift their feet up off the ground as they move. The increased freedom and naturalism was accompanied at Athens by a

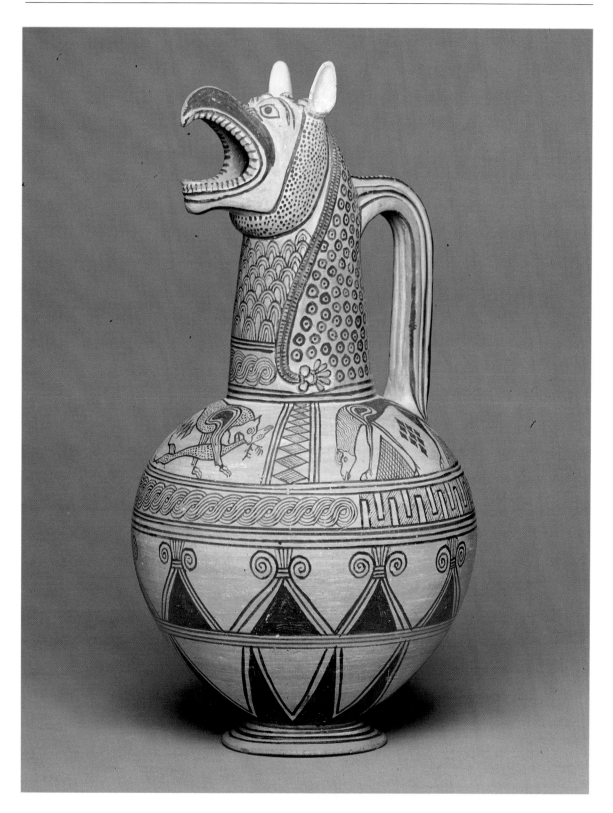

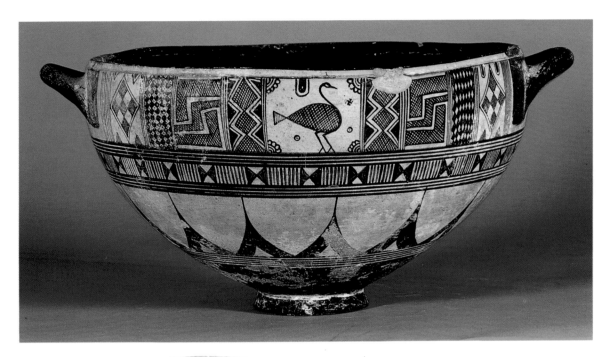

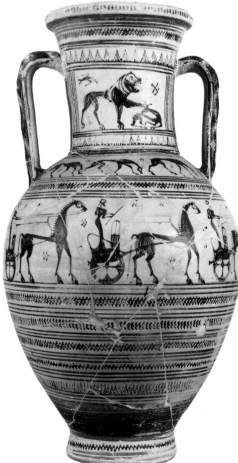

19 OPPOSITE Jug with a spout in the form of a griffin head. Both the griffin head and the centrally placed motif of a lion bringing down a stag are Near Eastern imports into Greek art during the Orientalising period. Made in the Cyclades about 675–650 BC; from Aegina. Ht 41.5 cm.

20 ABOVE 'Bird bowls' are found on numerous sites in the eastern Mediterranean; this unusually large example may have been made on Rhodes, where it was found. Its decorative scheme, with the centrally placed water-bird, demonstrates the way in which geometric patterns were becoming less important by the seventh century BC. Ht 23 cm.

21 LEFT *Amphora* (wine-jar) with a lion and a stag on the neck, grazing deer on the shoulder and a procession of chariots moving round the body. The Geometric style is gradually relaxing to admit Orientalising motifs such as the lion and stag. Made in Athens about 700 BC; from Athens. Ht 61.5 cm.

[33]

decline in the quality and accuracy of the painting; the best figures are powerfully drawn in a rather sprawling, impressionistic style, more remarkable for its energy than its precision. This is the so-called Proto-Attic style, which lasted for most of the seventh century BC.

It was Corinth that now took the lead in fine vase-painting, developing a careful, meticulous and basically miniaturist style, the Proto-Corinthian. This was the earliest form of the 'black-figure' technique of vase-painting, which was to dominate the decoration of painted pottery for the next two hundred years. Like the Geometric figure style, the new technique was basically one of dark silhouettes set against a light background; the difference was that the silhouettes were now enlivened with incision, and with touches of added red and white. The preferred shapes for vases made and decorated at Corinth were small perfume-bottles, *alabastra* and *aryballoi*. Corinth in the seventh century was becoming a great trading state; Corinthian colonies were established throughout the Mediterranean, especially in southern Italy and Sicily, and in all the colonies Corinthian vases are found, with their distinctive shapes, fine greenish-yellow clay and delicate decorative style. Some of the pots are covered in a rich, oriental-looking tapestry of flowers and real and fantastic animals; others, such as the Macmillan *aryballos* (named after a former owner), bear figured scenes. This tiny ²²

22 Two Proto-Corinthian perfume bottles. The *alabastron* (*left*) is decorated with an interlinking lotus and palmette chain above a frieze of animals, including a griffin; the dot-rosettes are typical of the Proto-Corinthian style. The Macmillan *aryballos* (*right*) is modelled with an intricately detailed lion-head spout and bears three figured friezes. Made in Corinth between 680 and 640 BC; the *alabastron* was found at Camirus, Rhodes, while the Macmillan *aryballos* is said to be from Thebes. Ht (of the Macmillan *aryballos*) 6.8 cm.

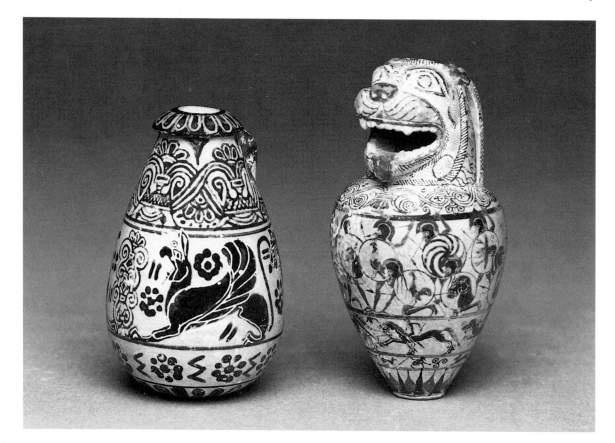

scent-bottle is less than 7 cm high; its mouth is modelled as a lion's head, with gaping jaw and beautifully detailed mane, while the shoulder bears a rich design of scrolling tendrils. Below this are no fewer than three figure scenes. The main one shows a battle, with eighteen warriors engaged in energetic combat, each bearing a shield with an intricately emblazoned device; below this is a horse-race, and below this again, a hare-hunt. On both Proto-Attic and Proto-Corinthian vases, mythological scenes are now distinctly recognisable; the subjects chosen include Odysseus and his companions driving the stake into the Cyclops's eye, and several of the Labours of Herakles.

Small-scale sculpture in bronze and terracotta also flourished during the Orientalising period. As in the Late Geometric period, much of what survives comes not only from graves but also from sanctuaries, which, it seems, were playing an increasingly important part in the social and political affairs of the Greek world. The sanctuary of Artemis Orthia at Sparta, for example, though clearly never as large and wealthy as those at Delphi, Ephesus or Olympia, has yielded a fascinating range of small objects, which were almost certainly locally produced to be sold to visitors who would dedicate them to the goddess. The iron spits may be an early form of currency; the terracotta heads, small bronze animals, pins and double axes must simply have been

23 Seven of the hundreds of thousands of small lead figurines and other objects found in the sanctuary of Artemis Orthia at Sparta. The two winged figures probably represent Artemis herself, while the helmeted figure between them is the warrior goddess Athena. Warriors and animals such as stags and horses are numerous, as are the strange grid-like objects which may be intended to signify textiles. The figures were locally mass-produced in moulds; they must have been bought and dedicated by visitors to the sanctuary. Seventh century BC. Ht (of the 'textile') 4.5 cm.

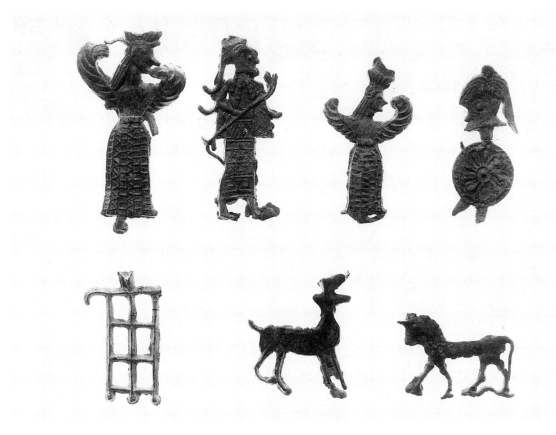

gifts for the goddess, as were the carved ivory seals, animal figures, plaques and pieces of inlay, and the hundreds of thousands of lead figurines recovered from the site. The sanctuary of Artemis Orthia was [23] excavated by the British School at Athens in the early decades of this century, and a portion of the finds was presented to the British Museum by the Greek government.

Although large-scale bronze sculpture does not survive from this period, we know that techniques for working bronze were by now well

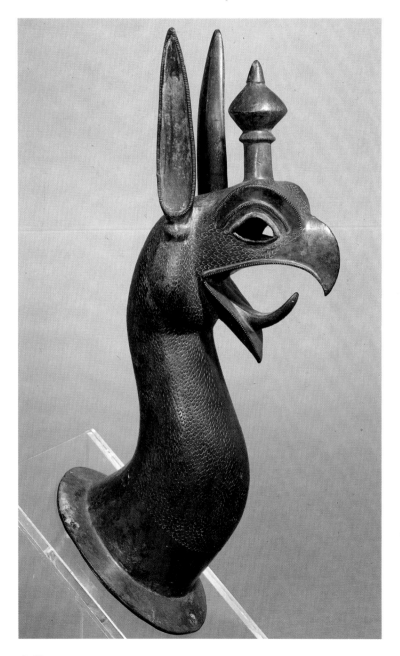

24 LEFT Bronze griffin *protome* from the shoulder of a *dinos* (wine-bowl); every scale is beautifully lined in, while the borders of mouth, eyebrows and ears are emphasised with careful hatching. Such heads may have been thought to possess apotropaic powers – that is, to have averted the evil eye from the contents of the bowl and those enjoying it. Made in a Greek city of Asia Minor about 650 BC; probably from Rhodes. Ht 23.4 cm.

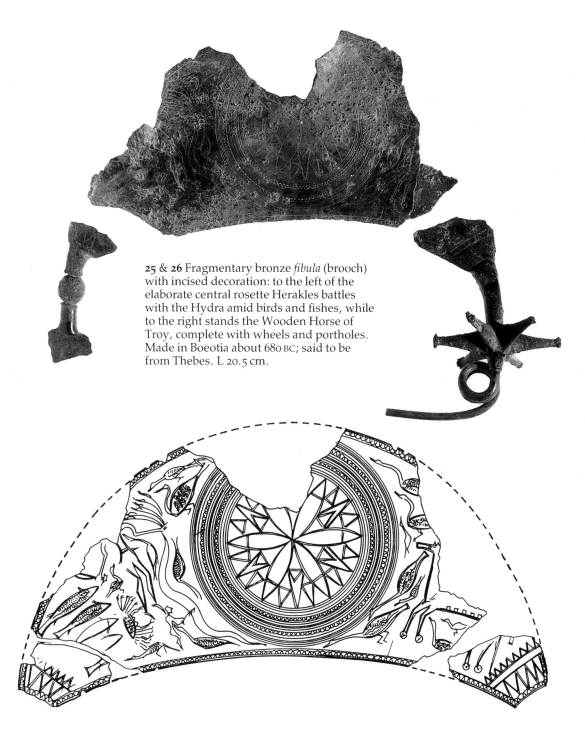

25 & 26 Fragmentary bronze *fibula* (brooch) with incised decoration: to the left of the elaborate central rosette Herakles battles with the Hydra amid birds and fishes, while to the right stands the Wooden Horse of Troy, complete with wheels and portholes. Made in Boeotia about 680 BC; said to be from Thebes. L 20.5 cm.

developed. There are, for example, bronze griffin-heads that were [24] originally attached to the shoulders of large cauldrons; this type of vessel seems to have originated in Urartu, but it was imported and imitated all over the Near East and in Italy as well as Greece. The British Museum's two griffin-heads are both cast hollow, and are among the earliest examples of this technique to have survived. The method must have been introduced from the East, perhaps by immigrant craftsmen.

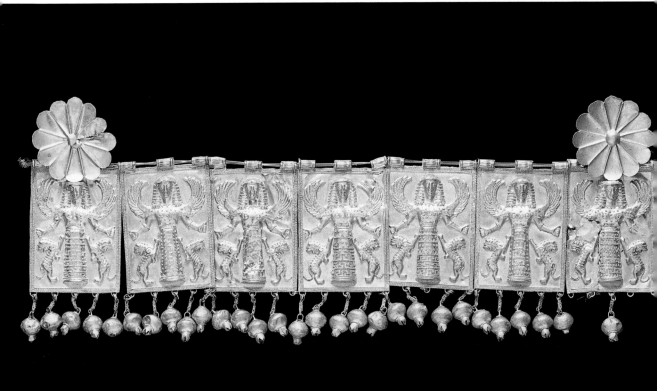

27 Seven gold plaques, designed to be strung together and worn across the chest, with the rosettes pinned at the shoulders. Each plaque shows a winged goddess flanked by lions; details of the figures are picked out with filigree and granulation. The winged goddess may be the Near Eastern Astarte, whom the Greeks worshipped as Artemis; the pomegranates which hang below the plaques were symbols of fertility. Ht (of one plaque) 4.2 cm.

Also typical of the Orientalising period is a series of engraved bronze *fibulae* (brooches), believed to have been made in Boeotia, where many of them have been found. Most of the catch-plates are decorated with figures of birds or animals, usually deer or horses, but some of the larger examples include minutely engraved incidents from mythology; one shows Herakles fighting the Hydra opposite a representation of the Wooden Horse of Troy. [25,26]

The small-scale arts of engraving seal-stones and producing fine gold jewellery also flourished in the seventh century. The seal-stones of the period are mostly cut in soft stone, usually steatite. They seem to have been made in the Cyclades, principally Melos and Naxos, and both their shape and style suggest the influence of stray finds of Mycenaean seals. The two main shapes are lentoid (lens-shaped) and amygdaloid (almond-shaped); the designs represent animals, fish and birds in an attractive, rather impressionistic style, and occasionally a mythological figure, such as Herakles, is attempted.

While these seals suggest the independent initiative of individual Greek craftsmen, much of the finest goldwork of the period demonstrates both techniques and motifs that must have been learned from the Near East. Most of it has been found on the wealthy island of

Rhodes, and the British Museum is fortunate to possess a fine collection excavated in the Camirus cemetery in the mid-nineteenth century by August Salzmann and Alfred Biliotti. Perhaps the most striking among the rich assemblage of pendants, beads, pins and earrings are [27] the series of pectoral plaques, designed to be worn in strings across the top of the garment, pinned to it at the shoulders. These plaques represent a variety of subjects, from centaurs to goddess figures, winged and holding a lion or a bird in each hand; this is the Near Eastern 'mistress of animals' whom the Greeks adopted and worshipped as Artemis. The workmanship of these plaques is superb; the techniques of filigree and granulation are both employed, often to pick out the minutest details of the goddess's dress or her animals' manes. It is interesting that many of these plaques shows signs of wear or of ancient repairs, so that they must have been worn by their owners during life, not simply placed with them in the grave. They provide, therefore, a rare and fascinating glimpse of the wealth enjoyed by some Rhodians of the time.

The Orientalising period was an age of enlightenment and awakening. By the end of the seventh century BC, firm cultural and political foundations had been laid for the civilisation that was to attain its finest artistic expression in the Archaic and Classical periods of the sixth to fourth centuries BC.

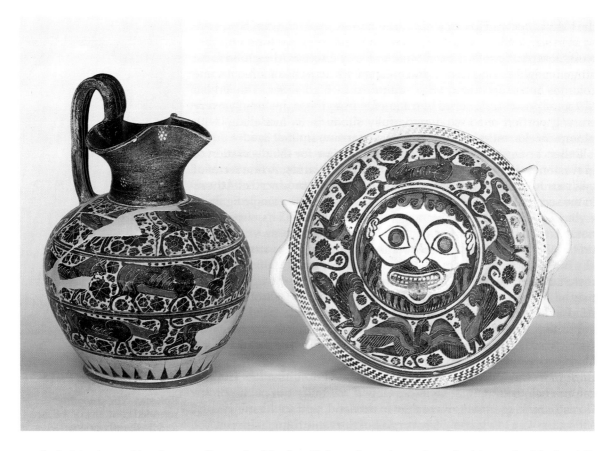

32 Corinthian jug and bowl decorated with friezes of closely packed animals, a gorgon's head filling the centre of the bowl. The pale, creamy Corinthian clay contrasts very effectively with the rich reds and blacks of the figures, and the shapes are well designed and very competently potted. About 625–600 BC; from Camirus, Rhodes. Ht (of jug) 35.5 cm.

enlivened with plentiful touches of purple and white and with the skilful use of incision, stand out effectively against the fine greenish-yellow clay, while the shapes are taut and well potted. However, as the century wore on the style degenerated, with the animals growing ever longer and the filling ornament more careless; mass production resulted in dullness and ultimate failure. Another school of black-figure painting developed at Sparta in Laconia, where it was used principally for the decoration of drinking cups, but occasionally for other shapes as well; much Laconian pottery is finely made and painted, and several interesting mythological scenes appear amongst more standard representations of banqueters or horsemen.

Animals were also favoured by East Greek vase-painters, but the effect here is rather different from that of the Corinthian animal vases: the 'Wild Goat' style produced much livelier animals which stalk ³³ nimbly around their vases, giving an overall impression that is lighter and more cheerful than the Corinthian. One plate produced on Rhodes ³⁴ in the early sixth century BC is unusual in East Greece for its representation of a scene that not only involves human figures rather than animals, but actually represents an incident from Greek mythology: two warriors, the Trojan prince Hector and the Greek hero Menelaos, are shown fighting over the body of a fallen Trojan, Euphorbos, in an inci-

dent described in Homer's *Iliad*. The names of all the characters are written beside them, and the forms of the letters suggest the plate is the work of Argive artists resident in Rhodes; the scene is executed in an attractive and unusual outline technique with areas of dark red used to cover flesh and for other details. Other East Greek styles included the 'Fikellura' (from a cemetery on Rhodes where many examples were found), which relied on single figures set dramatically in an open field.

Some of the finest sixth-century vases were made on the East Greek island of Chios; the thin-walled chalices and *kraters* are coated outside in a fine white slip with polychrome decoration on top, while the dark ground inside is sometimes decorated with an intricate tapestry of lotus and palmette designs in red, white and purple. The fragility of these vases means that few have survived intact, but even as fragments they have an enormous impact. The British Museum has a large collec- tion of Chiot and other fragments, principally East Greek, from Nau- kratis, a Greek trading settlement in the Nile delta where Greek merchants from a variety of cities seem to have been free to maintain their own way of life, even worshipping their own gods. Many of the pot fragments bear scratched or painted inscriptions recording the dedication of the vessel to one of the Greek gods or goddesses, usually Apollo or Aphrodite. The dedicators often record the name of the city or area from which they came, a practice that helps to suggest some- thing of the rich and cosmopolitan nature of the settlement in the sixth century BC.

Also from the eastern part of the Greek world is the British Museum's large terracotta sarcophagus (coffin) with gabled lid, one of

33 **33** East Greek bowl decorated in the 'Wild Goat' style, with friezes of animals inside and out, and moulded female heads attached to the rim. The scratched inscription may be translated 'Sostratos dedicated me to Aphrodite'; this is one of the very few virtually complete vessels found at Naukratis in Egypt. About 600 BC. Ht 17.5 cm.

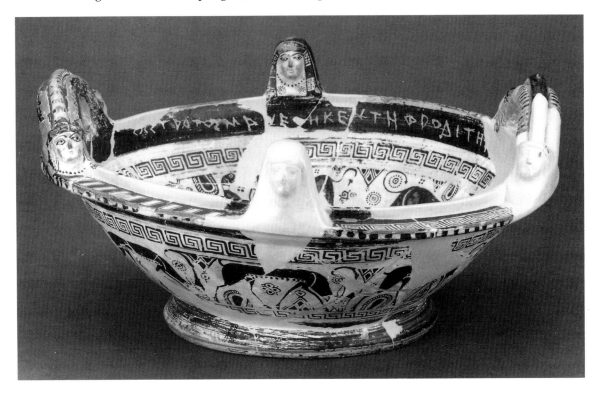

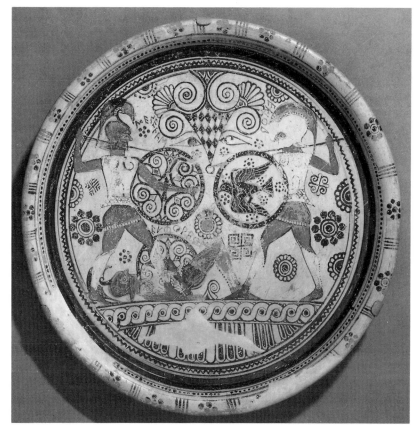

34 East Greek plate decorated with a scene from Homer's *Iliad*, with the Greek and Trojan princes Menelaos and Hector fighting over the fallen body of the Trojan Euphorbos. The heroes' names are written beside them, and the background is filled in with a variety of rosettes, floral and linear patterns, and, at the top, a pair of eyes. Made on Rhodes about 600 BC; from Camirus, Rhodes. D 38 cm.

a series produced at Clazomenae, north of Smyrna (Izmir) in Asia Minor, in the late sixth and early fifth centuries BC. Its very existence is a testimony to the skill of its producers, since both the construction and the firing of an object of this size and weight are extremely delicate operations. The decoration of the sarcophagus recalls that of contemporary East Greek black-figure vase painting, with an elaborate series of friezes of real and mythological animals and battle scenes; details of the figures, however, are indicated not by incision but by added white lines.

In the Archaic period Athens assumed the lead in vase-painting, a position that would not be relinquished for some centuries. By the beginning of the sixth century Athens was learning from Corinth to tidy up the rather careless exuberance of the Proto-Attic style. Some Corinthian painters may have emigrated to Athens; at any rate, early sixth-century Athenian vases show definite signs of Corinthian influence in both style and subject-matter. This is true of the so-called 'Sophilos Dinos', a large wine-bowl produced about 580 BC, which sits ³⁵ on a separate stand; the two parts together are over 90 cm tall. The stand and lower part of the bowl are covered in Corinthian-style animal friezes, but the highest register of the bowl bears an essentially Athenian representation of a mythological subject, the arrival of guests

to celebrate the wedding of Peleus and Thetis. The son of Peleus and Thetis would be Achilles, destined to become the greatest of the Greeks to fight at Troy, and because Thetis was a favourite of the gods, they all came to her wedding. Thetis does not appear in the painting, but Peleus stands at the door of his house to receive the guests. In the forefront strides the wine-god Dionysos, bringing with him a vine to contribute to the festivities, and not far behind is Achilles's future tutor, the centaur Cheiron, a brace of animals hanging from a stick over his shoulder. All the visitors have their names inscribed beside them as they approach in a varied procession, some in chariots, others on foot. The chariots are very finely drawn: there are white, black and purple horses, with the details of the harness finely observed and the requisite number of tails and legs meticulously lined in.

³⁶ forefront

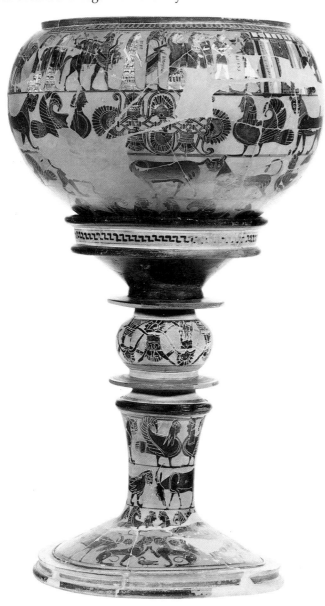

35 The 'Sophilos *dinos*', a large wine-bowl set on a separate stand. The friezes of animals and the large floral complex recall contemporary Corinthian vase-painting, but the ambitious figured scene is executed in the new Athenian style. Its subject, the wedding of Peleus and Thetis, is appropriate for a vase which may itself have been a wedding gift. Made in Athens about 580 BC; signed by the painter Sophilos. Ht 71 cm.

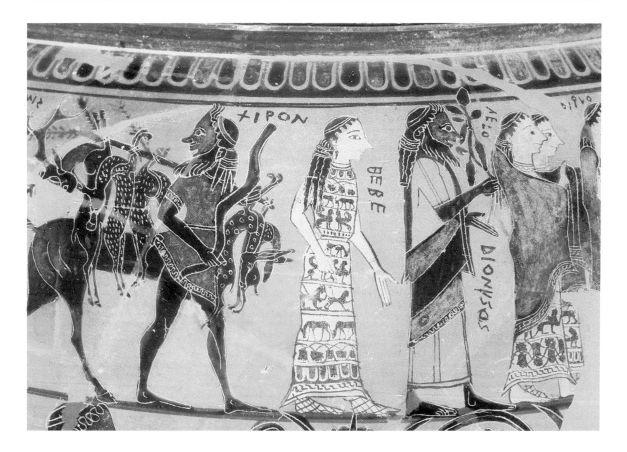

36 Detail from the upper frieze of the Sophilos *dinos* (fig. 35). The wine-god Dionysos, bearing a vine, is one of the first wedding guests to arrive at Peleus's house. He is followed by Hebe, goddess of youth, dressed in a boldly patterned garment, and after her comes the centaur Cheiron, the tutor of Peleus and Thetis's future son Achilles. Cheiron has brought a practical contribution of game for the wedding feast. Ht (of frieze) 8 cm.

Between the pillars of Peleus's house, Sophilos has signed his name: translated, the inscription reads 'Sophilos painted me'. Sophilos's is the first name of a Greek vase-painter that we know, but as the century wore on more and more signatures appeared on Athenian vases. These, both of painters and of potters, formed the basis of a system of attribution of vases to specific hands which was worked out in the first half of this century by an English scholar, Sir John Beazley. Although by no means all painters signed their names, Beazley was able to identify over five hundred individual black-figure artists and groups. These he named in various ways: some, like the Amasis Painter, from the signature of the potter with whom he worked; others, such as Elbows Out or the Deianeira Painter, from a stylistic peculiarity or an interesting subject; others again, like the Princeton Painter, from the present location of a key vase. Not all of his attributions are totally convincing, and all are subject to constant scrutiny and revision by scholars working in the field today, but the general principles are still widely accepted.

From the early sixth century onwards, Athenian vase-painters concentrated on depicting the human form. The subject-matter of their scenes was drawn either from life around them, at the drinking party (*symposium*), in the gymnasium, at the hunt or the fountain house, or

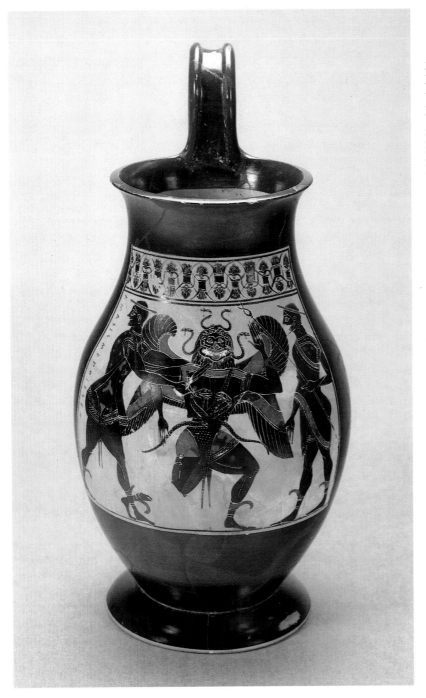

37 Black-figured *olpe* (wine-jug) signed by the potter Amasis and attributed to the Amasis Painter. Perseus, watched by the messenger-god Hermes, slays the monstrous gorgon Medusa. Made in Athens about 550 BC. Ht 26 cm.

else from the realm of mythology, where the most popular subjects were the Labours of Herakles and the Trojan War. Sometimes it is impossible to distinguish precisely between the 'real' and the 'mythological', as in the popular fight scenes or representations of warriors leaving home. The shapes of sixth-century black-figured vases were very varied, but most were primarily concerned with wine and its consumption at drinking-parties. Since the Greeks drank their wine mixed

with water, there were vessels to bring the wine and the water to the party and others in which to mix it; wine was stored and transported in two-handled jars (*amphorae* and later *pelikai*) while water was collected from the fountain in the elegant *hydriai*, vases with one vertical and two horizontal handles to facilitate pouring and carrying. At the table, the wine and water would be mixed in large bowls with wide open tops (*kraters*). Until it was needed, the wine might be chilled inside a cooler (*psykter*), a mushroom-shaped vessel which would float in a *krater* of ice-cold water. Jugs of several shapes (*oinochoai*) would be dipped into the *kraters* of wine and water, then used to fill the actual drinking-cups. These came in a variety of shapes in the sixth century. Among the finest are the high-stemmed, thin-walled 'lip' and 'band' cups, named after the systems of decoration they employ; some bear a painted inscription exhorting the owner to 'drink and be of good cheer'!

Although Greek vase-painting was always a minor art, some of its practitioners were extremely skilful and their work is worth considering not merely as a reflection of the large-scale paintings now lost to us, but as art in its own right. The greatest of the black-figure artists was undoubtedly Exekias, whose signatures suggest that he worked as both a potter and a painter. It is certainly true that on his vases the painting and the potting are exceptionally complementary; on the British Museum's *amphora* depicting the death of Penthesileia, for [38] example, the taut, round shape of the vase and the beautiful glossy surface of both red and black areas provide a fitting background for the delicately rendered figures. Penthesileia was the Queen of the Amazons, a race of warrior-women who lived on the shores of the Black Sea; at a late stage of the Trojan War they came to offer their services to the Trojans, and Penthesileia was killed by the Greek hero Achilles. According to the legend, their eyes met at the moment of her death and they fell hopelessly in love. Exekias may or may not have been aware of this tradition, but he has certainly shown the incident most poignantly: Penthesileia crouches defenceless at the feet of Achilles, her white flesh contrasted with the cruel, black-helmeted head of Achilles, as he thrusts his spear mercilessly into her breast. The composition is beautifully balanced, and every detail of the combatants' armour and equipment is finely worked. The neatly written names of the participants, and Exekias's own signature, add to the balanced and decorative effect.

Figurines of fired clay, generally known as 'terracottas', were produced in various centres in the Archaic Greek world; they were dedicated in sanctuaries and also laid in the grave. Boeotia, which was to become important for its Hellenistic 'Tanagra' figures, was already establishing itself as a major centre for terracotta production in the sixth century, turning out gaily painted figures of seated and standing god- [39] desses and cheerful zebra-striped horses, some with tiny riders clinging to their manes. Corinth favoured scent-bottles modelled in the form of animals, principally lions and sphinxes, varied with occasional figures of comic actors squatting on their haunches; all these were

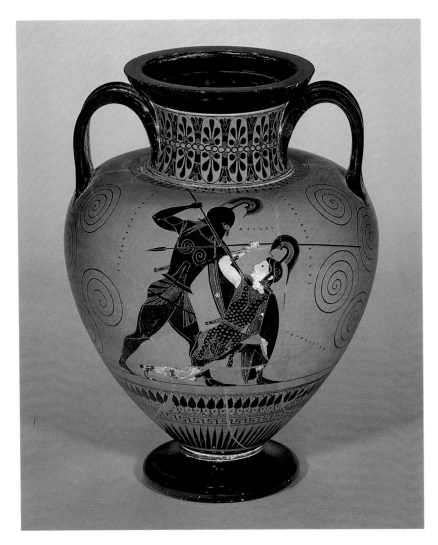

38 Black-figured *amphora* (wine-jar) signed by Exekias as potter and attributed to him as painter. The potting and the pattern-work, as well as the composition and execution of the figure scene, are all of a superlative standard and combine to make this one of the finest of all surviving Greek vases. Made in Athens about 540–530 BC; from Vulci in Etruria. Ht 41.6 cm.

characteristically decorated with neatly executed rows of spots. Scent-
⁴⁰ bottles of various interesting shapes, including cockle-shells, the
heads of lions, women and warriors, or even human legs, were pro-
duced in Ionia; one of the most attractive and unusual is in the shape of
a swallow, very gracefully formed save for the rather large feet which
stop him from falling over. While the Boeotian figures were modelled
by hand, the scent-bottles were made in moulds; all terracottas of the
period were decorated before firing, so the range of colours they bear is
very similar to that of contemporary vases. Other moulded scent bot-
tles were made in Rhodes and probably elsewhere in East Greece from
faience, a glazed material made from quartz sand bound with natron (a
naturally occurring sodium compound); the techniques of faience pro-
duction are thought to derive from Egypt or Phoenicia. These faience
bottles are generally coloured in attractive shades of pale or turquoise
blue and green.

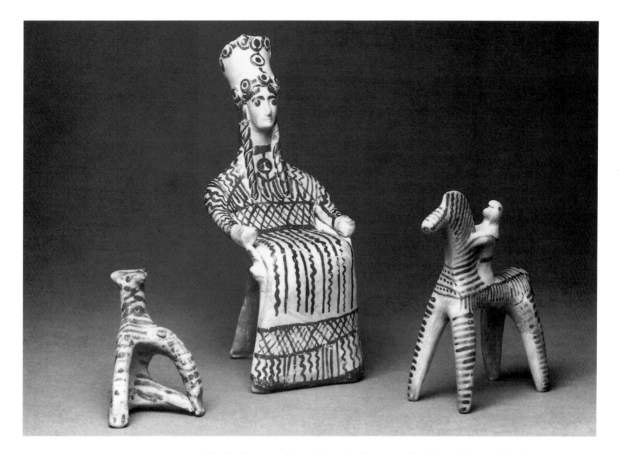

39 Terracotta figurines of a monkey, a seated goddess and a horseman, made in Boeotia in the sixth century BC. The monkey was found near Lake Copais in Boeotia, the other two at Tanagra. Most terracottas are thought to have had some ritual significance, but the monkey may simply have been a child's toy. Ht (of the goddess) 21 cm.

Techniques of working in bronze, both solid- and hollow-casting, were well established in the sixth century BC. Although relatively few large bronzes survive intact due to the practice, common throughout antiquity, of melting down and re-using bronze, many statues of *kouroi* and *korai* were made of bronze, as were a range of vessels. On the whole, the levels of skill and expertise involved must be estimated from the quality of the small bronze figurines that survive in large quantities. Many of the finest bronzes have been associated with Sparta, which traditionally had a reputation for skilful bronze-casting. Two of the British Museum's small Archaic bronzes are thought to be of Spartan origin. One is the figure of a reclining banqueter holding a libation bowl and the other is a running girl; both are beautifully worked in terms of composition, detail and finish. Small bronzes like these are generally found in tombs but might also have been offered to the gods as dedications in sanctuaries. One interesting group of rather more crudely worked bronze figurines comes from the site of Çesme, in south-west Asia Minor, and was perhaps a votive deposit; besides a variety of animals and reptiles, it includes some interesting pieces such as a woman with her head facing backwards over her shoulders, two women fighting, and a ploughman with one ox walking backwards; it has been suggested that some of these abnormal figurines may have

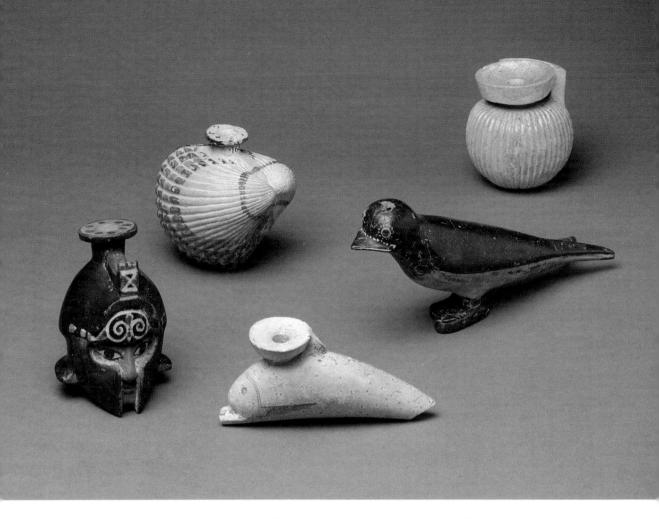

been supposed to possess magical properties.

Finally we come to the smallest of the arts, the engraving of coin-dies and seal-stones. These two arts are related, especially at this early period: although the die engraver worked with metal and the seal-cutter with stone, both were engaged in cutting into their material an intaglio design that was intended to appear in relief when stamped on [42] to either a metal blank or wet clay. The earliest ancient coins were produced in Lydia in Asia Minor about 600 BC; they were made of electrum, a naturally occurring alloy of gold and silver. At first they bore no designs at all, but gradually they came to be produced with punches decorated first with simple patterns and later with more elaborate designs, such as the head of a lion. By the late sixth century the idea of coinage had spread across the Aegean to the Greek mainland, and it [43] came to be accepted that the design would be the badge and guarantee of the issuing authority. Cities such as Athens scarcely varied the design of their coins for several centuries; the obverse (the front) bore the head of the city's patron goddess Athena, while the reverse (the back) showed an owl, the bird associated with the goddess and with the city, and an olive spray, emblem of the tree that tradition said Athena had made to grow on the Acropolis. Other states adopted other devices; among the most important and attractive of the Archaic period

40 Scent-bottles moulded into various shapes in faience and terracotta. Made in Rhodes in the sixth century BC; from Camirus, Rhodes. Ht (of helmeted head) 6.5 cm.

[53]

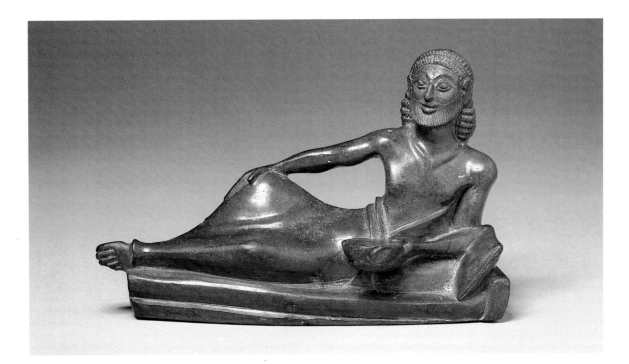

41 Bronze figurine of a reclining banqueter. Greek, sixth century BC; said to have been found in the sanctuary of Zeus at Dodona. L 10 cm.

were those of Corinth, with their depiction of the winged horse Pegasus, and those of Aegina, with their inartistic but appealing turtles.

Seal-stones were cut in soft materials in the Orientalising period, but in the sixth century a greater range of stones, principally various types of quartz such as cornelian, jasper and onyx, started to be used with the introduction of new techniques, principally the use of the drill. Seals were produced and used in all areas of the Greek world. The favourite shape, which was to be retained until well into the fifth century, was that of the scarab beetle, borrowed from Egypt and Phoenicia, the device cut into the flat under-surface of the seal. Many scarabs were pierced along their length so that they could be set in a ring or worn on a chain or thong; the names that occasionally appear on the stones, such as Mandronax which is written beside a fine ram on one example, are thought to refer to the owner rather than the engraver of the seal. The designs are very varied in both subject and quality, but the finest are superb, such as the British Museum's large banded onyx [44] scarab with the figure of a reclining satyr holding up a drinking cup, or the green plasma stone that bears a tiny but immensely detailed scene in which the hero Herakles holds up the horn of the vanquished river god Acheloos while the woman whom they both wished to marry, Deianeira, stands alongside with her hands raised in triumph.

The most successful Archaic Greek art combines high levels of technical accomplishment with a lively and vigorous conception. The art of Classical Greece was to demonstrate still greater perfection of technique, but it would never surpass the energy and vitality of the Archaic period.

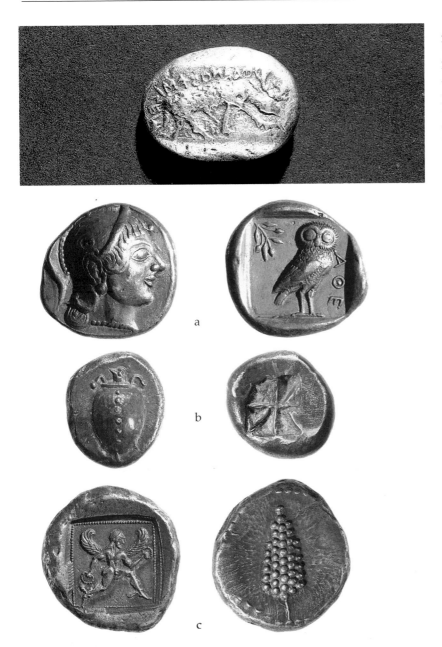

42 LEFT Electrum stater bearing the device of a stag and an inscription which may be translated as 'I am the badge of Phanes'. It is not known who Phanes was, but the inscription suggests the coin device was his personal emblem; he may have been the ruler of an East Greek city such as Halicarnassos, where the coin was found. About 600–550 BC. L 2.1 cm.

43 LEFT Archaic Greek coins, all shown at 1.5 × life-size. **(a)** Silver tetradrachm of Athens: (*obverse*) helmeted head of Athena; (*reverse*) owl, olive branch and the first three letters of the city's name; about 520–510 BC. **(b)** Silver didrachm of Aegina: (*obverse*) turtle; (*reverse*) simple punch-mark; about 550 BC. **(c)** Silver tetradrachm of Peparethos: (*obverse*) running winged figure, perhaps the north-wind, Boreas; (*reverse*) bunch of grapes, an allusion to the wine made on the island; about 500–480 BC.

44 BELOW Impressions of three Archaic Greek seal-stones: (*left*) a ram and the name MANDRONAX; (*centre*) a reclining satyr; (*right*) Herakles with Deianeira and the River Acheloos. W (of central seal-stone) 2.2 cm.

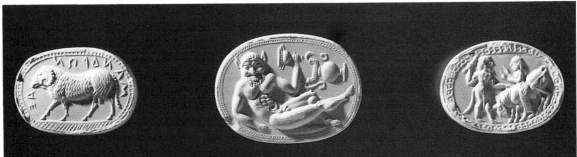

4

CLASSICAL GREECE:
SCULPTURE IN BRONZE
AND MARBLE

The threat posed by the ever-expanding Persian empire dominated the Greek world in the last decades of the sixth century BC and the first of the fifth. After Croesus, the philhellenic king of Lydia, had failed in his attempt to challenge Persia's might in 546 BC, the Greek cities of Asia Minor that Croesus had protected were swift to fall under Persian rule. In 499 BC they rose in revolt, with aid from the mainland Greek cities of Athens and Eretria, but were brutally suppressed. In 490 BC the Persian king Darius retaliated by invading Greece. He burned Eretria to the ground, but his forces were soundly defeated by the Athenians at Marathon and were forced to withdraw. In 480 BC Darius's successor Xerxes tried again. With an enormous army he succeeded in burning and plundering many of the more northerly Greek cities, including Athens, before his navy was decisively routed at Salamis and his land forces were brought to a halt at the great battle of Plataea.

In the defeat of Persia a leading part was taken by the Athenians. During the years around the turn of the century, the Athenian constitution had undergone a series of reforms which were ultimately to result in a democratic system of government; this, combined with their Persian triumph, inspired a mood of great confidence and self-assertiveness in the Athenians, who had reason to see their city as the sponsor and protector of the freedom not just of the individual, but of Greece as a whole. This attitude was to have profound consequences not only for the political alignments of the Greek city-states in the fifth century BC, but also for the art of Classical Athens.

The period of the Persian wars itself saw major developments in Greek painting, which are considered in the next chapter. In sculpture the changes were perhaps less dramatic. The preferred subjects for free-standing sculpture were still *kouroi* and *korai*, yet there is a pro-

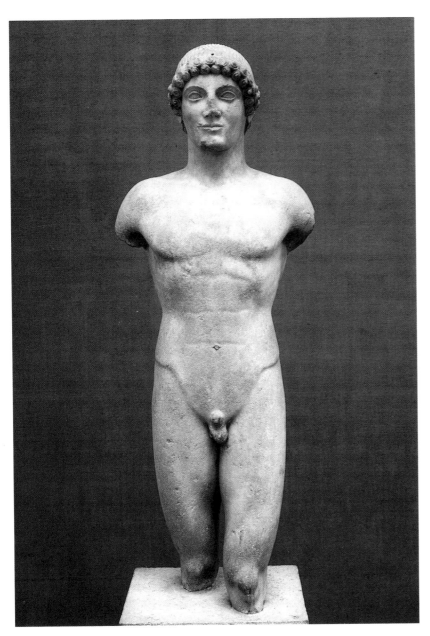

45 The Strangford Apollo, dated to around 500 or 490 BC, spans the transition between the Archaic and the Classical periods of Greek art. Said to have been found on the island of Anaphe; formerly in the collection of the sixth Viscount Strangford. Ht 101 cm.

found difference between the pieces produced during the Persian wars
45 and their predecessors. The 'Strangford Apollo', for example, is a
kouros carved around 500 or 490 BC. He shares the strictly frontal pose
of the earlier *kouroi*, and the even snail-shell curls of his fringe are typ-
ical of the Archaic interest in formal pattern; there is, however, a new
confidence in the modelling of the contours of the face, while the
musculature of the body is better understood and less insistently but
more successfully rendered.

Only a tiny proportion of the free-standing sculpture of the fifth cen-

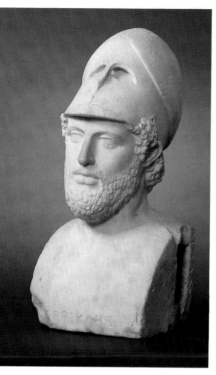

48 This portrait of the Athenian statesman Pericles dates to the Roman period but is thought to reflect an original Athenian work of around 430 BC. The head is set on top of a square pillar of the type known as a herm: equipped with a phallus and topped by the head of a god, usually Hermes or Dionysos, such pillars were sacred images for the Greeks. Found in a Roman villa at Tivoli. Ht 59 cm.

noted theorist, who devoted much time to the evolution of a 'Canon' of the ideal proportions and measurements of the human body; he wrote a treatise on this 'Canon', which is thought to have been embodied in at least one much-copied work of his, the Doryphoros (spear-bearer). The Westmacott Athlete stands with his weight on his left leg, his right leg and left arm relaxed; his right arm is raised, probably to place a wreath on his head. The carefully arranged contrasts between muscles that are relaxed and those that are in use, along with the slight tilt of the torso and the pensive inclination of the head, are all thought characteristic of Polykleitos's style. It has been suggested that the original statue of which this is a copy once stood at Olympia: the Westmacott Athlete's feet would fit perfectly into the depressions left on a statue base there, which is inscribed with the name of a youthful boxer, Kyniskos, and the Roman writer Pausanias, who visited Olympia in the second century AD, mentions a statue of Kyniskos which he attributes to Polykleitos. Another probable copy of a lost original is the British Museum's portrait-herm of the Athenian statesman Pericles, which [48] may reflect a full-length statue by the Athenian sculptor Kresilas, probably made around 430 BC.

Before the battle of Plataea in 479 BC, the city-states of Greece had sworn a solemn oath that they would not rebuild the shrines desecrated by the Persians, but leave their ruins as a lasting reminder of the sacrilege. After 479, the Athenians and their allies formed a League, whose purpose was to drive the Persians from all Greek territories. The headquarters of the League were on the sacred island of Delos, and there too was the Treasury, to which those states that were either unwilling or unable to contribute ships and manpower paid tribute in the form of silver. By the middle of the fifth century, the League had achieved its aim. But no moves were made to disband the alliance; in 454 the Treasury was moved from Delos to Athens, and Pericles, the leading politician of the day, announced that from then on one-sixtieth of the tribute would be reserved 'for Athena'. Since the expulsion of the Persians, there had been a considerable amount of building-work in Athens, but largely on secular projects. The middle of the century, however, witnessed the initiation of the most ambitious temple-building programme ever seen in Greece, a programme which completely ignored the terms of the Oath of Plataea and aimed to make not just the Acropolis but also the lower city of Athens and the outlying districts of Attica more glorious than they had ever been. The new temples were largely financed by the Delian League tribute, and even within Athens there were those shocked at the way funds were 'wantonly lavished out by us on our own city, to gild her all over, and to adorn and set her forth, as it were some vain woman, hung about with precious stones and figures and temples, which cost a world of money'. But despite the criticisms many of Pericles's grand schemes went ahead, none grander than the great temple of Athena Parthenos, the Parthenon. [49]

When the Persians had sacked the Acropolis, they overthrew much

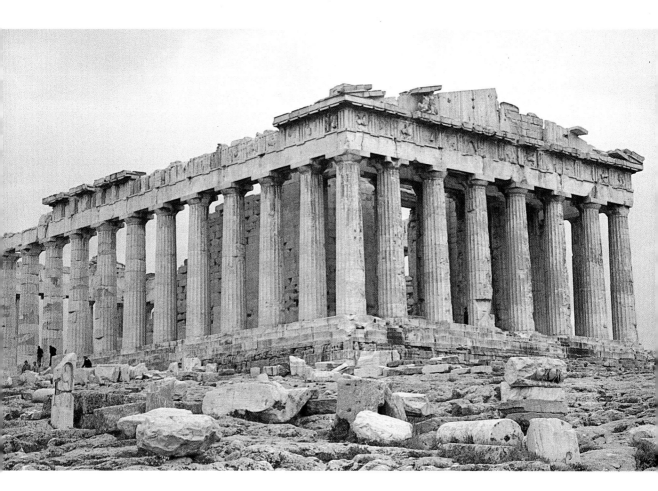

of the superstructure of a great temple under construction for Athena. The new temple was to be erected on the same site, the highest point of the Acropolis. Its scale, with eight columns across the front and seventeen down the side, suggests that it was designed to be impressive, and even with other buildings clustered around it must have dominated the city's skyline in antiquity as its ruins do today. The central building (cella) inside the colonnade was divided by a cross-wall into two rooms of unequal size, each with a porch of six columns. The smaller room at the west end was used as a treasury, while the larger housed a great gold and ivory statue of Athena, some 12 m high.

The Parthenon was exceptional not just for its size but also for the richness of its sculptural decoration. The architects, Iktinos and Kallikrates, designed it in the Doric order, and its sculptural decoration was located in the usual places for Doric temples, that is, the pediments and the exterior metopes. Unusually, however, all the metopes were carved, not just those on the ends, and set above the porches of the cella was an Ionic feature, a figured frieze carved in low relief; this continued down the long sides of the building along the top of the wall of the cella. There were thus three distinct sets of architectural sculpture: the figures of the pediments, carved fully in the round; the ninety-two metopes, carved individually in high relief; and the frieze, a continuous strip of low relief carving that extended right round the temple, a distance of about 160 m. Both the scale and the extent of the decoration

49 View of the Parthenon on the Acropolis of Athens, from the north-west.

were exceptionally lavish for the period. The sculptor whose name is associated with the sculpture of the Parthenon is Pheidias, though it is not clear how much of the work he did himself; the statue of Athena was almost certainly his, but it is impossible to know whether he was responsible for the overall design of the other sculpture, or to what extent he supervised its execution.

The Parthenon was constructed with a speed that seems extraordinary today. Surviving building accounts suggest work started in 447 BC, and the temple was dedicated at the Panathenaic Festival of 438; however, since accounts were still being rendered in 432, it seems likely that not all the sculpture was finished until then. Fifteen years seems a remarkably short time for the building itself, let alone its sculpture; when it is remembered that other Athenian building projects were under way at the same time, we can only wonder at the number of skilled stone-masons and sculptors apparently available, and at the remarkably high quality of the finished work.

The state of survival of the sculpture is explained by the building's history. In late antiquity it was transformed into a Christian church, a process which involved the construction of an apse inside the peristyle at the east end of the building. At this time much of the sculpture, including the centre of the east pediment, was defaced or destroyed because of its pagan subject-matter. Subsequently the Parthenon became a mosque. Yet it was still largely intact in 1674, when valuable drawings were made of much of the sculpture by the French artist Jacques Carrey. It was not until 1687 that disaster struck, in the shape of a shell fired by the Venetian admiral Morosini, whose fleet was besieging the Turkish-occupied city: the shell set fire to the gunpowder that the Turkish garrison had stored inside the building and the resulting explosion blew out the central part of the structure, destroying part of the frieze and a great many metopes. The late eighteenth and early nineteenth centuries saw a resurgence of interest in the monuments of Classical antiquity; the Parthenon was studied and drawn by numerous scholars and artists, until in 1812 much of the surviving sculpture was brought to England by Lord Elgin, who had obtained permission from the Turkish authorities to remove from the Acropolis 'any pieces of stone with figures and inscriptions'. In 1816 the 'Elgin Marbles' were bought for the nation by the British government and housed in the British Museum, where they have remained ever since.

The metopes of the Parthenon were probably the first set of sculpture to be carved and placed on the building. They illustrate various subjects, including the Sack of Troy and the battles between Greeks and Amazons, gods and giants. Among the best preserved are those in the British Museum, which represent scenes from the fight between Lapiths and Centaurs at the wedding feast of Peirithoos. They vary in quality of both composition and execution, but on the finest the figures are carved practically in the round, seeming almost to break free from the restraining background. On one example, a young Lapith is shown 50 seizing the neck of a wounded Centaur with his left hand while raising

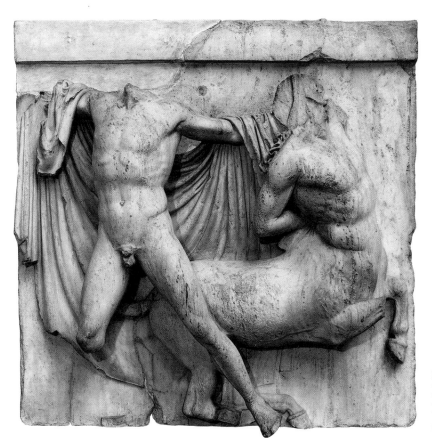

50 One of the metopes from the south side of the Parthenon: a Lapith prepares to finish off his Centaur opponent. W 137 cm.

his right to deliver a decisive blow; the Centaur twists in obvious pain as he gropes at a wound in the small of his back. The two figures strain apart from each other, two sets of muscles tensing, but are at the same time drawn inexorably back together by the power of the Lapith's arm, their union formally reinforced by the magnificent backdrop of the 51 Lapith's cloak. On another fine metope the Centaur has the upper hand: his Lapith opponent lies crumpled on the ground while the Centaur rears triumphantly above, his animal nature emphasised by the lion-skin that hangs over his outstretched arm in place of a cloak, the lion's tail waving out behind him.

The Parthenon frieze too has moments of intense drama. Its subject is a procession, which has its starting point at the south-west corner of the building. From here two branches set out, one travelling from right to left along the west front, then continuing down the long north side to the east front, where it is met by the second, shorter branch, which has come up the south side of the building. The exact purpose of the procession as depicted is controversial, but it is generally agreed that it represents the Panathenaic procession with which, every four years, the people of Athens brought a new robe up on to the Acropolis for the goddess Athena. Near the centre of the east frieze this robe, neatly folded, is shown handed to a priest or official by a child; this scene is

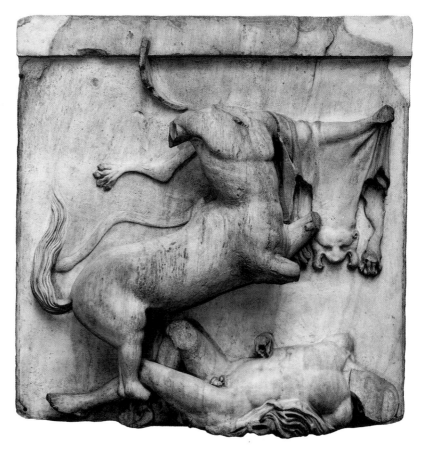

51 One of the metopes from the south side of the Parthenon: a Centaur rears in triumph over a fallen Lapith. The crescent-shaped object above the Centaur's right shoulder is all that remains of the large bowl he has been wielding as a weapon. W 133 cm.

framed by two groups of seated gods. Much of the procession is formed by a cavalcade of young horsemen. On the short west end they are shown getting underway; some are not yet mounted and adjust their dress or their equipment. In places on the long sides they are galloping at speed, often five or six abreast, legs and flying hooves intertwined in a flowing stream of rapid movement. In front of the horsemen come the chariots, and in front of them again are people carrying ritual vessels and implements, or leading animals to be sacrificed. Among these last is a beautifully carved cow that tries to break free of her captors, her horned head raised in vociferous protest; this is the figure generally thought to have inspired the poet Keats to mention, in his 'Ode on a Grecian Urn', 'that heifer lowing at the skies'. [52]

The subjects of the pediments, both now very fragmentary, were fortunately recorded by Pausanias. The west showed the contest between Athena and Poseidon for the land of Attica. The centre was occupied by the two deities sweeping away from each other but turning back to the centre as they go: the story was that Poseidon made a salt-spring gush forth on the Acropolis, but that Athena planted an olive tree and so won the day. Behind the protagonists are their chariots, led by the messenger gods Hermes and Iris, and a range of spectators

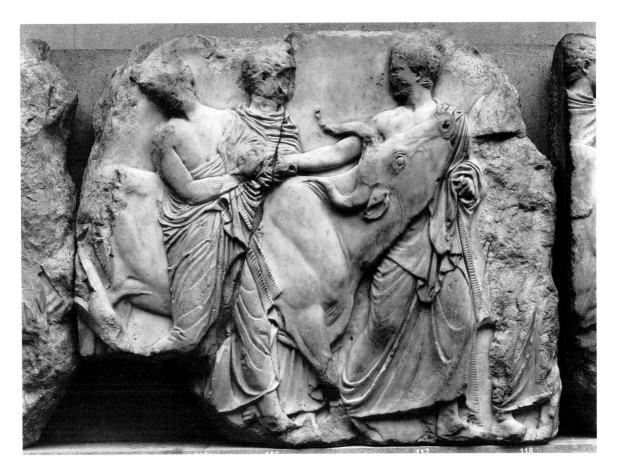

whose precise identity is uncertain but who are believed to have included several of the ancient kings of Athens, besides local figures such as river gods. One of the best preserved fragments is a torso identified as that of Iris by the presence of cuttings in her back for the attachment of wings; she is shown starting eagerly forward, with her finely pleated garment pressing back against her body to reveal the form beneath and to emphasise the speed of her action.

Similar drapery effects may be seen on some of the female figures of the east pediment, the subject of which was the birth of Athena, goddess of wisdom and war, from the head of her father, Zeus. This scene is framed by the sun and the moon, the sun driving his chariot up into the heavens from the left-hand angle of the pediment, while the moon lets her tired horses sink into the sea at the right; watching the miraculous birth are gods, goddesses and heroes. Particularly fine are three ⁵³ seated female figures from the right-hand side of the pediment, perhaps Hestia, goddess of the hearth, with Aphrodite reclining in the lap of her mother Dione. The treatment of the drapery here is astonishing; there are so many contrasts of texture, between the smooth polished flesh of the goddesses's necks and arms, the sensuously clinging, pleated *chitons* that mould the forms of their breasts and stomachs, and

52 Part of the south frieze of the Parthenon: a cow led for sacrifice raises its head to low. The animal's solid bulk and soft folds of skin are sympathetically rendered; note, too, the realistically shown selvedges of the mantles. Ht 1 m.

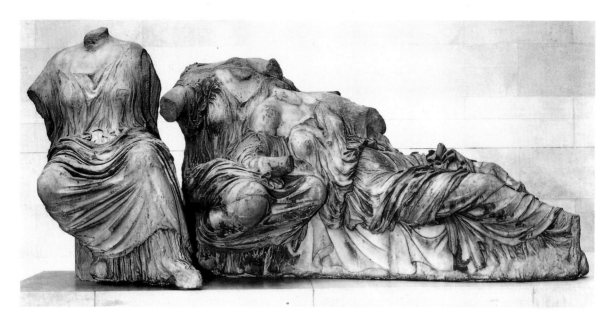

53 Three figures from the east pediment of the Parthenon. The poses of the three are carefully planned to fit under the sloping cornice of the pediment; the drapery of the figure on the far right is particularly impressive, its languid folds and loops appearing to mirror the relaxed attitude of the wearer. L (of group) 315 cm.

the heavier mantles over their knees.

It is not known who chose the subjects of the sculpture of the Parthenon, or of any other Greek temple. They appear, however, to present an accurate reflection of the preoccupations of contemporary Athens. The various subjects of the metopes suggest the triumph of civilisation over the barbarian, of Greeks over Persians. The pediments honour the goddess of the temple and of Athens, one illustrating a peculiarly local myth. And the frieze shows the Athenians themselves honouring their goddess; it glorifies the people of the city, both for their military and athletic prowess and for their piety. The temple as a whole, down to the great gold and ivory statue of the goddess that it contained, was a symbol of the wealth, the pride and the success of Athens at the peak of her greatness.

Pericles died in 429 BC, but already in 431 the challenge to the supremacy of Athens had begun, with the outbreak of the Peloponnesian war. This long drawn-out struggle between the Athenians and their allies on the one hand and the Peloponnesians, led by Sparta, on the other, was to continue with interruptions for the rest of the century. Artistic activity, however, did not entirely cease with the outbreak of war, and the last thirty years of the century saw the construction of several more temples in Athens, besides the development of a fine series of private grave reliefs. There was, for example, the small Ionic temple of Athena Nike (Victory) near the entrance to the Acropolis, built upon a bastion and embellished with a carved balustrade, representing figures of Nike sacrificing to the goddess Athena; these are among the most beautiful figures of Classical art, their clinging, transparent drapery more finely carved even than that of the Parthenon. Among the sculptures brought from Athens by Lord Elgin were sections of the frieze from the Nike temple itself: they are worn, and enigmatic in their 54

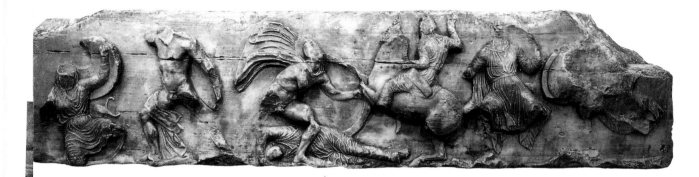

subject-matter, but seem to represent either heroic or actual battles that might again be associated with the victory over the Persians. Another of the newly refurbished and extended Acropolis temples, the Erechtheion, was a building of complex functions with a ground-plan and architecture to match. Among its many striking features were its frieze, which consisted of a background of dark bluish-black marble against which individually carved figures of white marble were separately attached, and its Caryatids. The Caryatids are statues of women who take the place of columns in the south porch of the building. There were six of them, almost identically carved with baskets on their heads and *phialai* (offering bowls) in their hands; in their stance and their formally patterned, braided hair, they have a slightly Archaising air, reminiscent of the *korai* of the sixth-century Acropolis. The architectural ornament of the Erechtheion too is very fine, and parts are preserved in the British Museum, including coffer blocks from the ceiling of one of the porches and beautifully carved sections of the architrave.

Not all Classical temples were Athenian. The temple of Zeus at Olympia, built in the years between about 470 and 456 BC, was in many

54 ABOVE Part of the sculptured frieze from the temple of Athena Nike on the Athenian Acropolis. Greek warriors, naked apart from flying cloaks, engage in a fierce conflict with orientals, who are equipped with distinctive crescent-shaped shields and wear sleeved tunics and trousers. About 420–410 BC. Ht 44 cm.

55 BELOW Carved anta-capital and architrave section from the east porch of the Erechtheion. The principal lotus and palmette frieze is enhanced and complemented by the meticulously carved mouldings above. About 421–406 BC. Ht 49 cm.

British Museum. The body of this vase is coated in glossy black glaze, while the neck is decorated with the figures of Dionysos and two satyrs on one side, a frontal four-horse chariot on the other. These scenes are executed in black-figure, but the painters who worked with Andokides were also the pioneers of the red-figure technique. They were among the leading producers of the so-called 'bilingual' vases, which were decorated partly in the red-figure and partly in the black-figure technique. Another slightly later painter who worked in both techniques has left us his name, Epiktetos, inside a fine 'bilingual' cup, where a ⁶² solitary black horseman is elegantly posed in the circular field; outside, red-figure satyrs blow trumpets between the stylised eyes commonly found on cups of this period, probably designed to avert evil spirits.

Many of the very finest red-figure vases were produced in the period from about 500 to 480 BC. The Berlin Painter, named from the present location of one of his most characteristic pieces, was perhaps the consummate artist of the time. He generally preferred to set one or at most two figures dramatically against the black background: this sets off to full advantage the interestingly arranged and well-balanced red shape of the figures, and at the same time avoids distraction from the meticulously rendered anatomical details in which he evidently delighted.

62 RIGHT Interior of a cup decorated in the black-figure technique with the figure of a horseman, beautifully posed in the circular field. Made in Athens about 500 BC; signed by the painter Epiktetos. D (of tondo) 12 cm.

63 OPPOSITE ABOVE Exterior view of the same cup, decorated in the red-figure technique with a satyr blowing a trumpet between apotropaic eyes. Ht 12.8 cm.

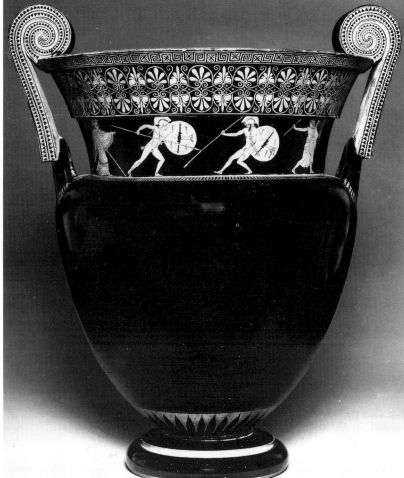

the tim
situatio

Vase
mon ir
treated
silhoue
nique c

64 Red-figured *volute-krater* (wine-bowl), the rim bearing fine geometric and floral friezes, and the scene on the neck showing a duel between the Greek hero Achilles and the Trojan prince Hector. In Classical Greek art, the victor almost always attacks from the left, as Achilles does here. The goddess Athena urges on her protegé, while on the far right the god Apollo abandons Hector to his fate. Made in Athens about 500–480 BC; attributed to the Berlin Painter. From Cerveteri. Ht 64.5 cm.

glaze, but gradually matt colours came to be used for outlines, usually grey or red, with colour washes of red, blue, green and mauve for clothes and other accessories. Most colours were added after firing, and often they have faded, resulting in a somewhat ghostly appearance. White-ground vessels were unsuitable for daily use, and so it is scarcely surprising that the technique was virtually confined to shapes which had a ritual function. Most white-ground vases are *lekythoi*, the ⁶⁶ tall cylindrical containers of perfumed oil that were offered as a gift to the dead, either placed in the actual grave or laid above it. The earlier examples show a range of subjects, but from the mid-fifth century onwards they are generally of a funerary nature: sometimes they show visitors to a tomb, tying sashes round it or placing vases, including *lekythoi*, on the steps; sometimes they may include the dead person, perhaps seated in front of his monument. The dejected attitudes of the figures in these scenes can be very poignant; like the contemporary sculptured *stelai*, they bring the people of fifth-century Athens vividly before us, suggesting that however remote their views of death and the after-life may have been from ours, their feelings of bereavement were not so unlike our own.

A small number of cups decorated in the white-ground technique

66 Three white-ground *lekythoi* (oil-flasks) decorated with funerary subjects: (*left*) mourners surround a corpse lying on a bier; (*centre*) the ferryman Charon stands in his boat, reaching for the hand of a dead person whom he will transport across the Styx, the underworld river that separated the living from the dead; (*right*) a woman brings sashes to decorate a tombstone, perhaps that of the youth shown on the far side. The vase on the left was made in Athens about 470–460 BC and has been attributed to the Sabouroff Painter; the other two were made in Athens about 420–400 BC and have been attributed to the Reed Painter. Ht (of left-hand vase) 33 cm.

have also survived. All have been found either in sanctuaries or in graves. One tomb-group, which included three such cups, was found in Athens. The cups are very small, with unusual wishbone handles and extremely thin walls. Outside, they are decorated in combinations of black glaze and coral red, while the interiors are all white-ground. The scenes painted inside are tiny, but beautifully executed. The best preserved shows a segment through a beehive tomb, with a marking tripod on the top and a pebbly floor. The two figures in the tomb are Glaukos and Polyeidos (their names are inscribed). Glaukos was the son of Minos, king of Crete. One day he disappeared while playing ball or chasing a mouse; eventually the seer Polyeidos found him, drowned in a tub of honey. Since a dead son was not what he had wanted, Minos shut the seer and the dead boy up together in the tomb and issued an ultimatum: Polyeidos could either bring the boy back to life or die there with him. As he waited in the tomb a snake approached, and Polyeidos killed it lest it harm the body. A second snake entered, saw its dead companion, and went away; returning with a leaf, it rubbed this over the dead snake, thereby restoring it to life. This gave Polyeidos an idea; he applied the leaf to the boy with equally satisfactory results, and together they made their escape from the tomb. What is perhaps most

67 White-ground cup decorated with a scene showing Glaukos and Polyeidos in the tomb. Made in Athens about 470–450 BC; signed by the potter Sotades and attributed to the Sotades Painter. From Athens. D 13.4 cm.

striking about the vase-painting is the way the painter has condensed the successive episodes of the story: while Polyeidos prepares to strike, one snake lies dead already, and the boy, crouching in his dark grave-clothes, watches the episode that is actually the prelude to his own resuscitation.

White-ground vase-paintings such as these are also important for the way in which they can suggest the nature of contemporary wall- or panel-painting, so little of which now survives. One very rare example of the genre is a small fragment of a painted wooden panel from Saqqara in Egypt, probably part of a casket. The fragment shows a woman seated on an elegantly decorated chair, dressed in a long white garment which contrasts with the dark ringlets of hair that hang loosely over her shoulders; above her is an enigmatic inscription that may be part of a name. The panel has been dated to around 400 BC.

Red-figured vases continued to be produced well into the fourth century BC, but in both potting and painting they are generally inferior to those of the preceding century. On some vases, the red-figure decoration has been embellished with areas of added colour, principally blue or pink; sometimes particular figures or details are worked in relief and gilded. The subject-matter of the figured scenes is repetitive; most popular is the wine-god Dionysos with his entourage. Of rather higher technical and artistic quality are the large black-glazed vessels of the fourth century; some of these *amphorae* or *kraters* are finely ribbed, and many are decorated with beautiful wreaths or necklaces of gilded terracotta, exact counterparts to the gold examples found in contemporary tombs. 68

A wide range of terracotta figurines continued to be produced in

68 (*left*) Black-glazed *hydria* (water-jar); (*centre*) *amphora* (wine-jar); (*right*) *calyx-krater* (wine-bowl) decorated with raised and gilded terracotta ornaments. Made in Athens about 340–320 BC; from Capua in Campania. Ht (of *calyx-krater*) 69.5 cm.

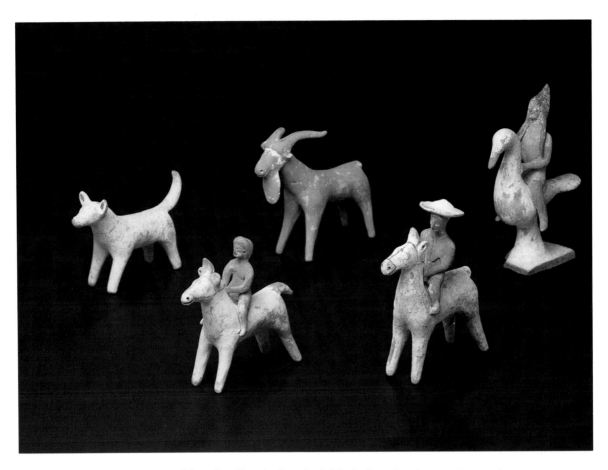

most parts of the Greek world in the Classical period. Their function is largely unknown and much disputed; some, such as a group of five brightly painted animals and birds from Tanagra in Boeotia, were very probably children's toys placed in the grave to keep their youthful owners company. Other figurines have been found in sanctuaries, where they may have been offered as gifts to the deity; many of these may be recognised as images of either the deity or his votaries. Techniques of terracotta production became more advanced as the Classical period progressed. The animals mentioned above are solid and hand-modelled like those of the Archaic period, but soon hollow figurines were being produced, the fronts made in a mould and the backs constructed from flat pieces of clay laid across like pie crust. Such figurines were clearly not designed to be seen from the back, which is generally further disfigured by a large rectangular air vent, intended to prevent accidents during firing. Athens and Boeotia seem to have been the main centres for terracotta production at this time. The commonest types were standing or seated female figures, and female busts; all of these are sometimes identified as goddesses. Unlike the Archaic figures, which were decorated before firing, those of the Classical period were simply coated in a white slip before firing; the other col-

69 Group of terracotta figurines, some brightly painted: a dog, a goat, two horsemen and a man riding a goose. Made in Boeotia about 500–480 BC; from Tanagra. Ht (of goat) 9 cm.

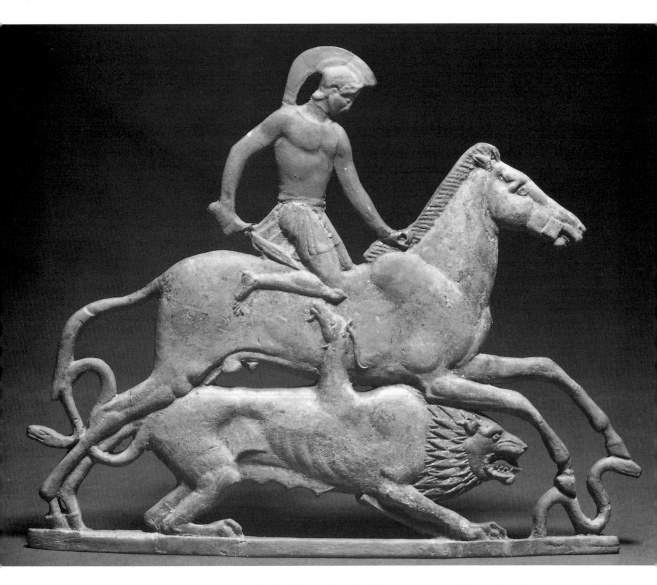

70 Terracotta plaque showing the Greek hero Bellerophon riding down the Chimaira, represented as a lioness with a goat's head and a snake in front. Made in Melos about 460–430 BC; from Melos; partially restored. Ht 14 cm.

ours, principally red and yellow ochre and blue glass frit, were added later, which is why they do not always survive very well. Of particular interest is a very distinctive group of terracotta plaques made on Melos in the Cyclades, where they were apparently a speciality. These thin plaques are moulded on the front and flat at the back, with the background behind the figures cut away, and they are pierced for attachment to other objects, possibly wooden chests or coffins. Most portray mythological subjects, such as Scylla, Peleus wrestling with Thetis, or Eos carrying off Kephalos; their style is lively and idiosyncratic, and some preserve traces of their once bright paint.

In the period of about 400 to 350 BC a new range of terracottas, the so-called 'plastic *lekythoi*', was produced in large quantities in Athens. These were small containers for perfumed oil, moulded at the front

70

and hand-made behind, fitted on top with the mouth of a standard *lekythos* or *oinochoe*. The fronts are decorated like other terracottas with various matt colours laid over a white slip, while the backs, mouths and handles are treated like vases and covered in black glaze. The fronts are usually moulded in the form of Eros, Aphrodite or the infant Dionysos, generally treated in a pretty and rather cloying style, the effect of which is heightened by the lavish use of separately made and attached rosettes, wings and other decorative appendages.

Small bronze figurines, like terracottas, were made in large numbers both for laying in graves and for dedication in sanctuaries. A diminutive figure of a goddess (identifiable as such by her tall head-dress, or *polos*) bears an inscription recording her dedication by one Aristomacha to Eileithyia, goddess of childbirth; the inscription on a small hare explains that it was dedicated (perhaps in gratitude for success in

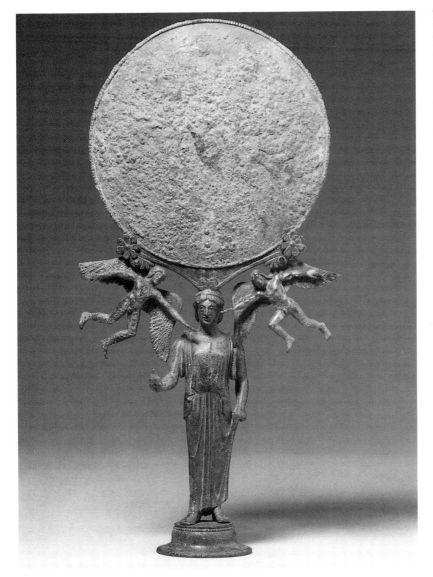

71 Bronze mirror, the stand in the form of a female figure, perhaps the goddess Aphrodite, flanked by hovering Erotes; in her hand she holds a pomegranate. Probably made in Athens or Corinth about 460–440 BC; said to be from Athens. Ht 32.5 cm.

hanging from a rosette with a siren perched on top, and four tiny cockle-shells suspended below on chains. Filigree, granulation and enamelling are all employed in the embellishment of these tiny works of art.

Gold became much more plentiful in Greece in the second half of the fourth century BC, as a result of Macedonian exploitation of the gold mines of Thrace. To this period is dated an almost complete gold wreath found in a tomb near the Dardanelles. Thickly clustered and very realistically modelled oak leaves spring from a curved gold band; acorns emerge from the leaves on long stalks, and two cicadas, symbols of immortality, perch among them. Such wreaths appear to have been given as prizes, worn in processions, dedicated in sanctuaries or buried with the dead. A spectacular group of gold jewellery found in a number of tombs at Kyme in north-west Asia Minor is dated to the same period of about 350 to 300 BC. Among the finest pieces are two pairs of virtually identical gold earrings, each consisting of a large cir- 74 cular disc from which are suspended an inverted cone and two Erotes, hanging from delicate filigree chains. The discs are covered in filigree spirals and curls arranged around a central filigree flower. Fine gold

74 Pair of gold earrings found in a tomb at Kyme, north-west Asia Minor. Ht 6.5 cm.

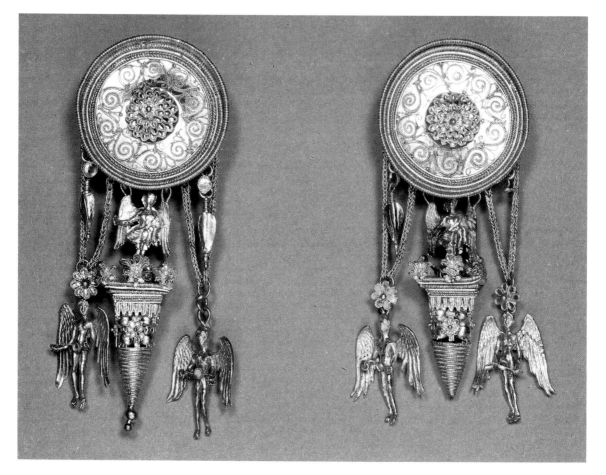

wire coils neatly around the lower part of the cone and on its top crouches a female figure, winged on one of the pairs. On the other pair, two doll-like figures of naked women, curiously truncated at the waist, hang between the chains that support the Erotes: perhaps like the terracotta 'dolls' they represent the oriental Aphrodite. The Erotes themselves are finely detailed, down to the last feather on their wings; each is spinning an 'iynx'-wheel, a magic implement mentioned in Hellenistic poetry, whose purpose was to bind a potentially faithless lover to his beloved.

Alongside jewellery, many fine coin dies and seal-stones continued to be engraved throughout the Classical period. The best coins were produced in the Greek colonies of south Italy and Sicily and are considered in a future chapter; elsewhere in the Greek world, the types tended to remain standard, with many of the most important Greek cities such as Athens and Corinth continuing to use the same designs that they had chosen in the Archaic period. This is not to deny that 75 many well-designed coins were produced in the fifth and fourth centuries BC. At Thebes, for example, there are intricate scenes of some of the Labours of Herakles, or Herakles stringing his bow, the straining

75 Classical Greek coins, all shown at 1.5 × life-size. **(a)** Silver didrachm of Elis: (*obverse*) head of Zeus; (*reverse*) eagle perched on an Ionic column-capital; about 360 BC. **(b)** Silver stater of Corinth: (*obverse*) helmeted head of Athena; (*reverse*) the winged horse Pegasus; about 380 BC. **(c)** Silver tridrachm of Delphi: (*obverse*) two ram's-head drinking horns below two dolphins, the issue perhaps marking a sudden influx of bullion to the sanctuary at Delphi in the aftermath of the Persian wars; about 475 BC. **(d)** Silver didrachm of Thebes: (*obverse*) a Boeotian shield; (*reverse*) the infant Herakles (a local hero) strangling the snakes that attacked him in his cradle; about 390 BC. **(e)** Silver tetradrachm of Mende: (*obverse*) the wine-god Dionysos riding on a mule; (*reverse*) a vine inside a square framed by the city's name (Mende was a great exporter of wine); about 450 BC.

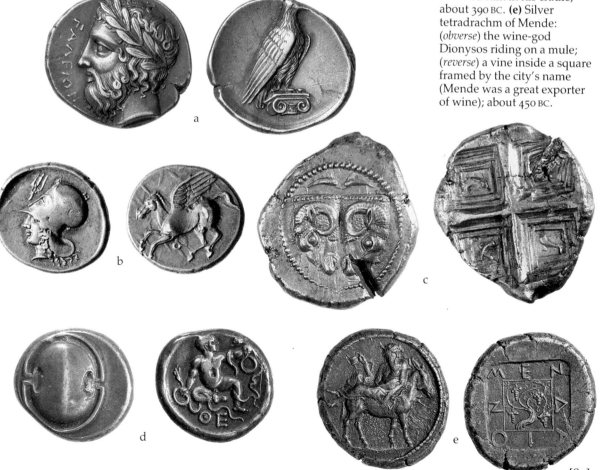

76 Chalcedony seal-stone engraved with the figure of a half-naked reclining woman who reaches up to feed a heron. L 2.1 cm.

figure of the hero elegantly fitted into the field along with the letters of the city's name. A number of fine coins were produced at Elis, possibly for the occasions of the Olympic Games; these include superb engravings of the heads of both Zeus and his eagle, and delicate scenes of winged Nike (Victory) bearing the victor's wreath.

The art of seal-engraving now reached a peak of excellence; the materials used remained the same, and some scarabs were still produced alongside scaraboids (scarab-shaped stones without the proper markings of the scarab-beetle), flat ring-stones, and various other shapes including sliced barrels or heart shapes. Some master engravers, notably Dexamenos of Chios, signed their finest pieces, which included powerful and delicate vignettes of people, animals and birds. Some of the most attractive stones bear designs of large birds, either geese or herons, in flight or preening, with every feather meticulously rendered; one large chalcedony scaraboid bears a miniature scene of a 76 lady's boudoir, with the lady reclining on her cushions to feed a tame heron while an ant hovers above.

The end of the Classical period traditionally coincides with the death of Alexander the Great in 323 BC, an event which ushered in the Hellenistic age. This was clearly a decisive political turning point, but in cultural and artistic terms the transition from Classical to Hellenistic was more gradual. Classical Greek art continued to exert an influence throughout the Hellenistic and Roman periods; surviving works were copied and admired, and there were repeated attempts to revive the Classical spirit.

6

THE GREEKS IN SOUTHERN ITALY AND SICILY

The first settlers from the mainland of Greece reached Italy before 1600 BC. They were probably exploring for new sources of metal ores, and they established trading outposts in several places including Taras (Taranto) and Syracuse. These outposts shared in the general collapse of the Mycenaean world in the twelfth century BC, and it was not until mainland Greece was emerging from the Dark Ages that a new wave of explorers started to cross the sea. The first to come were the Euboeans, great seafarers who arrived first at Pithekoussai on the island of Ischia, around 750 BC, and soon afterwards at Cumae on the mainland opposite. Once there was a Greek foothold in Italy, progress was rapid, and soon there were settlements in all the most fertile places of Sicily and around the south coast of Italy. These Greeks of the eighth and seventh centuries BC were driven from their native cities by an acute shortage of land, caused by their rapidly expanding populations; in southern Italy and Sicily they found the rich agricultural land they needed.

From the moment of their foundation the colonies seem to have prospered; from early on they were collectively known as Great Greece (Megale Hellas to the Greeks themselves, later Magna Graecia to the Romans). In the sixth and fifth centuries BC the south Italian cities were among the richest in Greece, their wealth vividly attested by the splendid series of silver coins they issued. With material prosperity came brilliant social and cultural achievements. Many of the recorded victors in the Olympic Games came from the south Italian cities; they were probably better nourished and so larger and fitter than many of their compatriots left at home. Poetry and drama flourished, too, and most of the carefully laid out cities were lavishly adorned with public buildings: the temples of Akragas (Agrigento) or Selinous (Selinunte) in Sicily are among the most impressive in the Greek world, while the fifth-century tomb-paintings of Poseidonia (Paestum) are a unique and colourful testimony to the talent and imagination of their artists.

Admittedly it is difficult to appreciate the scale of the achievements

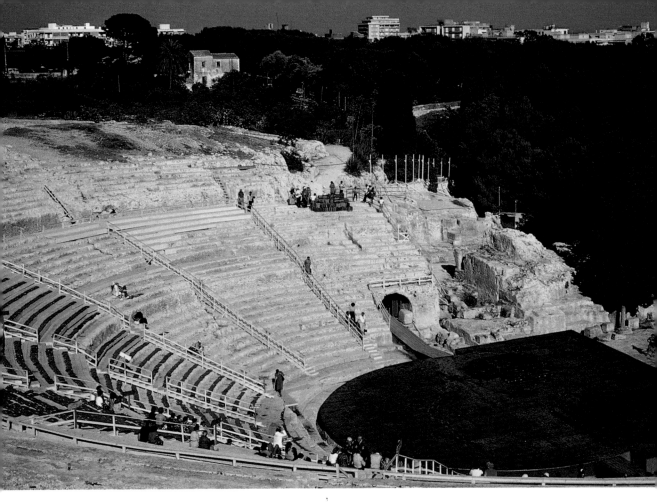

77 View of the theatre at Syracuse, Sicily, one of the largest Greek theatres known. Excavations have revealed that a wooden theatre stood on this site in the sixth century BC; the stone auditorium was largely constructed in the late fourth and third centuries BC.

of the south Italian Greeks from the remains of their culture housed in the British Museum. To get any real impression of the nature of their civilisation it is necessary to visit the actual sites, to sit in the great theatre at Syracuse, to admire the fine natural harbours of Taranto (still 77 an important base for the Italian navy), to glimpse the temple at Metaponto across a vast expanse of the same golden corn that the colonists set on their coins, to examine the grid-plan arrangement of the streets of Lokroi (Locri), or to watch the ruined temples of Agrigento turn red in the light of the setting sun. Where the Museum's collections are, however, rich, is in the small-scale objects used in daily life and taken with their owners to the grave – vases and small bronzes, jewellery and coins. All these display obvious connections with the art of mainland Greece, but at the same time they demonstrate the influence of native Italic and Etruscan traditions. These mixed sources of inspiration, combined with the naturally enterprising and innovative spirit of the colonists and promoted by their wealth, resulted in a uniquely 'South Italian' art.

The style of the earliest pottery produced in southern Italy was determined by the origins of the first arrivals. The Euboeans who settled at Pithekoussai and Cumae produced pottery distinguishable from mainland Euboean Geometric wares only by its clay. When Corinth began to send out colonies, Corinthian potters were among

78 them, and in the seventh century the production of vases decorated in the Proto-Corinthian style flourished in Campania. These were very finely made and may be distinguished from true Corinthian only by the clay, which is orange where that of Corinth is greenish-yellow; the colour was, however, frequently disguised with the use of a yellow slip. Much of the fine pottery used in the colonies in the seventh and sixth centuries was imported from the mainland, from Corinth, Athens, or, in the case of Taranto, from Sparta. However, from about 550 to 510 BC, an enterprising group of Euboean potters and vase painters seems to have been in business at Rhegion (Reggio di Calabria) in the 'toe' of Italy; here they produced fine vases decorated in the black-figure technique that might have passed for Athenian were it not for a certain provinciality of style and for the fact that the forms of the letters used to name figures in the scenes were those current at Chalkis in Euboea.

In the fifth century, black-glazed vessels were produced in many places, but until about 440 BC the only red-figured vases were those imported from Athens. In 443 the Athenians established their first and only colony, Thurioi, near the ruins of Sybaris, which had been destroyed by the neighbouring city of Croton in 510 BC. It is supposed that Athenian potters and painters were among the first colonists and that they set up their workshops further north at Metaponto, where kilns with fragmentary remains of the first south Italian red-figured vases have been found. The Lucanian 'school' of which they were the earliest exponents lasted well into the fourth century and produced

78 (*left*) Proto-Corinthian *aryballos* (perfume-jar) and (*right*) *skyphos* (drinking-cup) found together in a tomb at Cumae on the Bay of Naples. The *aryballos* was made at Pithekoussai while the *skyphos* appears to be a Corinthian import; both about 700–680 BC. Ht (of *aryballos*) 7.5 cm.

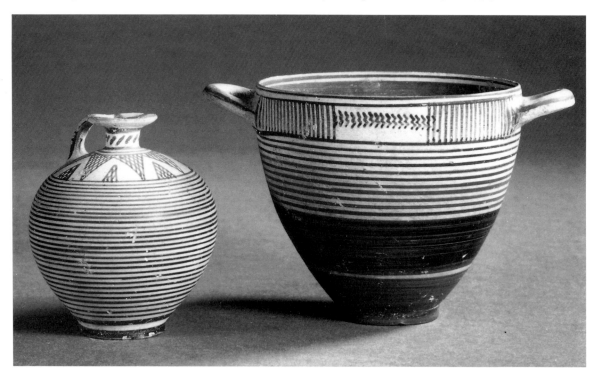

vases of variable quality. Alongside large numbers of small and indifferently potted *pelikai* and *bell-kraters*, decorated with repetitive scenes of athletes, women and Erotes, are found occasional masterpieces such as the large *calyx-krater* that gives the Dolon Painter his name. The scene illustrated is an incident from the siege of Troy, described in the *Iliad*, where the Greek heroes Odysseus and Diomedes set out to reconnoitre behind the Trojan lines and come across a Trojan spy, Dolon, engaged in a reciprocal exercise: the painter shows the heroes, thinly camouflaged by scrubby trees, tiptoeing towards the luckless Dolon with exaggerated caution, the whole scene imbued with a burlesque quality that must surely have been as evident in antiquity as it is today. A slightly earlier *calyx-krater* bears another epic scene, the blinding of the Cyclops Polyphemos by Odysseus: Polyphemos sprawls in a drunken sleep beside his empty wine cup, while Odysseus and his crew heave a great tree-trunk into position, ready to gouge out the monster's single eye; the satyrs moving stealthily

79 Lucanian red-figured *calyx-krater* (wine-bowl) with a scene from Homer's *Iliad* of the Greek heroes Odysseus and Diomedes surprising the luckless Trojan spy Dolon. About 420–400 BC; attributed to the Dolon Painter. From Pisticci. Ht 50.2 cm.

around the scene suggest the painter may have been inspired by the production of a satyr-play.

Around 430 or 420 BC a second school of red-figure vase-painters, the Apulian, seems to have become established at Taranto. The early Apulian vases are often hard to distinguish from Lucanian, but by about 380 BC Lucanian production was declining, while the vases of Apulia were becoming more numerous and more ambitious in both shape and decoration. The most striking are the huge *volute-* and *calyx-kraters*, masterpieces of the potter's art; without exception they are lavishly decorated with figure scenes, floral and geometric friezes, and sometimes with moulded heads set at the curl of the volute handle. Many of the figure scenes represent episodes from Greek mythology. One *calyx-krater* bears two tiers of figures, the upper unidentified, with one pensive and one languorous heroine, the lower a lively rendering of the fight between Greeks and Centaurs at the wedding of Peirithoos, with the young hero rescuing his bride from a Centaur's clutches,

80 Detail from a large Apulian red-figured *volute-krater*, showing the chariot of Hippolytos facing destruction in the form of a great bull that rises up from the sea in front of the horses' hooves. About 340–320 BC; attributed to the Darius Painter. From Ruvo. Ht (of complete vase) 102 cm.

81 Apulian red-figured *volute-krater*, decorated with a representation of a tomb-monument; the elaborate floral patterns on the neck of the vase are a characteristic feature of later Apulian vases. About 325 BC; attributed to the Baltimore Painter. Ht 88.9 cm.

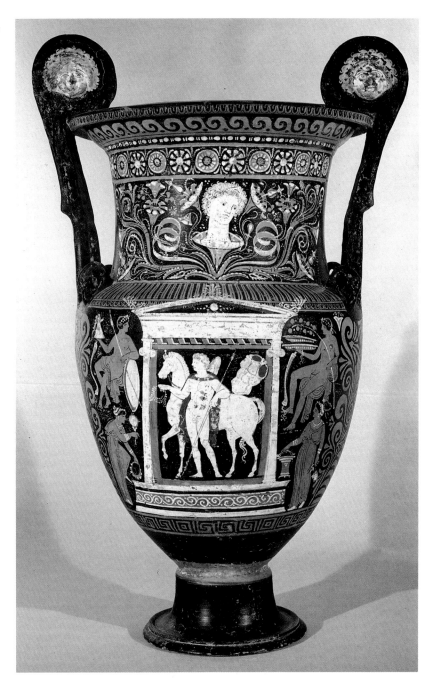

assisted by his friend Theseus; a *volute-krater* shows the youthful Hip- ⁸⁰ polytos driving his chariot to destruction, as yet oblivious of the heavy-shouldered bull from the sea which is looming up under the flying hooves of the leading horse. Many of these scenes are thought to have been influenced by local productions of fifth-century Greek tragedies, especially those of Euripides; one especially popular subject seems to

have been the story of Orestes, whether meeting his sister Electra at their father's tomb, or pursued by Furies, and seeking purification from the god Apollo at Delphi.

Representations of tombs and tomb monuments were also popular. These often take the form of a fairly elaborate shrine, of the type known to have been popular with the wealthy citizens of fourth-century Taranto; inside, the dead person, sometimes represented as a statue, waits to receive visitors bearing offerings. Since many of these vases
81 were found in graves, or placed as markers above them, the tomb scenes are particularly appropriate to the function of the vase; they were, perhaps, a cheaper substitute for those who could not afford an actual monument. A typical example shows a youth standing beside his horse inside his tomb monument; above the horse is a breastplate which, like the youth, horse and building, is painted white, perhaps to represent marble or stuccoed limestone. The youth is posed like a statue, and the four visitors to the tomb are strikingly life-like by comparison. Three of them bear plates of fruit, baskets, a mirror and a wreath, while the fourth holds a shield and a helmet, perhaps the property of the dead youth.

Sicily, Campania and Paestum all developed distinctive red-figure styles of their own in the course of the fourth century BC, the two mainland fabrics probably developing out of the Sicilian. Sicilian red-figure is not well represented in the British Museum, or indeed anywhere outside Sicily, but the other two fabrics are. The Campanian vases are notable for their sober and distinctive colour scheme; the base colour of the clay is paler and browner than that of Apulia, and there is plentiful use of white and occasionally other colours, too. The vases are also interesting for their detailed representations of native Oscan warriors in their remarkable and idiosyncratic armour, including crested helmets, cuirasses decorated with three discs or circles, and elaborate belts. Paestan vase-painting, however, is perhaps the liveliest of the South
82 Italian schools. A huge *bell-krater* signed by the painter Python bears a richly worked and highly dramatic scene: Alkmene, the mother of Herakles, sits on the enormous log pyre where her husband Amphitryon, rightly suspecting her of infidelity, has placed her; as Amphitryon and a companion lay torches to the pyre, Alkmene raises her right arm in an almost operatic appeal for mercy. Fortunately help is at hand in the persons of the Clouds, who empty jars of water over the pyre to quench the flames, while Zeus, who had disguised himself as Amphitryon in order to seduce Alkmene, watches from the side. This painting may reflect a scene from a tragedy; other Paestan pots, in common with several Apulian and a few Lucanian examples, show scenes
83 with comic actors, padded and with large phalluses, performing slapstick farce on a raised stage. Such scenes are thought to derive from a type of local comedy known as Phlyax, which seems to have consisted of parodies of Greek myths.

Many people find south Italian red-figured vases oppressive in the ornateness of their decoration, and overwhelming in their scale. By

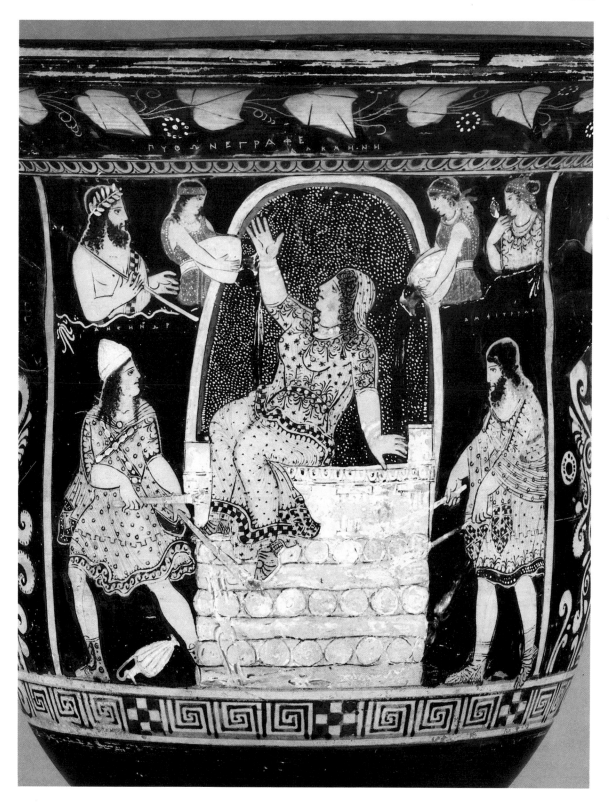

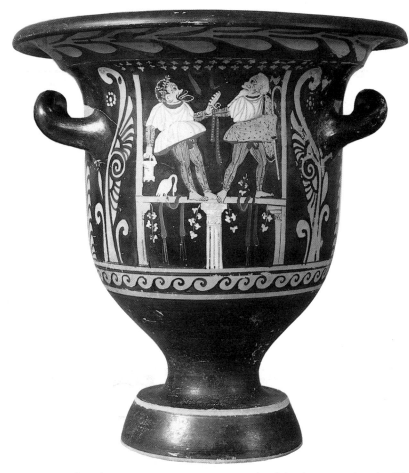

82 OPPOSITE Alkmene on the pyre: detail of a Paestan red-figured *bell-krater* signed by the painter Python. The complex and highly dramatic scene is typical of the finest Paestan vases. About 330 BC; from Sant'Agata dei Goti. Ht 56 cm.

83 LEFT The painting of this Paestan vase has also been attributed to Python. The scene shows two comic actors on a raised stage; the older man on the right appears to be dragging his drunken and argumentative slave home from a party, and the drooping bird may also have had too much to drink. About 330 BC. Ht 40 cm.

contrast, Gnathia vases can appear refreshingly restrained. The Gnathia style seems to have originated in Apulia (perhaps at the site of Egnazia) around 350 BC, but was thereafter manufactured in several centres of southern Italy. Gnathia vases are black-glazed, with polychrome decoration, principally red, white and yellow, applied on top; the finest are beautifully ribbed, the polychrome limited to discreet bands of scrolling flowers, with perhaps a single bird preening itself among them. More elaborate, yet still beautifully constructed and re-markably elegant in appearance, is a tall *loutrophoros* (a special type of two-handled jar) on a stand, its ribbed body enlivened and articulated by neat floral bands, its handles formed from moulded leaves and flowers, and its lid crowned with a delicate handle formed by a bird emerging from a flower calyx.

The last major group of vases produced in southern Italy is classed as Canosan, after the site where many examples were found and where it is thought they were principally made. Canosan vases combine the arts of the potter and the maker of terracotta figurines; they come in various shapes, including large, bulbous *askoi* (oil-flasks) that derive from local Italic forms, but almost all are on a grand scale. They are

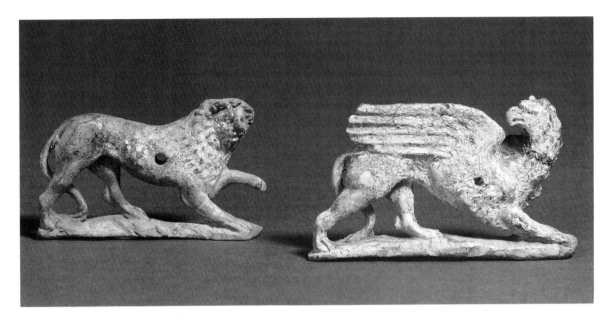

86 Two terracotta plaques representing a lion and a griffin, still preserving traces of the gilding with which they were once coated; the holes presumably allowed them to be attached to wooden boxes or furniture. Made in Taranto about 330–300 BC. Ht (of lion) 5.1 cm.

century BC, an enormous quantity of terracotta plaques was produced, moulded in high relief and supported at the back by a strut. They vary in size but are decorated with a very limited range of subjects, the favourites being Dionysos reclining at a banquet, often attended by a female figure sometimes identified as Persephone, and a satyr abducting a nymph. These plaques seem to have been made principally for dedication in sanctuaries; so too was another type of plaque found in large quantities in a sanctuary of underworld deities at Locri. The Locrian plaques, which date to the fifth century BC, are notable for the high quality of their design and execution, and extremely interesting in their subject-matter; many represent the abduction of Persephone by the god of the underworld, Hades, or her subsequent life as mistress of the underworld; some represent scenes, as yet unexplained, of unrecognised myths or rituals.

The south Italian Greeks were skilled bronze workers, too. Very few large-scale bronze statues survive, but among them is most of an over-life-sized leg and foot and associated fragments of drapery that it has been suggested may belong to an equestrian statue erected in Taranto in the mid-fifth century BC; the workmanship is of exquisite quality, with such details as the gorgon's head on the greave finely modelled, and the meander border of the cloak carefully inlaid with strips of copper. A rather earlier, small-scale version of a virtually intact Tarantine equestrian statue was found at Armentum. The 'Armentum Rider' [87] dates to around 550 BC; it is very finely worked and beautifully preserved. The slowly moving horse with its carefully designed and ordered mane and tail is rather longer in the body than is strictly correct, and the warrior, who has now lost his spear and shield, sits somewhat stiffly astride it, arms outstretched to grasp the now-missing reins; but the final effect is both dignified and appealing. Such statu-

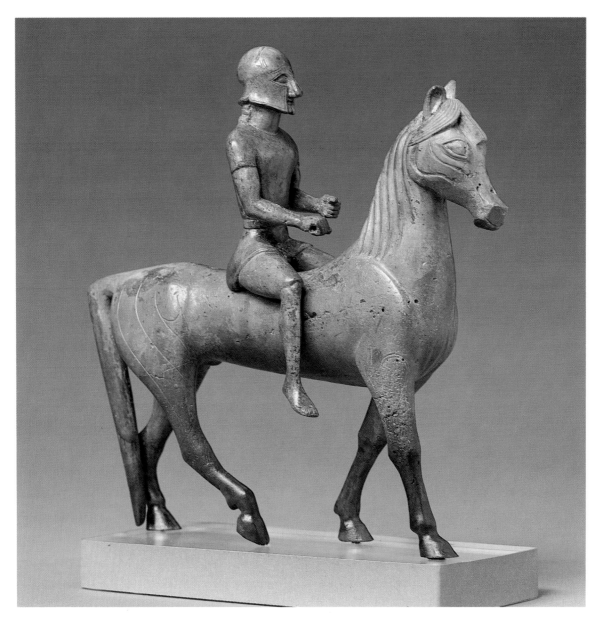

ettes as this recall the bellicose tendencies of the south Italian cities, which were frequently at war both with the native Italic peoples whose territory they had usurped and with each other; further reminders of this aspect of their lives are provided by the numerous bronze breast-plates, greaves and helmets that survive. One helmet in the British Museum was apparently lost by a member of the Etruscan forces defeated by the Syracusans and their allies at the naval battle that took place off Cumae in 474 BC; the inscription on the helmet records its dedication to Zeus at Olympia by Hieron, ruler of Syracuse, and the Syracusans, as Etruscan spoils from Cumae. Particularly fine are two

87 The Armentum Rider would originally have held a spear in his left hand and carried a shield in his right, which would also have guided the reins. Both horse and rider are solid bronze; hollow-casting was not yet in common use. About 550 BC; from Armentum in southern Italy. Ht 23.6 cm.

88 Part of one of the straps from a bronze cuirass, decorated in relief with a scene of a Greek fighting an Amazon; both figures are finely and strongly modelled, the Greek's powerful muscles contrasting with the naked breast and flowing drapery of the Amazon. About 400–350 BC; said to have been found in the River Siris. Ht 16.5 cm.

shoulder straps from a bronze cuirass, each decorated with a power- [88] fully modelled and beautifully finished group of a Greek fighting an Amazon, made in Taranto about 400 to 350 BC. Many of the small bronzes that survive from south Italy are statuettes of naked youths or draped women, made as handles for mirrors or shallow bowls. One attractive figure, which was probably originally attached to the rim of a large bowl, represents Nike (Victory), running to the viewer's left. Her [89] elegantly feathered wings are spread on each side in a wide arc which is echoed by the plaited tresses of her hair, swept back across her chest and shoulder by the speed of her progress; her forward leg is bent at

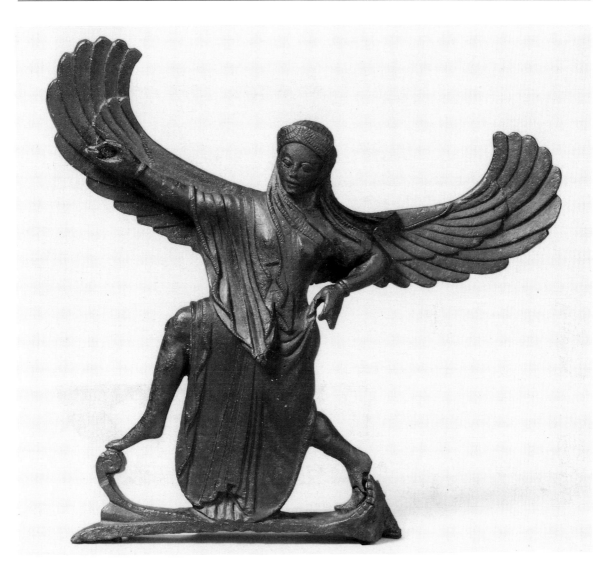

the knee where it emerges from the hanging folds of drapery that help to anchor the figure and lend stability to the impression of rapid flight.

The wealth of south Italy is perhaps most impressively reflected in its gold and silver. The finest jewellery appears to have been made in and around Taranto in the fourth century BC. There are, for example, gold wreaths of exquisite quality, the leaves made from sheet gold so thin that the slightest breeze will set them in rustling motion. There are numerous earrings, finely worked and decorated with filigree; favourite motifs were Erotes, sometimes carrying cosmetic equipment or musical instruments; figures of Nike; and a range of birds and animals, including a large and endearing pair of dolphins. Gold finger-rings are numerous, the most impressive type having a box-bezel, the upper surface bearing a fine design in relief or intaglio, and the sides often decorated with intricately worked filigree chains.

89 Bronze figure of winged Nike (Victory); many of the finest small-scale south Italian bronzes were made as handles for vessels or mirrors. About 550 BC. Ht 16 cm.

90

90 RIGHT Pair of gold earrings in the form of plunging dolphins. According to legend the founder of Taranto, where these earrings were made and found, was carried to the future site of his city by a friendly dolphin, and dolphins appear not infrequently in the art of the region. Fourth century BC. Ht 5.2 cm.

91 OPPOSITE Gold necklace from a mid-fourth-century tomb at Taranto. The individual elements were made from thin sheet gold hammered into shape, with details then added in the filigree technique. The design is finely arranged to lie in a flat curve on the wearer's neck. L 30.6 cm.

Several tomb-groups of fine jewellery have been identified. One of the most interesting is from a Tarantine tomb that seems likely to have belonged to a priestess of Hera who died in the mid-fourth century BC. The first item in the group is a small sceptre; the core of its shaft was probably made of bone and no longer survives, but the network of gold wire that surrounds it does, each intersection decorated with a small circle of enamel; the shaft is topped by a fruit of green glass, enclosed by gold acanthus leaves set over a Corinthian capital. Next comes a gold necklace, consisting of a chain of alternating gold rosettes and **91** double palmettes, with female heads and half-acorns suspended from it, all finely worked with extensive use of filigree ornament. Three of the heads are horned, most probably a reference to Io. She was the unfortunate priestess of Hera, divine wife of Zeus, king of the gods, with whom he fell in love; in order to protect Io from his wife's jealousy, Zeus turned her into the shape of a cow. The third object in the Tarantine tomb was a gold box-bezel ring, its upper surface bearing a relief design of a seated woman holding a sceptre. Slightly later in date, perhaps around 340 to 330 BC, is the Santa Eufemia Treasure, named from the site where it was found. This too is a tomb-group, consisting of a large number of items worked in gold, including a spectacular diadem, finger-rings, pendants and a series of ridged bands that seem to have belonged to a belt.

Gold and silver vessels were also made in south Italy and Sicily, though relatively few have survived. A gold *phiale* (offering-bowl) dating to around 600 BC was found at Gela in Sicily; its interior frieze of six

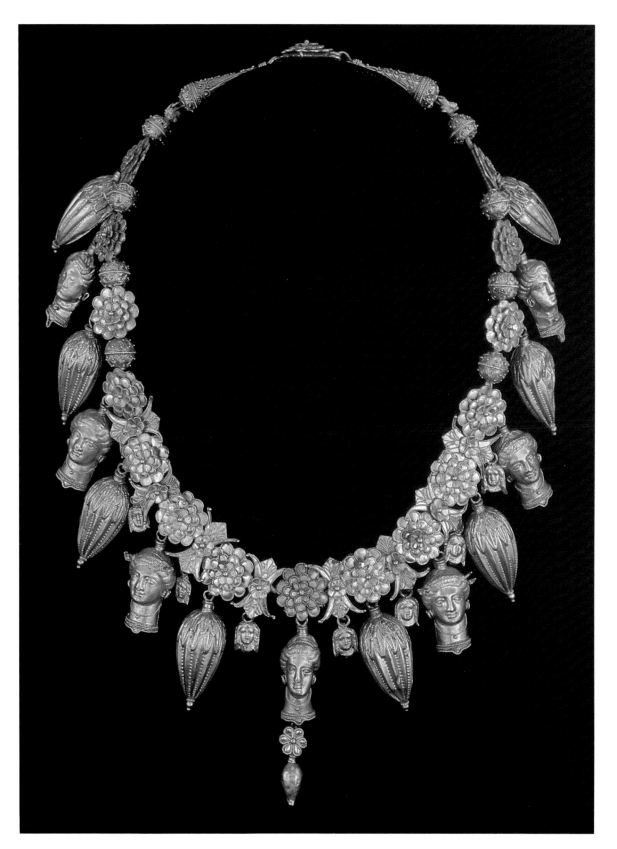

7

MONUMENTAL SCULPTURE IN LYCIA AND CARIA

The Lycians and the Carians, neighbours in south-western Asia Minor, were both indigenous Anatolian peoples. Because it is extremely remote, mountainous, and difficult of access, Lycia was virtually untouched by the Greek colonisation movement of the eighth and seventh centuries BC; colonies were, however, established on the coast of Caria, the two largest being Halicarnassos (modern Bodrum) and Cnidus. Both were to prove important centres of Greek learning and culture; Halicarnassos, for example, was to be the birthplace of the great historian Herodotos. After the fall of Lydia in 546 BC, Persia was in control of most of western Asia Minor, including, to varying degrees at different times, both Lycia and Caria. Persia was, however, defeated by the Greeks in 480 BC; and with the establishment of the Delian League, Athenian influence in these areas was paramount until the collapse of Athens in the late fifth century and the recovery of all the Asian cities by Persia in the so-called King's Peace of 387 BC. Until this time, the Greek presence on the coast had led to the confinement of the native Carians in inland towns and villages. Now, however, Carian satraps or local governors were chosen to take overall responsibility for Carians and Greeks alike, and, when in 377 BC Mausolos succeeded his father Hekatomnos as satrap, he moved his capital to Halicarnassos. Mausolos and his family were exceptionally philhellenic. He had plans to hellenise the whole of Caria, and in pursuance of this aim he remodelled Halicarnassos and embellished it with splendid buildings; at the same time he rebuilt other Carian centres in the Greek style and forced the reluctant population to aban- [96] don their villages and live like Greeks in cities.

The most famous of the monuments of Mausolos is the tomb that bears his name: the Mausoleum, one of the Seven Wonders of the Ancient World. The Mausoleum was designed by a Greek architect and decorated by Greek sculptors, but both its plan and its function have less in common with other Greek monuments than with those of neighbouring Lycia. The Lycians had managed to retain a great deal of

cultural independence under Persian and Greek domination. Though clearly interested in and receptive to both Greek and Persian art, the monuments they built, especially their distinctive tombs, retained a uniquely Lycian character from the sixth to the fourth century BC.

The cities and monuments of Lycia were virtually unknown in western Europe before Charles Fellows visited the area in 1838, in the first of four expeditions. The account he published of his travels and discoveries attracted the attention of the authorities of the British Museum, and after protracted argument between Fellows and the British Museum over terms and conditions, permission was obtained from the Turkish authorities for him to remove some of the finest sculptures and architectural elements from the monuments of Xanthos and bring them back to England. Fellows was enthusiastic about the culture that he could justifiably claim to have discovered, and anxious to point out its independent, idiosyncratic style. The classical purists of the mid-nineteenth-century British Museum were less impressed, since in their eyes the sculpture was inferior to and so less valuable and important than unalloyed Greek or even Roman work; the only tomb to excite their admiration was the most obviously Greek example, the so-called Nereid Monument. Only relatively recently, as the result of the scientific excavation and study of the sites and monuments of Xanthos and other Lycian cities, has a true appreciation of the Lycian civilisation

96 Watch-towers mark the line of the city wall of Heracleia under Latmus. This Carian city was fortified by Mausolos, although most of the surviving structures are of Hellenistic date.

97 A view of Xanthos, engraved after a drawing by the artist George Scharf the younger, who accompanied Charles Fellows there in 1839. The Harpy Tomb, on its high column, appears in the foreground.

started to emerge, with its difficult and idiosyncratic language, still only partially understood, and its imaginative and eclectic art.

The earliest of the monuments from Xanthos in the British Museum is the so-called Lion Tomb, which probably dates to the second half of the sixth century BC. Like many Lycian tombs, it was basically a stone chest with an opening in one side, set on top of a high pillar. The walls of the chest are decorated with sculptures in low relief of a lion, a lioness with cubs, a man fighting a panther, and a warrior and horseman. The style is curious and difficult to parallel or date; it has been suggested that it is the work of a local craftsman translating into a different material and larger scale the style he has seen in small works of Greek art, and it does have the look of an early experiment in an unfamiliar medium. The subjects, however, the warriors and lions, are thought to reflect the Lycian preoccupations of martial prowess and royalty, so that already the fusion of Greek and Persian elements in Lycian culture is becoming apparent. The larger and rather later 'Harpy Tomb' is of similar construction; it too is basically a stone box, and originally it was perched on top of a high pillar of dark limestone. The tomb is named from the four woman-headed birds that fly out at the corners of two sides, bearing small-scale human figures; these 'Harpies' would today be identified as Sirens, while their burdens might perhaps be seen as

98

the souls of the dead. The four sides bear sculptured scenes of standing and seated figures; they seem to show offerings or ceremonies in honour of gods or deified ancestors. In many ways this is a very Greek monument: many of the motifs, including the Sirens, the procession of girls in their finely pleated drapery bearing birds or flowers, and the youth who doffs his helmet before a seated elder, find close parallels in Archaic Greek art. There are, however, stylistic oddities, such as the curious way the drapery of the seated female figures sweeps stiffly back under their chairs in rigid wings, which give the impression that this is a non-Greek artist copying something he does not perhaps fully understand. The iconography too has undertones of the Lycian interest in glorification of the ruling family that is foreign to the spirit of Greek art. One figure, for example, has been seen as Harpagus, founder of the Lycian dynasty, and another as the warrior king Kybernis, perhaps the occupant of the tomb. Above the opening or doorway is a cow suckling its calf, a motif that appears on the coins of Sppndaza, ruler of Lycia from 475 to 469 BC; this suggests that, despite the archaic style, the date cannot be much earlier than 470 BC.

Many of the sculptures from the funerary monuments of Xanthos now in the British Museum seem to be roughly contemporary with the Harpy Tomb, or slightly later. Among the most attractive is a small-scale frieze of cocks and hens, their plumage and attitudes naturalistically observed and effectively rendered; also of interest are scenes of men, horses and chariots, and a lively group of satyrs and wild animals. Reliefs of two sphinxes heraldically posed on either side of a false door once masked the gable ends of a distinctive type of tomb with pitched or barrel-shaped roof; the construction of such tombs appears to imitate that of wooden buildings, and decorative, non-functional projecting stone beams are common. A number of such tombs appear in a landscape scene sculptured in low relief on a tomb in the Lycian city of Pinara; a plaster cast of this was brought back to

98 On this side of the Harpy Tomb, three girls carry offerings towards a seated female figure; a similar figure sits on the left. The small opening in the wall is the doorway through which the body must have entered the tomb. About 470–460 BC. Ht 102 cm.

the Blessed, like the heroes of the Greeks, while the battles and sieges, perhaps part mythical and part historical, allude to the fame and prowess of the dead man and his family and so enhance the prestige of both the dead and the living.

It seems extremely probable that Mausolos, ruler of Caria, had seen such Lycian tombs as the Nereid Monument and vowed that he himself would have a still more splendid resting place. According to the Roman writer Pliny the Elder, the Mausoleum was commissioned after

100 The Nereid Monument, as erected and reconstructed in the British Museum. About 400 BC.

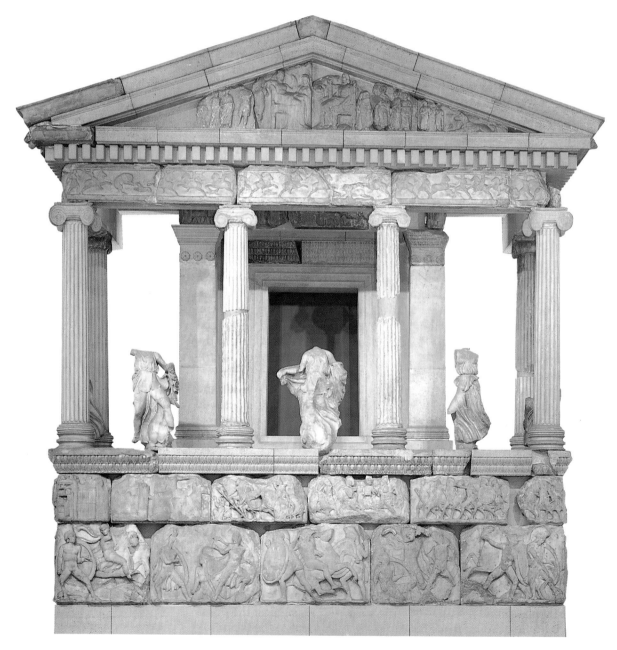

101 LEFT One of the Nereids that originally stood between the columns on the podium of the Nereid Monument. With its alternately clinging and wind-swept drapery emphasising the forms of the body beneath, this figure has strong affinities with contemporary Greek sculpture. About 400 BC. Ht 143 cm.

102 BELOW The besieged city on the right is shown as a series of walls surmounted by rounded crenellations; there are soldiers sheltering between them and a distracted woman flinging up her arms; the fight to the left of the walls is carried on by warriors shown on a much larger scale. From one of the sculptured friezes of the Nereid Monument; about 400 BC. Ht 65 cm.

the death of Mausolos (in or about 353 BC) by his grieving widow, Artemisia, but most modern authorities believe that the building must have been started by Mausolos in his own lifetime. The most obvious feature of the site of the Mausoleum of Halicarnassos today is the large cutting in the rock made for the building's foundations; some effort of the imagination is required to remember that out of this cutting once rose a monument so magnificent that it was ranked among the Seven Wonders of the World. In order to reconstruct the original grandeur of the Mausoleum, it is necessary to rely on a variety of sources, ancient and modern, starting with a consideration of the history of the site and the discovery of the monument.

The Mausoleum must have been intact in the first century AD, when Pliny the Elder gave a partial description of it. Pliny attributes the sculptural decoration of the building to four famous Greek sculptors, Skopas, Bryaxis, Timotheos and Leochares, and from his description of the monument some basic facts may be ascertained. The Mausoleum was rectangular in plan, with sides of about 30 and 40 metres. It was about 45 m high, and consisted of three main elements: at the bottom was a podium; above this stood a colonnade; and the roof took the form of a great stepped pyramid, with a marble four-horse chariot on the summit. Pliny's account also makes it clear that it was the quality and quantity of its sculptural decoration that made the Mausoleum so famous and so spectacular.

It is believed that the Mausoleum remained more or less undamaged until the thirteenth century AD, when the colonnade and the pyramid collapsed, perhaps as the result of an earthquake. In the late fifteenth century, the Knights of St John of Malta started to rebuild and extend their castle at Bodrum, and in the remains of the Mausoleum they 103 found a very convenient source both of squared stone and of irregularly shaped pieces of marble that could be broken up and burnt to make lime mortar. The depredations of the Knights were largely responsible for the absence of material on the site today; one late-sixteenth-century account describes how a party of Knights discovered the burial chamber of Mausolos, and even admired some sculptured friezes that adorned it, before continuing their process of tearing down the walls and breaking up the sculptures. They did not, however, destroy absolutely everything they found, for about a dozen slabs of a frieze showing the battle between the Greeks and the Amazons, one block from a second frieze with the battle between Lapiths and Centaurs, and the foreparts of four free-standing lions and a leopard were built into the walls of the castle between 1505 and 1507.

The British Museum's connection with the Mausoleum started in 1846, when the British ambassador in Constantinople, Sir Stratford Canning, obtained permission to remove the slabs of the Amazon frieze from the castle and bring them to London. Ten years later Charles Newton, who would become the first Keeper of Greek and Roman Antiquities at the British Museum, mounted an expedition to locate and excavate the site of the Mausoleum. Much of the area was

covered by Turkish houses, and Newton's accounts of his dealings with the inhabitants make entertaining reading; among his anecdotes is the story of one of his assistants' enthusiastic investigation of some subterranean passages:

> ... he detected a soft place, and his crowbar suddenly finding its way upwards, lifted up the hearthstone of a grave sententious Turk who was sitting quietly smoking his chibouque in his own house. The astonishment of this respectable gentleman at being so invaded was great; but he took the intrusion very good-humouredly, having a secret desire to sell me his house ...

At this time the science of archaeology was scarcely in its infancy, and were he to be judged by modern standards Newton's methods of digging and recording would seem wholly inadequate, although he was certainly a pioneer in the use he made of photography. His expedi-

103 View of the fine natural harbour at Bodrum (ancient Halicarnassos), with the castle of the Knights of St John of Malta. The site of the Mausoleum was plundered in the late fifteenth century by Knights searching for building materials to improve and extend their fortifications.

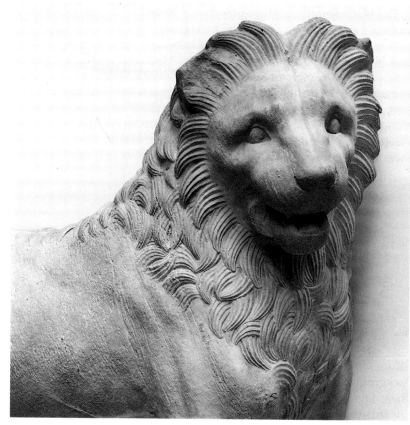

106 Parts of at least fifty-six marble lions have been identified among the fragments of free-standing sculpture from the Mausoleum. Some, if not all, are likely to have patrolled the base of the great stepped pyramid that formed the roof. Ht 1.5 m.

and strongly drawn brows; the treatment both of his drapery and that of his female companion is also distinctive, the heavy swathes and ropes of creased, pulled and wrinkled fabric completely concealing the underlying forms and yet at the same time enhancing the mass and stature of the figures. Huge as they are, these two statues are dwarfed by the head and forepart of one of the horses from the chariot that topped the roof of the building. It is not clear who, if anyone, stood in the chariot, or what it signified: if there was an occupant he was probably Mausolos himself, but was he shown as man or god? Another fine but fragmentary statue is the so-called 'Persian rider', which must belong to one of the groups of free-standing sculpture arranged along the steps of the podium. Here the drapery of the oriental trousers that cover the right leg, and of the tunic worn over them, is finely and realistically portrayed blowing backwards in the wind as the horse surges powerfully forward. The numerous lions that have survived, none quite intact, are believed to have patrolled the base of the pyramid; their bodies are rather commonplace, but their noble, expressive heads [106] and elegantly stylised manes have considerable appeal.

Of the three friezes, only that which shows the battle between the Greeks and Amazons survives in any quantity: in addition to the [107] twelve pieces recovered from the castle, Newton excavated four more

substantial sections and a large number of fragments. Because they had been buried in the earth and not exposed to the elements like those built into the castle walls, Newton's slabs are much less weathered than the rest, and in places remains of the blue and red pigments with which the whole frieze was originally coloured may be seen; Newton himself commented on the colours at the time of his discovery.

Pliny stated that the four Greek sculptors each worked on a side of the monument, and because the Amazon frieze is the most coherent surviving part of the sculptural decoration, numerous attempts have been made to assign various blocks to Skopas, Bryaxis, Timotheos or Leochares on the basis of what little is known about their respective styles. It is certainly possible to see different hands at work on the frieze, but the current approach is to suggest that efforts to identify the hand of Skopas or any of the others is misguided, since the famous sculptors are likely to have worked mainly if not exclusively on the free-standing sculptures, leaving the frieze to be carved by anonymous masons working to a master plan. Of course the style of the frieze is still worth considering, but perhaps rather as a general example of mid-fourth-century trends than as the work of named masters; if their influence appears at all, it is perhaps most likely to be in the overall design of the frieze rather than in any stylistic details. What is immediately striking about its composition, in comparison with fifth-century friezes, is how widely spaced the figures are, and how much of the background is left blank. Noticeable too is an obsession with diagonal lines: favourite groupings of figures include two leaning violently towards each other with a third fallen on the ground between them, forming a pyramid, or one figure pressed backward, either to the ground or at a dangerously precarious angle, the opponent leaning forward in a parallel direction; even the horses prefer to rear diagonally across the available space. As an overall design, the Amazon frieze is perhaps rather disappointing: motifs are frequently repeated, and there often appears to be little progress or connection between one block and the next. Individual blocks or groups of figures, however, can be very striking: in many places the effect of movement is well conveyed, sometimes through the use of flying cloaks; most of the figures

107 Part of the Amazon frieze from the Mausoleum: the fight is energetic, with the strong, athletic bodies of the Amazons and their Greek opponents straining towards each other or bending lithely away. Ht 90.5 cm.

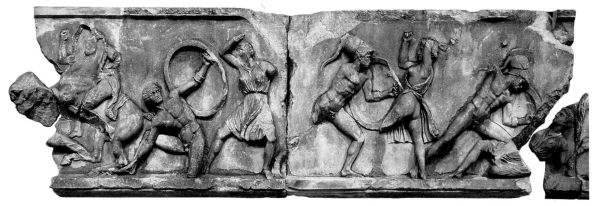

are carved in high relief; and the different qualities of male and female flesh and muscles are finely expressed.

The Mausoleum is a culturally eclectic building. The podium recalls that of such Lycian tombs as the Nereid Monument, and the general idea of glorifying an individual and a dynasty through a sumptuous funerary monument also seems more Lycian than Greek. Other aspects of the architecture, however, most notably the Ionic colonnade that crowned the podium, are purely Greek; they recall the style of the great Greek temples of Ionia, such as the temple of Athena Polias at Priene, said to have been designed by the architect Pytheos whose name Pliny associates with the Mausoleum. The style of the sculpture is, of course, purely Greek; again there are close connections with Priene, and it has been forcefully argued that the same sculptors worked on both buildings. The subject-matter of the sculpture is a mixture of traditional Greek themes (Greeks fighting Centaurs, Amazons and Persians) and allusions to contemporary life at the Carian court (portraits of members of the dynasty, chariot races, and hunting). The pyramidal roof above the colonnade introduces yet another culture, the Egyptian, and the fact that the rulers of Caria did derive some of their ideas from Egypt is confirmed by their practice of Pharaonic habit of brother-and-sister marriage. The innovative blend of cultures evident in the Mausoleum can perhaps best be described as purely Carian; at the same time, the cosmopolitan, international approach to the monument's construction may be seen as an early intimation of the spirit of the Hellenistic world.

8

The Hellenistic World

T raditionally, the Hellenistic period is defined as beginning with the death of Alexander the Great of Macedon in 323 BC; Alexander's brief but dramatic career had deeply and irrevocably changed the political and cultural complexion of the Greek world. Partly through the skilful exploitation of the gold mines of Thrace and partly through the construction of an extremely effective army, Alexander's father, Philip II, had converted Macedon from a relatively insignificant kingdom on the periphery of the Greek world into the most powerful and dominant of the Greek states. Philip crushed the feeble resistance of Athens and a few others in a decisive military victory in 338 BC, but was prevented from achieving his self-appointed task of freeing the Greek cities of Asia Minor from Persian rule by his assassination in 336. Alexander, however, in the thirteen years of his reign, was to accomplish all that his father had hoped to do, and more.

Alexander invaded Persian territory in 334 BC and rapidly pushed through Asia Minor to Egypt and as far east as India, conquering all before him and acquiring enormous wealth for himself and his armies; he married two Persian princesses and planned to found a Macedonian-Persian empire that would span most of the known world. Such plans were cut short by his own premature death in 323 BC, after which his generals divided up his kingdom between them. In theory, they ruled at first as regents for Alexander's posthumous son, Philip Arrhidaios. But soon they were fighting among themselves like independent rulers, and by the end of the century the Macedonian royal line was extinct, while Alexander's successors had assumed royal titles and were establishing their own hereditary kingships; in this way two of the great Hellenistic dynasties, the Ptolemies of Alexandria and the Seleucids of Antioch, were created.

The new Hellenistic world was on a far larger scale than the old world of Classical Greece that it replaced; it encompassed vast new areas, most significantly Egypt and Syria, which with their strong independent cultural traditions were destined to have a considerable impact on native Greek styles; the culture of the Hellenistic world was,

therefore, to be more exotic than before. Paradoxically, perhaps, there was also to be more uniformity of style, with fewer regional differences; artists and their products travelled much more freely between the different centres of population, transferring and transplanting ideas and techniques. The underlying reason for this movement was that the political structure combined with the wealth of the Hellenistic kingdoms to create a new and unprecedented demand for all forms of art. Like oriental monarchs, individual rulers vied with each other in their conspicuous displays of opulence. Alexander himself had led the way with the many cities he founded and the numerous public buildings he endowed – one of the first of these was the temple of Athena Polias at Priene; and his example was followed by his successors, as is evident to anyone visiting such great Hellenistic cities as Pergamon, Priene or Miletus in Asia Minor, each carefully laid out and lavishly adorned with public buildings and monuments. Statues too were commissioned on a grand scale; even the city of Satala (modern Sadagh) in north-east Asia Minor, little known today, has yielded the magnificent bronze head and hand of the 'Satala Aphrodite', thought to be the Per- 108,10

108 View of the Hellenistic temple of Athena Polias at Priene in Ionia. Pytheos, the architect of the Mausoleum, designed this temple too, and it has been suggested that some of the same sculptors worked on both buildings.

sian deity Anahita whom the Greeks identified with both Artemis and Aphrodite. Hellenistic kings were renowned for the extravagance of the entertainments with which they regaled their subjects and for the sumptuousness of their private lives. At the same time, several were prepared to devote considerable resources to the promotion of scholarship and learning, and these in turn generated a demand for more art, whether it was the construction of special library buildings and theatres or the production of portraits of eminent philosophers and poets.

It is sometimes asserted that portraiture began in the Hellenistic period. This is not strictly true, as there are both literary accounts and plausibly identified Roman copies of portraits of fifth-century Athenians, among them the statesmen Pericles and Themistocles. These, however, are generally believed to have been idealised representations of their subjects, attempts to portray the essence of the statesman rather than true records of the outward appearance of individuals. The most convincing fifth-century portraits are found on the fringes of the Greek world, in the images of themselves that the rulers of Lycia liked to set upon their coins. It seems very likely that here, as in the Hellenistic world, the concentration of political power in the hands of one person and the consequent importance of the individual personality were contributory factors in the rise of the idea of the portrait as a political symbol.

The concept of ruler portraiture was certainly encouraged by Alexander. The head that appears on his coins belongs, strictly speaking, not to Alexander but to the hero Herakles; Alexander, however, was quite happy to identify himself with the hero, and it is generally agreed that as time passed Herakles's features were gradually assimilated to those of Alexander. Not long before his death, Alexander gave official notice that he was to be regarded as a god. Thus, when his successors placed his head on their coins, they were using his divine authority to

109 Alexander the Great is said to have offered to fund the new temple of Artemis at Ephesus, provided that his name was inscribed on the building. The Ephesians rejected the offer, diplomatically suggesting that it was unfitting for one god to offer a temple to another. This inscription from Priene, which may be translated 'King Alexander dedicated the temple to Athena Polias', suggests Alexander had to content himself with a less prestigious offering. About 334 BC. Ht (of block) 48.7 cm.

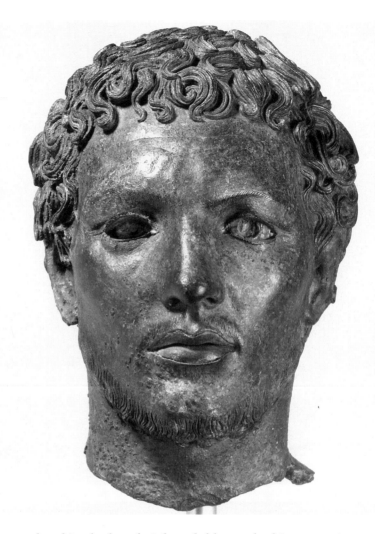

115 Bronze head of an African, found in the temple of Apollo at Cyrene. 350–300 BC. Ht 30.5 cm.

are rendered in shades of pink, red, blue and white, sometimes with touches of gold. Most of these figures are found in tombs, and their purpose or significance is uncertain. When compared with the stiff and formal terracotta goddesses of the sixth to the mid-fourth centuries, their life-like appearance suggests that they must represent ordinary women. While their dress and hair styles, however, are very probably modelled on contemporary fashions, many of the poses they assume are thought to imitate those of large-scale statues, and it is possible that they are in fact intended to represent Muses or divinities.

Terracotta figurines were produced in large numbers at many cities in Asia Minor, each of which developed its own individual style. One major centre of terracotta production in the later Hellenistic period was Myrina, a city lying to the north of Smyrna (Izmir). Technically, Myrina terracottas are exceptionally fine, thin walled and highly fired, com- 117 plex in their poses and often very detailed in their finish; contemporary awareness of their quality is perhaps suggested by the fact that large

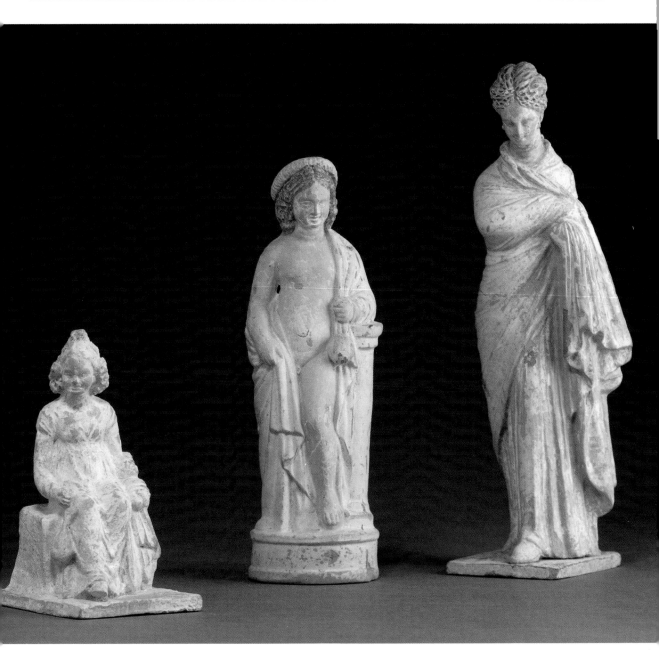

numbers of them were signed or stamped by the maker or the owner of the workshop. At Myrina, as at Tanagra, the commonest types are standing female figures sometimes identifiable as Aphrodite, but Erotes and Winged Victories were also popular, as were curious jointed figures with high head-dresses, often called 'dolls' but more probably an oriental form of Aphrodite. One large and complex piece represents two women seated on a realistically rendered couch with finely turned legs and comfortable-looking cushions; they lean

116 Terracotta figurines of a little girl, a boy and a woman. Made at Tanagra in Boeotia between 300 and 230 BC. The boy and girl are said to be from Tanagra. Ht (of woman) 19.1 cm.

towards each other earnestly, engrossed in conversation. There has been much debate as to their identities and the subject of their talk; one likely interpretation is that they represent the archetypical mother and daughter, the goddess Demeter with her daughter Persephone.

Terracotta figures of comic actors were also popular in the Hellenistic world, reflecting the great contemporary enthusiasm for the theatre. The New Comedy of the era was concerned with a topic of justly perennial interest, the human condition. One of its 'new' characteristics was a fascination – or obsession – with the concepts of Fortune and Chance, and it is perhaps hardly surprising that these preoccupations were also reflected in the visual arts. A famous and much copied Hellenistic statue was the Tyche, or Fortune, of Antioch, while Lysippos is said to

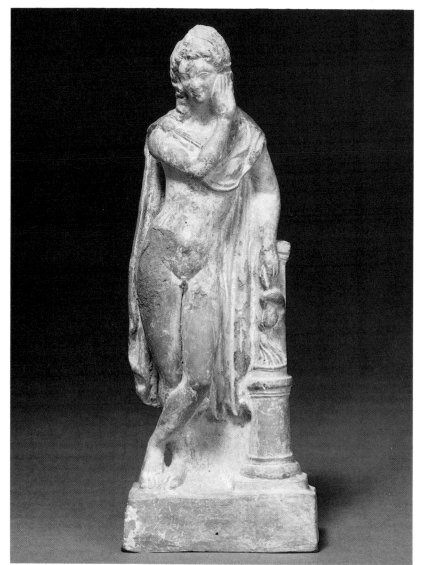

117 Terracotta figure of Eros averting his eyes while he holds a butterfly over a flaming altar. Made at Myrina in Asia Minor in the first century BC; from Myrina. Ht 20.4 cm.

have been responsible for a celebrated image of Kairos (Chance or Opportunity). The interest in allegory included other figures as well, such as the brothers Hypnos and Thanatos (Sleep and Death).

The 'Apotheosis of Homer' is a piece of Hellenistic relief sculpture that reflects not merely this fondness for allegory but also the rather self-conscious interest in scholarship that typified the Hellenistic age. The relief is signed by Archelaos of Priene; its date is uncertain, but around 150 BC seems likely. Its purpose seems to have been to commemorate the victory in a poetic competition of an unknown poet, who appears uncomfortably squeezed in front of a victory tripod against the right-hand edge of the central tier of the three in which the composition is arranged. Homer himself sits in the left-hand corner of the low-

118 Marble relief representing the Apotheosis of the poet Homer. About 150 BC; from Bovillae, near Rome. Ht 115 cm.

120 This clay-ground Hadra *hydria* still contains the remains of a dead person, sealed in with a clay bung. Made in Crete, perhaps in the Mesara region, about 240 BC; from Alexandria. Ht 33.5 cm.

jugs appear to have been mass-produced for the use of loyal subjects wishing to pour libations in their honour. The queens, who are named by inscriptions, are regularly shown with a cornucopia in one hand and a libation-bowl in the other, standing between an altar and a sacred column. These jugs represent an interesting fusion of elements of Greek and Egyptian culture: the material and its use for libation vessels is Egyptian, but the shape of the jugs is Greek; the queens are always shown in Greek dress, and they generally stand in the relaxed position favoured for most Tanagra figures or large-scale sculptures of the time, and yet the angularity of the profile of Arsinoe II on an example in the British Museum, and the stylised patterns of her drapery, seem rather to reflect the conventions of Pharaonic art.

Another series of vessels that seem to have been very much connected with the Alexandrian court are the clay *hydriai* (water-jars)

found in large numbers in the Alexandrian cemetery of Hadra, which
120 has given its name to the ware. Hadra *hydriai* were made from the late
fourth to the second century BC, and two principal varieties are
known. The clay of the first type is coarse and red; it is covered with
whitewash, on top of which polychrome decoration is applied, usually
in the form of floral swags or animal heads. There is little doubt that
vases of this type were locally produced. Vases of the second type bear
brown glaze decoration on a clay ground; analysis of their clay has
revealed that many were made in Crete. Many of the *hydriai* found in
the cemeteries of Alexandria contained the ashes of foreign dignitaries
who succumbed to the Egyptian climate or to other health hazards of
the ancient city while on official visits to the Ptolemaic court. Some of
the clay-ground *hydriai* bear inked or incised inscriptions that record
the date, along with the name and origin of the deceased.

The art of glass-making was first practised most skilfully in the east-
ern Mediterranean, but in the course of the Hellenistic period the tech-
nique gradually spread elsewhere. A variety of shapes designed to be
used at the table were now made; among the finest are large poly-
chrome mosaic glass plates. A group of Hellenistic glass vessels was
found at Canosa in southern Italy; the most spectacular are the so-
121 called 'sandwich gold' glass bowls, made by casting two thin glass
bowls that fitted one inside the other, laying patterns of gold leaf care-
fully between the two bowls and then applying heat to the rims to fuse
the two layers of glass together. The effect of the technique is to sug-
gest that an intricate pattern of gold leaves and flowers has been
trapped in the thickness of the glass, like ferns or skeleton leaves fro-
zen in a block of ice. It is not known where these bowls were made;
other examples have been found in Rhodes, Phrygia and on the shores
of the Black Sea. Their date is likely to be somewhere between about
210 and 160 BC.

The enormous wealth of the Hellenistic world is illustrated very
vividly in the quality and the quantity of its surviving jewellery. Both
the exploitation of the Thracian gold mines by the kings of Macedonia
and, more importantly, the influx and dissemination of captured Per-
sian wealth that followed the victories of Alexander meant that in the
late fourth and early third centuries there was suddenly a great deal
more gold in circulation; as a result, the burials of the period often
prove astonishingly rich. New motifs were employed, such as the cres-
cent, introduced from western Asia, and the reef-knot, thought to
derive from Egypt; in the ancient world this was known as the 'knot of
Herakles' because it was identified with the knot by which Herakles
tied the skin of the Nemean Lion around his shoulders. Its great pop-
ularity in all forms of jewellery has been ascribed to the successful as-
sociation Alexander had made between himself and Herakles. New
Hellenistic shapes introduced from Persia included hoop earrings with
animal or human-head terminals, a type that was to survive into the
Roman period. There were also new techniques, the chief of which was
polychromy, achieved by inlaying or attaching glass and precious

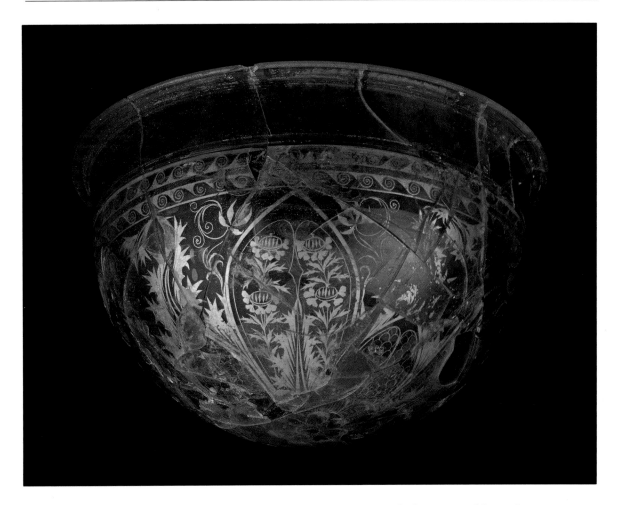

121 Gold glass bowl, with intricate gold designs of leaves and flowers sandwiched between two layers of glass. About 210–160 BC; from Canosa. D 19.3 cm.

stones; a wider range of these, including emeralds and garnets, was newly available in the expanded Hellenistic world.

The finest Hellenistic jewellery seems to have been made in the third century BC, when gold was at its most plentiful. Among the earrings is a pair with antelope-head terminals, the eyes rendered in large red garnets; lion heads are the most popular, but a wide variety of animal heads are found, alongside male and female human heads, including blacks. One impressive piece is a gold diadem or armband made up of three twisted gold bands, with gold rosettes applied to the middle band; in the centre of a large 'knot of Herakles' nestles a huge garnet, and flanking the knot are bands of green and blue enamel scales, edged with gold filigree. This piece is said to have been found in a tomb on Melos; the provenance of two matching bracelets, made of the same twisted gold bands and with lion-head terminals, is unknown.

Very gradually, Roman rule spread across the Hellenistic world. The Romans were originally drawn into Greece by the actions of Philip V of Macedon, who in the late third century formed an ill-fated alliance with Hannibal and the Carthaginians, deadly enemies of Rome. To

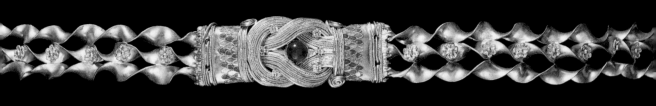

keep Philip under control, Rome allied herself with Pergamon and the group of cities in Asia Minor known as the Aetolian League, and after Hannibal's defeat in 202 BC it was at the request of Pergamon that Rome sent an expedition that crushed Philip's army in Thessaly in 197 BC. At this time there seems to have been no question of Roman annexation of Greek territory; only under the successive provocations of the Seleucid king Antiochos III, of Philip's son and successor Perseus and finally of another aspirant to the Macedonian throne, did the Romans react by imposing their own government. Macedonia became a Roman province in 148 BC and was joined two years later by southern Greece. The last king of Pergamon, Attalos III, died in 133 BC and in his will bequeathed his kingdom to Rome; Syria had been annexed by 63 BC and the last of the old Hellenistic dynasties, that of the Ptolemies of Egypt, was extinguished at the battle of Actium in 31 BC.

In artistic terms, however, it was the Hellenistic world that triumphed over its conqueror. As victorious Roman generals, first Aemilius Paullus and then Lucius Mummius, paraded specimens of Greek art through the streets of Rome in the triumphal processions that celebrated their successes, Romans were introduced to new and astonishingly accomplished levels of artistic achievement. Roman plundering of art treasures was on an enormous scale, with cities such as Corinth virtually emptied of their art by their conquerors. It is to the credit of the Romans that they were quick to appreciate the cultural achievements of the Greeks. An enlightened example was set by such influential figures as Aemilius Paullus, who employed the Greek artist and philosopher Metrodoros both to paint for him and to act as a tutor for his children. So Greek art, like Greek literature, lived on to inspire the art of Rome. Many of the artists of the Roman world were Greek, and in the eastern provinces of the empire the traditions of Hellenistic art did not merely survive but positively flourished under Roman rule.

122 Gold diadem, its centre marked by a 'knot of Herakles' adorned with a huge garnet. About 300–200 BC; from Melos. L (of central section) 4.2 cm.

9

CYPRUS

❧

123 OPPOSITE View of the
forecourt and north-west
entrance to the early
Christian basilica of Kourion
on the south-west coast of
Cyprus. There was
settlement in the area of
Kourion from the fourteenth
century BC onwards, and in
the Archaic, Classical,
Hellenistic and Roman
periods the city was an
important centre. Most of
Kourion's Roman buildings
were destroyed by
earthquakes in the mid-
fourth century AD, and the
fifth-century builders of the
basilica made extensive use of
the earlier Roman materials
available on the site,
including such architectural
features as the column-shaft
and capital shown here.

The position of Cyprus in the far eastern waters of the Mediterra-
nean was from earliest times a decisive factor in determining the
nature of Cypriot art and culture. Cyprus lies on the crossing
point of several ancient Mediterranean trade routes, from Asia Minor
in the north to Egypt and Africa in the south, and from Italy and Greece
in the west to the great eastern kingdoms of Syria, Phoenicia, Assyria
and Persia. The cosmopolitan nature of Cypriot society is vividly
demonstrated by the great variety of scripts and languages that seem to
have been in simultaneous use in the Iron Age: documents written in
Greek, Cypro-Syllabic, Phoenician, cuneiform and Egyptian hiero-
glyphs have all been found on the island. Cyprus was evidently well
placed to welcome a wide variety of both goods and talent from all
around the Mediterranean, and successive generations of Cypriot
artists and craftsmen proved themselves not merely apt assimilators of
the multi-cultural influences to which they were exposed, but creative
developers of their own eclectic, colourful and highly individual styles.

Throughout antiquity Cyprus was famous for its wealth. The fertile
soil produced wine and olive oil in abundance, but more importantly
there were extensive and valuable deposits of copper which could be
exchanged or sold throughout the Mediterranean. Until very recently
it was believed that the earliest inhabitants arrived in Cyprus from the
Near East in the Neolithic period, around 7000 BC, but new excavations
have revealed traces of habitation that appear to date back to the Paleo-
lithic period, around 8000 BC. In the Chalcolithic (literally Copper-
Stone) period, which succeeded the Neolithic period and lasted from
about 4000 to 2500 BC, settlement increased, especially in the western
part of the island. The survival of copper and bronze artefacts shows
that copper ore must have been mined and smelted from the Early
Bronze Age onwards, but the earliest archaeological evidence for these
processes dates only to the beginning of the Middle Bronze Age in the
nineteenth century BC. In the Late Bronze Age (about 1650 to 1050 BC),
Cyprus traded energetically with the Near East, Egypt and the Greek
world, and several prosperous towns were established, especially on

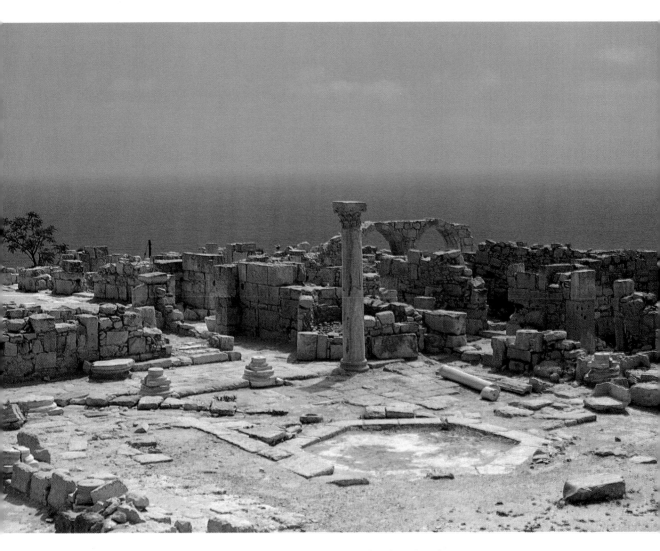

¹²³ the south and east coasts. The waves of destruction at the hands of
marauding raiders that affected many of the great Mycenaean centres
on Crete and mainland Greece around 1200 BC did not leave Cyprus
entirely unscathed, but the Cypriot population seems to have re-
covered more rapidly than others, and there is clear evidence that
around 1100 BC large numbers of Mycenaeans found refuge on the
island, bringing with them many of their own cultural and artistic tra-
ditions.

The 'Dark Age' that enshrouded much of the Mediterranean be-
tween about 1050 and 850 BC appears to have been less dark on Cyprus
than elsewhere; it is clear that contact was maintained with the east,
and jewellery and metalwork provide evidence of some prosperity. In
the mid-ninth century a Phoenician settlement was established at
Kition (modern Larnaca), which had an immediate and regenerative
effect on Cypriot culture. Throughout the succeeding Archaic and

Classical periods (which, together with the Hellenistic and Roman periods that followed, are sometimes known collectively as the Iron Age), Cyprus was dominated by a series of foreign powers that valued the island both for its natural resources and for the strategic military advantages its possession bestowed upon them. In the earlier seventh century Cyprus was ruled by Assyria, and in the mid-sixth by Egypt; in the later sixth century Cyprus shared the fate of the East Greek cities in being forced to accept the Great King of Persia as overlord. From at least as early as the seventh century, the political organisation of the island consisted of a series of semi-autonomous city-kingdoms, several of which, such as Salamis, became extremely prosperous and influential. In 498 BC the Cypriot cities joined in the revolt of the Ionians against Persia and, like their East Greek allies, were brutally repressed. For much of the rest of the fifth and earlier fourth centuries Cyprus remained under Persian control, but there were brief interludes of Greek influence achieved in the fifth century by various Athenian initiatives and in the fourth century by the struggles of the Cypriots themselves. Cyprus was still officially Persian when it surrendered to Alexander the Great in 333 BC, and was thereafter absorbed into the Hellenistic world as part of the territory of the Ptolemies of Egypt; in 58 BC the island was annexed by Rome, and in 30 BC it became a Roman province.

This brief survey of Cypriot material in the British Museum concentrates on the artefacts produced in the Bronze and earlier Iron Ages, since these were the periods in which Cypriot culture was at its most distinctive, displaying a unique and characteristic blend of Greek, Phoenician and native Cypriot elements. From the fifth century onwards, although artistic inspiration by no means flagged on Cyprus, Cypriot art was less distinct from that produced elsewhere in the Mediterranean.

The English word 'copper' derives from the Latin 'Cyprium aes', literally 'copper of Cyprus', an indication of the island's importance as a source of copper in antiquity. Since pure copper is very soft, it becomes much more useful when it is 'alloyed' or mixed with other elements to produce bronze. Most ancient bronze is alloyed with tin, and later with lead as well, but the earliest Cypriot bronzes are of copper alloyed with arsenic, produced either from a naturally occurring alloy, or else deliberately mixed. Tin was not used before the nineteenth century BC, when it is thought to have been imported from the east via Syria. In the Late Bronze Age, documentary evidence in the form of inscribed clay tablets, found at the site of el-Amarna in Egypt and elsewhere in the Near East, suggests that a country named Alashiya was an important supplier of copper to Egypt, Syria and various Anatolian kingdoms. The tablets are written in cuneiform script, and their language is Akkadian; in one, the King of Alashiya greets the King of Egypt as his brother and promises to send copper in return for an ebony bed encrusted with gold, a golden chariot, horses, linen and sweet oil. He speaks of an alliance between them, and complains that he has not yet

124 Bronze-working tools from the Enkomi hoard: a furnace spatula, charcoal shovel and pair of tongs. Cypriot, twelfth century BC. L (of shovel) 52.3 cm.

received the oil and linen already specified. Major difficulties inhibit the confident identification of either the whole of Cyprus or a single Cypriot city such as Enkomi with Alashiya; but since the suggestion was first made in 1895, scholars have been reluctant to lose sight of the theory altogether.

It is certainly true that Cyprus was a major producer of both raw copper and worked bronze in the Late Bronze Age. New techniques of working bronze appear to have been introduced to Cyprus at this time from Mycenaean Greece, Egypt and the Near East; these included methods of producing vessels out of sheet metal, sometimes on a large scale, and the use of hard solder to join parts of stands or other objects [124] that had been separately cast. Production methods are illustrated by

the contents of the Enkomi 'Foundry Hoard', a collection of smiths' tools, including tongs, spatula and shovel, pans for weighing out material, raw copper and scrap metal, and a selection of smiths' products: new tools for carpentry and agricultural work, stands for vessels, and weapons. This hoard is thought to date to the twelfth century BC; perhaps the most unusual item it contains is an enormous copper ingot in the shape of an oxhide. Among contemporary bronze artefacts, the most striking are a series of intricately made stands for supporting vessels, some cast in one piece, others in several, some with wheels and most with decorative openwork sides formed out of human figures, animals or flowers. One stand includes a scene that evokes the craft of its maker, with a man carrying a copper 'oxhide' ingot towards a stylised tree. Such stands are found throughout the Mediterranean, even as far west as Italy, where they appear to have been highly prized.

Cyprus continued to be an important bronze-working centre in later

125

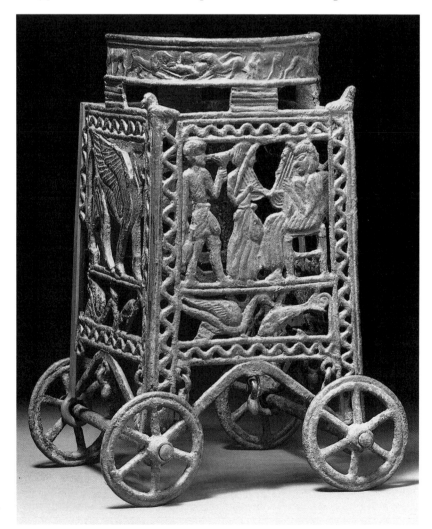

125 Bronze wheeled stand to support a vessel. The openwork scene shows a seated figure playing a harp, approached by another musician and a serving boy. Cypriot, thirteenth or twelfth century BC. Ht 37.5 cm.

years. Characteristic products of the eighth and seventh centuries BC include bowls with handles ornamented with lotus buds, and triangular brooches or fibulae. Some Cypriot bronze artefacts of this period, such as the bowls with elaborately incised designs or the lamp-stands in the form of columns of inverted lotus flowers, have a Phoenician appearance and were very probably made either by or under the influence of Phoenician immigrants like those who had settled at Kition; examples of these items too are often found in tombs on the western side of the Mediterranean. Numerous bronze and iron weapons also survive from the seventh century and later. In the Hellenistic and Roman periods bronze-working continued to be practised on the island, but the bronzes of these periods are not easily distinguishable from those produced elsewhere.

From the Bronze Age onwards, Cypriot potters developed a wide range of pottery styles. Influences from mainland Greece can be detected in the Late Bronze Age, when large quantities of Mycenaean vases decorated in a lively pictorial style were imported; some 'Dark Age' pottery also bears some relation to the products of the Greek Geometric style. For most of the time, however, Near Eastern pottery traditions seem to have been more influential than Greek, and their impact too was repeatedly modified by a strong streak of native Cypriot inventiveness. In contrast with the sober and restrained products of the Greek mainland, which with few exceptions display a relatively uniform and disciplined development of style and technique from the eighth to the fourth centuries BC, Cypriot pottery is pleasingly unpredictable, constantly throwing up surprises.

One of the most distinctive of all Cypriot wares is Red Polished, produced in the Early to Middle Bronze Ages. The shiny, leather-like surface of these pots was achieved by coating them in a slip of red clay, which was then burnished to produce a high polish. Some Red Polished pots are undecorated and some have designs in applied relief, but the most characteristic are decorated with patterns of incised lines, scratched into the surface with a sharp tool and sometimes filled in with white paint. By using clays with different quantities of iron oxide and exercising tight control over firing conditions, potters were able to produce Red Polished pots that were black in some areas, usually around the rims or the insides of bowls. Like almost all Early and Middle Bronze Age pottery, Red Polished Ware was hand-made; favourite shapes include round-bottomed jugs with cut-away beaked spouts and tulip-shaped bowls. The Middle to Late Bronze Age produced White Painted Ware, which occurs in numerous forms that have in common a design of dark lines on a pale slipped surface; of particular interest are vessels with human figures 'growing' out of them, or such pieces as a boat with a man sitting on the edge.

Two distinctive Cypriot Late Bronze Age pottery types are Base Ring and White Slip Ware. The first is named from the ring-shaped bases common to almost all its products. Base Ring pots are rather metallic in appearance, thin-walled, coated in a dark, highly burnished slip,

[149]

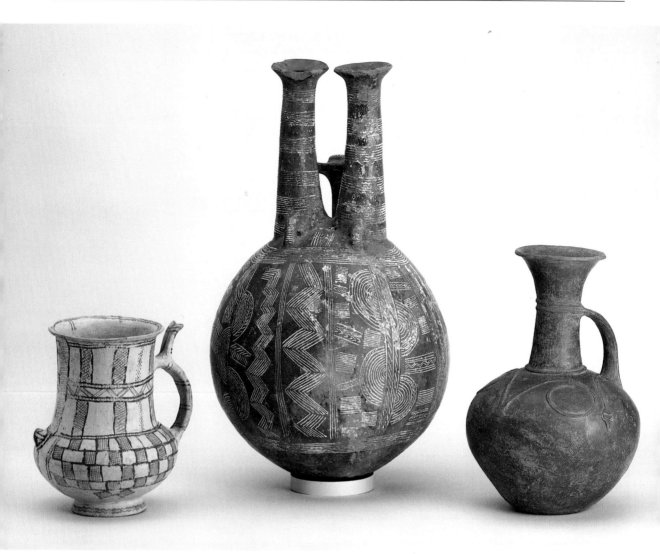

126 Three Cypriot Bronze Age vessels: (*left*) a White Slip tankard, (*centre*) a Red-Polished jug with two spouts and (*right*) a Base Ring jug decorated with applied coils, some ending in snake's heads. 2000–1450 BC. Ht (of Red-Polished jug) 47 cm.

highly fired and sparingly decorated with relief bands and white lines. One common Base Ring shape is the small jug resembling an inverted poppy-seed head; traces of opium have been discovered in some of these. White Slip Ware is often very finely made, the creamy white surface of the vessels decorated with carefully applied linear patterns in orange, brown or black; typical shapes include the so-called 'milk bowls', shallow, round-bottomed bowls with a single wishbone handle, which were widely exported around the Late Bronze Age Mediterranean. ¹²⁶

Cypriot potters started to use the fast wheel at the end of the Bronze Age; possibly it was introduced to the island by Mycenaean immigrants. Cypriot Iron Age pottery displays the influence of numerous sources, and regional differences now become more pronounced, with eastern Cyprus more receptive to Syrian and Phoenician styles, north-

ern and western areas perhaps more influenced by Greece. In the Early Iron Age a new type of White Painted Ware was very common in a wide variety of wheel-made shapes, some appearing to derive from Crete. Black-on-Red Ware was produced in large quantities from the eighth century onwards; the style of decoration originated in Phoenicia, as did many of the shapes, including deep bowls and flat-bottomed jugs. The ware is very attractive, well potted with its shiny red surface pleasingly ornamented with rows of black bands and concentric circles. Cypriot potters from the Bronze Age onwards displayed an enduring fondness for producing animal-shaped vases, and there are several fine Black-on-Red examples, including a comically spher-
127 ical ox reclining with his legs neatly tucked beneath him, his eyes rendered in typical Black-on-Red concentric circles and a hoop-like handle linking neck with tail. An appreciation of local flora and fauna is also

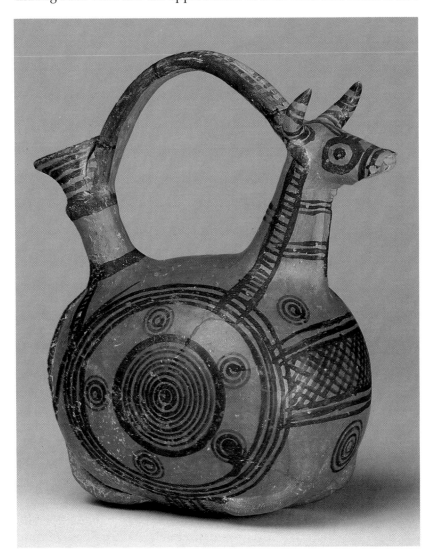

127 Cypriot Black-on-Red ware flask in the form of an ox, decorated with circles and linear patterns. From Kourion, about 750–600 BC. Ht 19 cm.

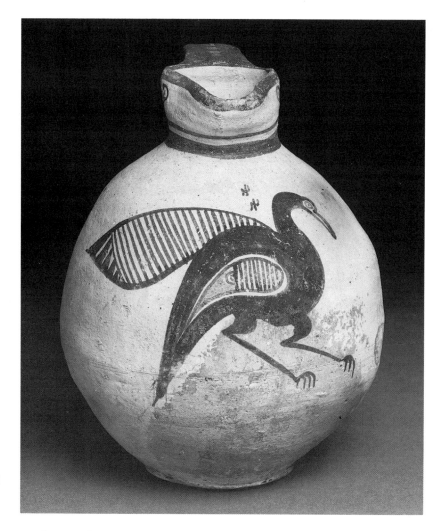

128 Cypriot bichrome jug, decorated in the free-field style with a stylised figure of a bird. Sixth century BC. Ht 18 cm.

evident in Cypriot Bichrome Ware; Bichrome vases are covered in a creamy-white slip, with designs added in two colours, red and dark-brown or black. Shapes and designs are various, ranging from chalice-like bowls decorated with friezes of lotus flowers to large shallow bowls decorated inside with friezes of figures; most characteristic, however, are round-bodied jugs made in the north and east of the island, decorated in the 'free-field' style with a single figure – a warrior, ¹²⁸ animal or bird – standing out against the creamy-white background of the vase. The birds are especially fine, often extremely elegant and stylised in a great variety of ways, their outlines enlivened with linear patterns or areas of solid colour. The beak-like mouths of the jugs themselves resemble the heads of birds, with an eye painted on either side of the spout.

From the later sixth century onwards, Cyprus started to import a great deal of its fine pottery from Athens and other Greek cities. Although local production was not entirely abandoned, and eastern

influences continued to be admitted, Cypriot pottery ceased to be quite so enterprising and lively.

Terracotta figures were probably produced in many of the same workshops that made pots. Characteristic of the Early and Middle Bronze Ages are a series of distinctive plank-shaped figurines, some in Red Polished Ware, others in White Painted. Most have rectangular bodies, with a smaller rectangle attached at the top to form the head; Red Polished examples have incised patterns representing such details as facial features, necklaces or belts, while White Painted figures are generally covered in linear patterns. Most of these figures are thought to represent females, since some have small breast-like projections and some cradle a child. It is uncertain whether they are a native Cypriot development or whether they originated in southern Anatolia, where they are also found. More certainly of foreign (in this case Syrian) derivation are a group of Late Bronze Age figures. These are very definitely female, with breasts, wide hips and prominently indicated pubic triangles. Some are given caps that flatten their heads and are thought to show possible Mycenaean influence, while others wear large hoop earrings in their pierced ears in a fashion that is definitely Syrian. Most of the terracotta figurines of the Cypriot Iron Age were produced for dedication in sanctuaries; they were made in a wide range of sizes and most represent either worshippers or deities. To the seventh century belong elaborate models of fully armed warriors driven in four-horse chariots; these suggest eastern influence, while a large female figure with a high head-dress and elaborate jewellery, her arms raised either in worship or in a gesture of divinity, recalls earlier Cretan figures. The small terracotta horsemen are not dissimilar to sixth-century Boeotian figurines, but the riders are generally shown as warriors, armed with shields and helmets, and the horses too are often given protective breastplates. One fragmentary terracotta figurine of the same period (the seventh century BC) represents a triple-bodied warrior, possibly the Greek mythological figure Geryon. The three raised hands once held three spears, each head wears a helmet and each torso is protected by a breastplate and a circular shield; the armour seems to represent an interesting fusion of Cypriot and Greek elements. In the Classical and Hellenistic periods, Cypriot terracotta figurines became less varied and were generally very similar to those produced elsewhere in the Greek world.

Limestone figures were also made in large numbers for dedication in Cypriot sanctuaries from the mid-seventh century onwards. Like their terracotta counterparts, they come in a range of sizes and styles, and many are extremely accomplished. With very few exceptions, the backs of figures were not modelled but left flat, with the chisel marks still plainly visible; it seems that they were only designed to be seen from the front. The earliest style seems to be a local creation, though eastern influence is apparent in such details as the men's beards, which are sometimes cut square in the Assyrian manner. The usual dress of both male and female figures is an ankle-length robe, over

129 RIGHT Two terracotta mother figures, perhaps fertility charms. The plank-like Red-Polished example dates to the nineteenth or eighteenth century BC; the more realistically rendered figure on the right, found at Enkomi, shows strong Syrian influence and was made about 1450–1200 BC. Ht (of Red-Polished figure) 26 cm.

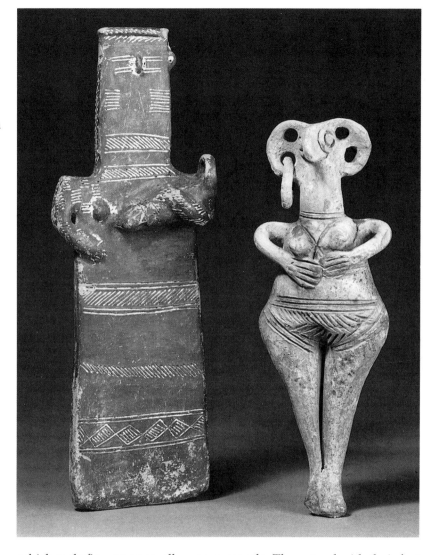

130 OPPOSITE LEFT Terracotta figure of a triple-bodied warrior, armed with three realistically detailed shields, helmets and breastplates. From Pyrga, late seventh century BC. Ht 24 cm.

which male figures generally wear a mantle. They stand with their feet together, left arm by their side and the right one bent across the body, either holding an offering or tucked into a fold of the cloak. Particularly fine is a type of figure common from about 575 to 550 BC, usually about [131] half life-size or smaller; wafer-thin from front to back, and slim from side to side, these sparsely detailed and highly stylised representations of individuals are extremely powerful in their impact. Other contemporary and later figures are by contrast almost excessively detailed, with elaborately carved jewellery, striped and patterned clothing and complex hair-styles. From the late sixth century onwards Cypriot sculpture becomes more dependent on East Greek models, though [132] some Phoenician influence is still apparent in the fondness for representing certain Egyptian fashions.

The wealth of Cyprus encouraged the manufacture of luxury goods

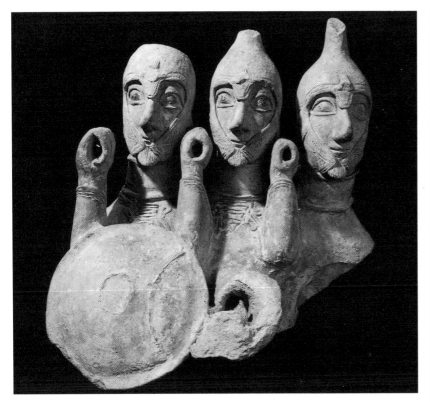

of various types. Many fine examples of worked ivories have been found, dating from the Mycenaean period onwards. Among the finest pieces of the Mycenaean period are carved mirror handles; one ex-
133 ample is decorated on one side with a fight between a man and a griffin, on the other with a lion attacking a bull. In both style and motifs this piece displays an eclectic blend of Aegean, Near Eastern and native Cypriot elements. So too does an ivory gaming box of the same
134 period, its sides decorated with panels carved in relief, its upper and lower surfaces marked out into squares for board games. To the eighth or seventh century belongs a bone spoon that displays strong Egyptian influence, its handle carved in the form of a naked girl swimmer. Small core-formed glass vessels were produced in the Late Bronze Age; one fine example is shaped like a pomegranate, with pointed leaves standing out around the rim. In the earlier Iron Age relatively little glass was made, but in the Hellenistic and Roman periods the art was revived and Cyprus became an important production centre. Fragments of a textile woven with purple stripes and believed to be from Enkomi evoke the fabled luxury of the Cypriot courts in the Hellenistic period,
135 while fine gold and silver jewellery was produced in large quantities from the Late Bronze Age into Roman times.

As elsewhere in the Mediterranean, the demand for personal seals was met in Cyprus from the early sixth century onwards with a range of scarabs and stones of other shapes, designed to be set in rings and

131 ABOVE Slender limestone figure of a male worshipper carrying a kid as an offering. About 600 BC; from the sanctuary of Apollo at Phrangissa, Tamassos. Ht 103 cm.

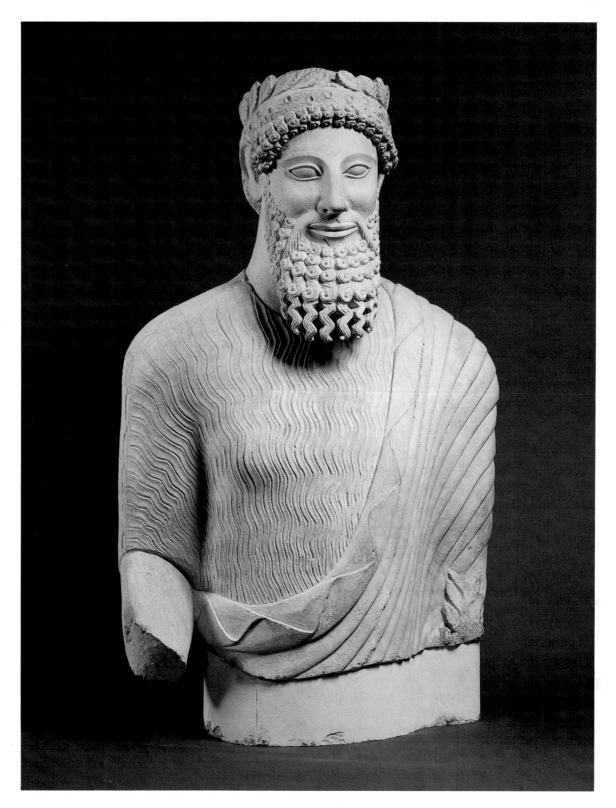

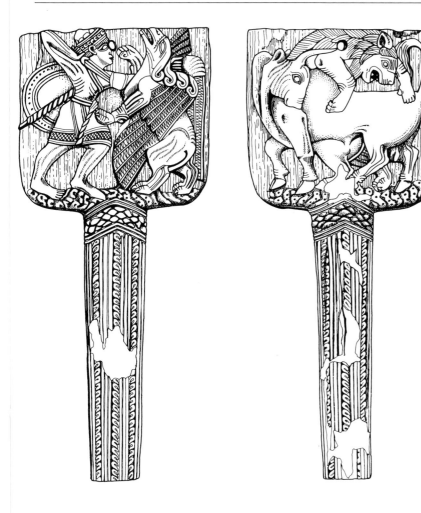

132 OPPOSITE Upper part of a colossal limestone statue of a bearded man, who may be a priest, a worshipper or possibly the god Apollo, in whose sanctuary at Idalion the figure was found. About 490–480 BC. Ht 104 cm.

133 LEFT One side of this ivory mirror-handle is engraved with a scene of a warrior stabbing a griffin, while on the other side a lion attacks a bull. Made by Mycenaeans in Cyprus from imported ivory in the twelfth century BC; from Enkomi. Ht 20.2 cm.

134 BELOW Ivory gaming box; the upper and lower surfaces are marked out for different board games, while the sides are decorated with hunting scenes and animals. Gaming pieces could be kept in an inner drawer. Made by Mycenaeans in Cyprus from imported ivory in the twelfth century BC; from Enkomi. L 29.1 cm.

136 Rock-cut road leading from Cerveteri to the Banditaccia cemetery; the deep ruts have been worn by the wheels of carriages in Etruscan funerary processions.

Some sites, such as those of Chiusi, Arezzo, Perugia or Cortona, have been continuously inhabited since antiquity, so that excavation of Etruscan remains has of necessity been very limited and haphazard; elsewhere, as at Vulci, Tarquinia or Orvieto, the abandonment of the site in antiquity or the location of the medieval or modern settlement on separate or adjacent territory has permitted fuller archaeological investigation. In many cases, the cemeteries of the Etruscans have been more fully explored than their cities; cemeteries were generally located either on the less habitable slopes of the city hill or on a neighbouring ridge, and their remains are often more impressive – and their contents more valuable – than those of the cities. A shortage of good building stone in Etruria, combined with a plentiful supply of timber, led the Etruscans to construct most of their domestic and public buildings from wood and unbaked brick on stone foundations; little, therefore, of their city architecture survives apart from decorative terracotta revetment plaques and other architectural ornaments in the same material. Etruscan tombs, however, were generally cut deep into the rock and so for centuries preserved their contents virtually intact; these included not merely the lavish gifts provided for the dead but also the brilliantly painted scenes with which the walls of many tombs were decorated. Etruscan tombs naturally attracted both excavators and treasure-hunters from early times and, not surprisingly, it is from tombs that the vast proportion of the British Museum's Etruscan collection derives.

In recent years the emphasis of archaeology has shifted away from the traditional excavation-based study of material culture towards a survey- and statistics-derived reconstruction of settlement patterns and population trends. Our knowledge of the Etruscans, as of other peoples, has undoubtedly benefited from such new approaches, and yet without the complementary study of Etruscan art and artefacts they would indeed be sterile, for it is admiration and appreciation of the creative endeavour to which the art and artefacts bear witness that stirs the imagination and puts flesh on the bones of Etruscan culture.

The culture of Early Iron Age Etruria (from about 900 to 700 BC) is often named Villanovan, after the site of Villanova near Bologna where characteristic products of the culture were first recognised. At this time people seem to have lived in small villages, and they practised cremation, placing the ashes of their dead in pottery or metal urns of distinctive types. The plans and building methods of their oval and rectangular huts may be deduced not only from the post-holes found in excavations but also from the model pottery huts that sometimes served as cinerary urns. The people of the Villanovan period in Etruria placed pottery, jewellery or other objects in the pits where they buried their ash-urns; examination of these grave goods has led archaeologists to conclude that in the course of the eighth century there was an increase not only in overall wealth, but also in the degree of social division, with some warriors receiving exceptionally rich burials. The increasing amounts of Greek pottery in the later burials suggest that, as

is hardly surprising, contact with the Greek world became much stronger after the mid-eighth-century establishment of the first and most northerly of the south Italian Greek settlements, at Pithekoussai on Ischia. Since these early Greeks were probably hoping to find metal ores, it seems likely that they would have ventured further north into Etruria had this been feasible. The fact that there were no Greek colonies north of Campania suggests that the Etruscans were better equipped or organised to resist Greek advances than were their southern neighbours.

The Etruscans were, however, perfectly ready to welcome the Greeks, or people of any other nationality, as traders; excavations at Gravisca, the ancient port of Tarquinia, for example, have revealed that from at least as early as 600 BC, and possibly earlier, until about 480 BC, Greek merchants lived there alongside the local Etruscans, even building their own sanctuary to the Greek goddesses Hera and Aphrodite. The archaeological evidence suggests that the Orientalising period of the seventh century BC saw rapid changes and developments in Etruscan culture, largely deriving from greatly increased contact with the outside world. One very significant advance was the adoption of a modified form of the Greek alphabet, enabling the Etruscan language to be written down; it is believed that the Etruscans learned the art of writing from the Greeks at Cumae. By now the scattered villages of Etruria had cohered into centralised towns, and the tombs of the period yield an exotic range of luxury goods, some imported from Greece and places further east, others apparently manufactured in Etruria by skilled immigrant craftsmen from Greece or Phoenicia, who seem to have been welcomed into Etruscan society. The Roman writer Pliny the Elder tells the story of a Corinthian nobleman, Demaratus, who fled from a political crisis at Corinth in the mid-seventh century BC to settle at Tarquinia, which he knew from previous trading contacts. For a Roman audience the chief point of the story was its account of how Demaratus's son Lucumo became Lucius Tarquinius the Elder, the first Etruscan king of Rome; of equal interest to us, however, are both the very idea of an individual Greek choosing to emigrate to Etruria, and Pliny's assertion that Demaratus brought Greek craftsmen with him to Tarquinia; the story offers an unusually specific illustration of the way in which the generally rather intangible concept of Greek influence could have spread to Etruria.

Among the innovations of the seventh century was the adoption, by several of the more southerly cities, of the practice of inhumation of the dead; further north cremation continued to be the rule. An extremely wealthy burial at Vulci, the so-called 'Isis Tomb', dates to the early years of the sixth century BC, but among the grave goods are a number of late-seventh-century items, which illustrate some of the range of both imported and locally produced luxury goods available at the time. Carved faience flasks with hieroglyphic inscriptions, for example, are thought to derive from the Greek trading settlement at Naukratis on the Nile delta, while a long, cylindrical gypsum perfume-flask, its top

carved into the head and upper body of a woman, may have been made in a Greek city of Asia Minor; ostrich eggs from Mesopotamia or Africa, on the other hand, seem to have been carved in Etruria in a style which seems to blend Phoenician and mainland Greek traditions. Other luxury imports of the period include carved tridachna shells from the Indian Ocean and the Red Sea, and ivory, some pieces worked in north Syria or Phoenicia and others locally in Etruria.

Pottery, bronzes and jewellery of the Orientalising period all display the same blend of foreign, usually Greek or east Mediterranean, influence and native adaptation. Much Greek pottery, especially Corinthian, continued to be imported into Etruria, and some local wares imitated Corinthian shapes and styles. The characteristic Etrus-
[137] can *bucchero* vessels of the period, however, seem rather to develop out of the burnished pottery of the Villanovan period. The metallic, lustrous black surface of the pots was produced by first burnishing and then firing them in a kiln with a restricted supply of oxygen, so that the iron oxides in the clay turned black. Early Etruscan *bucchero* was extremely high in quality, thin-walled and produced in a wide range of shapes, some following older Italian traditions and some imitating Greek prototypes. The pots are often decorated with incised lines, spirals and dotted fan designs, generally very neatly executed. In the absence of much suitable stone for carving statues, these too were generally modelled in clay, both at this period and later. Among the
[138] most impressive are a series of fairly large seated figures (over 50 cm high), possibly symbolic representations of the dead in whose tombs they have been found; these are believed to follow north Syrian or other east Mediterranean prototypes, but wear Etruscan dress and

137 Group of seventh-century Etruscan *bucchero* vessels with incised decoration and dotted fans. The chalice on the right, which was found at Chiusi or Volterra, is supported on an integral stand consisting of openwork struts and female figures holding their hair in both hands. Ht (of two-handled jar) 20.25 cm.

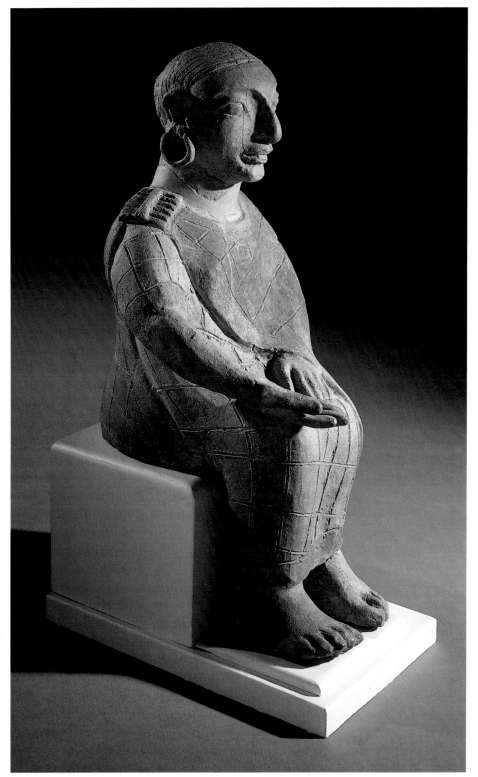

138 Seated terracotta figure dressed in a plaid mantle fastened on the shoulder with a comb-*fibula*. Found in the side-chamber of a tomb at Cerveteri along with five similar figures seated on thrones cut into the rock. About 625–600 BC. Ht 54.5 cm.

jewellery, and sit with one hand outstretched in what looks like a ritual gesture of some kind. There are also cinerary urns, set upon model chairs and with their lids modelled in the form of human heads; these are known as 'Canopic' jars because of their superficial resemblance to the Canopic urns of Egypt.

Greek influence is especially noticeable in the armour of the period, with the old Villanovan types of helmet and shield abandoned in favour of Greek, generally Corinthian, models. The styles and decorative motifs of other contemporary bronzes often suggest the inspiration of imports from the Near East; this is the case, for example, with the decorative attachments in the form of stylised horses and birds that adorn an early-seventh-century horse-bit and bridle. A slightly later cast bronze belt-clasp with iron inlay, each square half of the fastening decorated with a lithe horned animal, perhaps a deer, which twists its head round to bite its arching tail, finds parallels for both technique and motif in the region of the Caucasus.

Large quantities of magnificent gold and silver jewellery were produced in seventh-century Etruria. Like the motifs of contemporary Greek jewellery, many of the favourite Etruscan designs, such as the mistress or master of animals, appear to derive from Phoenicia, and may have been learned from Phoenician or Cypriot craftsmen; the techniques employed, which include stamping, filigree and granulation, may derive from the same source. Beautiful and extremely 139 elaborate earrings, bracelets, brooches and clasps have survived in 140 large numbers. Especially fine is one large brooch, on the catch-plate of which stand ten pairs of lions, all looking back over their shoulders towards the bow, where there are further lions and lion heads, sphinxes and the heads of horses; each element is intricately worked in minute detail and lavishly adorned with granulation. Another type of clasp, the so-called 'comb fibula', is modelled by the seated terracotta figures mentioned above, who wear identical clasps to fasten their mantles at the shoulder. The wealth of the Etruscans at this time is indicated by their readiness to translate into gold the kinds of objects pro-

139 ABOVE Two gold ornaments, probably earpendants; intricately worked in granulation are a series of tiny geometric patterns and a few human and animal figures. Seventh century BC; from Tarquinia. L 16.5 cm.

140 LEFT Gold *fibula* (brooch), the catch-plate and bow thickly covered in finely modelled lions and other animals; details are picked out in granulation. About 675–650 BC; from Vulci. L 18.6 cm.

142 Back of a bronze mirror decorated in low relief and with touches of silver inlay. Details of the central scene are finely engraved, the design beautifully adapted to the circular field. The names of the figures are engraved beside them: Herecele (Herakles) is abducting a woman named Mlakuch. About 500–475 BC; said to be from Atri, Abruzzi. D 18 cm.

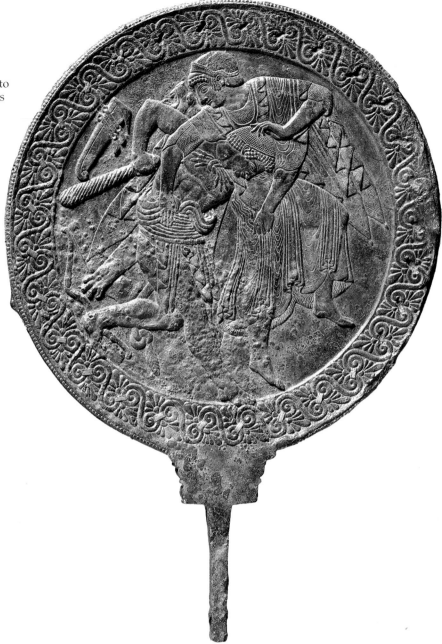

Greek mainland. From the mid-sixth century onwards, large quantities of Athenian vases were exported to Etruria; not surprisingly, Athens also replaced Corinth as a major source of inspiration for local pottery production. *Bucchero* continued to be made, much of it now decorated with roller-stamps, which pressed repeating patterns into the still-damp clay; this ware was widely exported around the Mediterranean. Various sixth-century Etruscan workshops produced black-figured

pottery, decorated either with lively and idiosyncratic interpretations of scenes from Greek mythology or with interesting evocations of aspects of Etruscan life; among the most notable of the Etruscan black-figure painters was the late-sixth-century Micali Painter, who appears to have worked at Vulci.

As in the Orientalising period, the creation of large-scale stone sculpture was restricted in Etruria by the shortage of suitable materials. There was, however, sculpture in terracotta, principally produced for the embellishment of temples and houses. Among the many terracotta antefixes (plaques made to cover the open ends of tiles) are fine examples of gorgoneia and female heads, which are both technically accomplished and finely modelled; most are still brightly painted. Large terracotta sarcophagi and cinerary urns were also produced at this time, some with figures of reclining couples decorating their lids.

The Classical and Hellenistic periods witnessed the political decline of the Etruscans; with this came a certain degree of cultural stagnation, largely due to a growing lack of contact with and stimulation from the world outside Etruria. From the early years of the fifth century onwards, the Etruscans suffered a series of military defeats at the hands both of the Greeks and of various of their Oscan-speaking neighbours, who usurped their Campanian colonies; for much of the fifth and fourth centuries they were intermittently at war with the rapidly expanding Roman Republic to the south, and eventually found themselves squeezed between Rome and the bands of marauding Gauls who had settled in the Po valley to the north. For some time they struggled to resist these powerful enemies, playing them off against each other with intermittent success, but by 280 BC Rome had emerged as the dominant power in Italy, with all the Etruscan cities reduced to the status of subject-allies; by the first century BC they were totally assimilated to Rome. The Hellenistic period, therefore, saw the loss of political independence for the Etruscans; but while their art shared to some extent in the increasingly international culture of the Mediterranean world, they did manage to retain some of their own artistic traditions, and these survived to influence those of Rome.

In many branches of art, Archaic styles lingered on well into the fifth century in Etruria. This is thought to result in part from the loss of Etruscan sea supremacy and the consequent decline in trading activities after the Greek defeat of the Etruscan fleet off Cumae in 474 BC. It seems likely too that this and other conflicts with the Greeks resulted in a certain antipathy on the part of the Etruscans towards Greek culture and a reluctance to follow the contemporary developments of Greek art. The square limestone base of a tomb-marker from Chiusi, dated to around 470 BC, is a good illustration of this lingering Archaism. It is finely carved on all four sides with scenes that seem Archaic in both style and subject-matter; each is very formally composed, with an old-fashioned interest in pattern and repetition, a stiffness of individual poses and an Archaic stylisation of hair and facial features. All four scenes, however, are interesting for the glimpses they seem to offer of

143

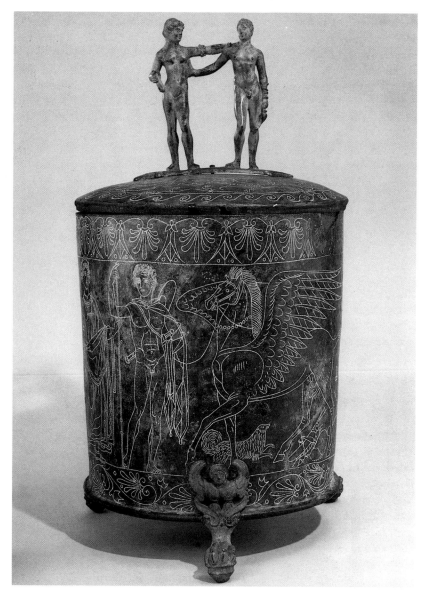

146 Bronze *cista* (casket) engraved with a scene of Bellerophon holding the winged horse Pegasus; the handle takes the form of a girl holding a perfume-bottle and an athlete with an oil-flask and strigil. Made at Palestrina (Praeneste) about 300 BC. Ht 48 cm.

years around 300 BC are the so-called 'Praenestine cistae', large cylin- 146
drical lidded caskets made at Praeneste (Palestrina) in Latium, from sheet bronze with separately cast feet and handles; the sides of the boxes are decorated with intricately engraved mythological scenes, often beautifully executed. These caskets were used to contain a lady's toilet articles.

The Etruscans do not appear to have produced coins before the early fifth century BC, and even then both their issue and their usage seem to have been sporadic rather than general. Between about 500 and 200 BC, various coastal cities, including Vetulonia and Populonia, issued coins in bronze and silver, and occasionally in gold. It seems possible that

the international trading activities of such cities made coinage more useful to them than it was to their inland neighbours, who must have conducted their business by some form of barter. More coins were produced at times of war, when they were needed to pay mercenaries. Many Etruscan coins, at least in the earlier phases, bore a device on one side only. Some of the designs, principally those of the gold and silver coins, appear to have been modelled on the coinages of the south Italian Greek cities. Others were of local significance: some Populonian coins, for example, bear the head of the smith-god Sethlans (Roman Vulcan) on one side, and a hammer and a pair of tongs along with the city's name on the other, clear references to Populonia's iron-mining and smelting industries.

Painted terracotta cinerary urns and sarcophagi (coffins) were produced well into the Roman period. The largest and best preserved in 147 the British Museum is the sarcophagus of Seianti Hanunia Tlesnasa, whose name is known from the inscription on the lower edge. The sarcophagus lid is decorated with the life-sized figure of a woman who reclines on a cushioned mattress, examining her reflection in the lidded mirror she holds in her hand. She wears a tunic and a purple-bordered mantle, and her jewellery includes bracelets, armlets, a necklace, ear- and finger-rings, and a diadem. The skeleton of a woman

147 Painted terracotta sarcophagus of a wealthy Etruscan woman, Seianti Hanunia Tlesnasa. The woman reclining on the lid is richly dressed and wears elaborate jewellery; she holds a lidded mirror in her left hand. About 150–130 BC; from Poggio Cantarello, near Chiusi. L 183 cm.

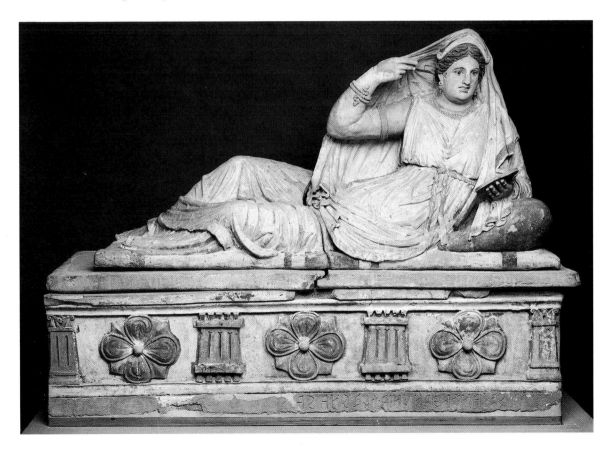

149 RIGHT *Olla* (funnel-mouthed vessel) with attachments that may be intended as stylised animal heads. Daunian, 500–480 BC; from Canosa. Ht 24 cm.

150 BELOW Fragment of a bronze belt, decorated with the figures of a dolphin and a winged hippocamp (fish-horse) in relief. Samnite, third century BC. L 13.5 cm.

the seventh and sixth centuries the Greek settlers at such sites as Paestum, Capua and Cumae lived peacefully alongside the native Oscan peoples, with Etruscan colonists joining the cultural mix in the sixth century. In the late fifth century, however, the Samnites moved south into Campania from central Italy, conquering and occupying Greek, Oscan and Etruscan cities alike. From Campania they spread still further south, into present-day Lucania and Calabria, where they dominated the local Lucanians and Peucetians. The Samnites appear to have been the fiercest and most warlike of all the Italic peoples; it was they who led the resistance of the Italic tribes to Rome in the Samnite Wars of 343 to 290 BC, inflicting several savage defeats upon the Roman army, and they who attacked Rome again in the Social War of 90 to 88 BC. Unlike the other tribes, who gradually came to accept the leadership and uniting force of Rome, the Samnites refused to come to any terms at all; in the end they were completely destroyed in a great battle outside the very walls of Rome in 82 BC. Representations of Samnite warriors are common on the Greek vase-paintings of fourth-century Campania, impressively armed with plumed helmets, triple-
150 disc breastplates and distinctive bronze belts. Several examples of these belts or their clasps are preserved in the British Museum; many are very finely made, sometimes decorated with repoussé work and almost invariably fitted with elaborate clasps, often in the form of stylised cicadas.

In the centuries that followed the decline of the Etruscans, the Roman state rose to a position of unprecedented power and influence. The Romans became by both choice and necessity a cosmopolitan people, eager to assimilate new territories and cultures. Their cultural and artistic development was greatly assisted by the various nations they conquered, but the Italic origins of Rome remained an important element in Roman civilisation, and a constant source of pride.

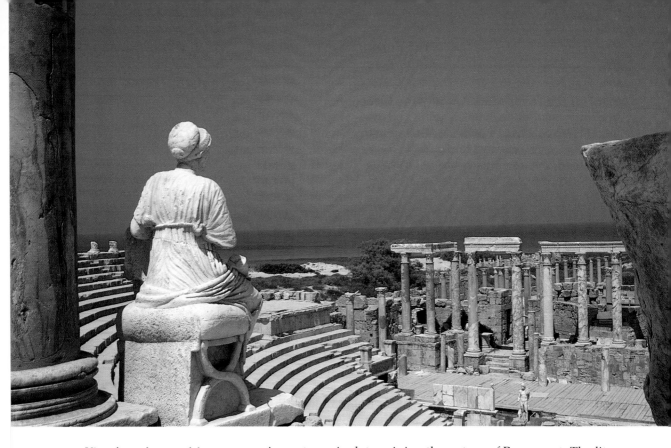

151 View from the top of the theatre at Leptis Magna in Roman north Africa. The completion of the building is dated to AD 1–2; the marble seated figure is a representation of Sabina, wife of the emperor Hadrian (AD 117–38).

mous importance in determining the nature of Roman art. The literary sources combine with the archaeological record to suggest that the citizens of the earlier Republic had a strongly puritanical streak in their attitude to art. From early times they had prided themselves on their adherence to such concepts as civic duty and the importance of hard work, and art was of very limited importance. Their trading activities, however, and their geographical proximity both to the Greek cities of southern Italy and to the Etruscans did offer some contact with more artistic cultures; early Roman coinage, for example, shows the influence of Hellenistic models. We also find references to the masks of dead ancestors that were carried at early Roman funerals, and to ancient temples with painted terracotta revetments and terracotta images of the gods; these appear to have been very largely influenced, if not actually produced, by artists from neighbouring Etruria. When the military achievements of Roman generals caused Greek art treasures to flood into Rome after the successive sackings of Syracuse, Taranto, and Corinth between 211 and 146 BC, popular and private admiration was tinged with a degree of disapproval from some quarters, producing a fundamentally ambiguous attitude towards Greek art that was to persist throughout the later period of the Republic. The lower classes of society are reported to have been impressed and delighted by the Greek statues and other items carried through the streets of Rome by triumphant generals, so different were they from anything they had seen before; and wealthy, cultivated individuals amassed collections of Greek art, arranging Greek statues, either originals or copies, around the gardens of their country villas, and importing Greek artists to dec-

orate their walls with paintings in the Greek style. Officially, however, some of these same individuals deplored the invasion of Greek culture: the influential statesman and moralist Cato the Elder, for example, believed that Greek sculpture had a corrupting influence on the susceptible citizens of Rome, encouraging them to scoff at the traditional terracotta images of the gods, the representatives of their ancestral values.

The Romans' attitude towards Greek art was of fundamental importance to the development of their own; and as the initial impact of Greek art on Roman taste coincided with a period of great political upheaval, it is perhaps hardly surprising that the ambiguity was in the end politically resolved. In the final stages of the civil wars, Octavian seems to have set himself up as the champion of traditional Roman values and morality against the decadent, art-loving Mark Antony, whose dangerously Greek proclivities were embodied in his immoral relationship with the Ptolemaic queen, Cleopatra. Octavian, however, was by no means anti-Greek, or anti-art. In many ways he found the idea of Hellenistic kingship a useful model for his own purposes, and it is clear that he was well aware of the political value of art and culture. He knew that if Rome were to maintain her military and political supremacy over so much of the known world, there was an urgent need for her to develop and assert her cultural superiority too; he probably also thought it advisable for the aristocracy to interest themselves in art as a distraction from politics. And so, in the course of his great programme of cultural renewal, Augustus promoted every branch of art at Rome and in the provinces; but so far as the visual arts were concerned, rather than adopting the Hellenistic style, he tried to revive the Classical spirit of fifth-century Athens.

In Rome itself, public buildings could only be erected by the emperor. In the provinces, however, wealthy individuals could emulate their leader by bestowing temples, theatres, council-chambers, baths, libraries and gymnasia on grateful cities; from the mid-first century AD
151 onwards, such buildings sprang up throughout the Empire, all lavishly decorated with marble portraits of the emperor and other suitable sculpture, and bearing inscriptions that recorded the rank and generosity of the donor. The tradition of promoting the arts established by Augustus was continued by his successors, most of whom realised that artistic expression had become an essential vehicle for the assertion of authority and power. The influence of Greek art remained paramount, although different styles and epochs were favoured at different times. Several emperors, such as Nero in the first century AD and Hadrian in the second, appear to have been genuinely enthusiastic about art. As wealthy citizens followed the emperor's lead, the city of Rome became a magnet for artists and craftsmen from all over the Empire, especially from Greece and the east, and fashions set in Rome gradually filtered out into the provinces. The eastern parts of the Empire, however, retained many of their Hellenistic Greek traditions, and strongly regional styles developed in the outlying areas of northern Europe or north Africa.

In the second part of this brief survey of Roman art we shall consider what might loosely be termed domestic art, some typical furnishings of a luxurious Roman villa, the equipment of a Roman dining-table, and a selection of the luxury goods on which a wealthy Roman might lavish his surplus wealth. The remainder of this chapter, however, will look first at the art of portraiture, both official and private, and in the case of imperial portraits, this leads naturally into a discussion of the coinage; it will finish with a discussion of Roman marble sculpture, principally funerary.

Portraiture was perhaps the only branch of art in which there was a long and indigenous Roman tradition. The many surviving marble portraits of the later Republic and the Empire appear to have developed in part at least from an ancient funerary tradition involving the display of portraits representing family ancestors at funerals. The Greek historian Polybius describes the practice as he observed it at Rome in the mid-second century BC:

> After the burial they place an image of the deceased in the most conspicuous spot in the house, surmounted by a wooden canopy or shrine. This consists of a mask made to represent the deceased in both shape and colour. These images are displayed at public sacrifices and when any distinguished member of the family dies, they carry these masks to the funeral, putting them on men thought as like the originals as possible in height and other personal peculiarities . . .

Large numbers of marble portrait-heads are preserved from the period of the late Republic, when the right of portraiture was restricted to the nobility and the families of serving magistrates; some may have been of funerary significance, but many are believed to come from full-length statues modelled on Hellenistic ruler-portraits. Although it was clearly felt appropriate for the subject of the portrait to adopt a stern, severe and authoritative demeanour, many of the heads are extremely individualistic, conveying a vivid impression of the personalities they portray.

In the early Empire, portraiture lost some of this freshness and individuality. So far as the emperor's own official portraits were concerned, he himself defined the image that he wished to project to his subjects, and this was then copied and re-copied in every medium across the Empire until the ruler himself decreed a change. Thus the youthful portraits of Octavian in bronze or marble, or on his coins, have either a fairly realistic and unflattering Republican look about them, or else they recall the portraits of Hellenistic kings; but when he received the title of Augustus and set about serious image-building, a new portrait-type was created, showing the emperor in the style of a Classical Greek hero with perfect, idealised features and a serene, somewhat aloof expression. This portrait in no way corresponds to contemporary descriptions of his appearance; it was a completely artificial construction, designed to convey the superior perfection of

152 Bronze head from a full-length statue of the emperor Augustus, found near a temple of Victory at Meroe in the Sudan. The eyes are inlaid with alabaster, coloured stone and glass. About 30–25 BC. Ht 44.5 cm.

152

153 Sardonyx cameo bearing a portrait of the Roman emperor Augustus (27 BC–AD14). The jewelled diadem is a medieval addition; the emperor may originally have worn a wreath. Ht 12.8 cm.

Rome's new leader. In the representations of Augustus that appeared on luxury objects designed to circulate only among close friends and acquaintances, such as the 'Blacas cameo' or the hilt of the ceremonial 'Sword of Tiberius', a rather different image is conveyed: on the cameo Augustus wears the aegis, attribute of the god Jupiter or his daughter Minerva, while on the sword-hilt he sits in the attitude of Olympian Zeus. Such professions of divinity were apparently thought beyond the pale for public consumption, but quite suitable for private adulation.

From the age of Augustus onwards, restrictions on who could have their portrait done were relaxed, and the traditional Republican type of realistic portrait came to be favoured by former slaves and people from the provinces. Augustus's immediate successors, the emperors Tiberius, Caligula and Claudius, retained the ideal type of portrait established by Augustus, while Nero (AD 54–68) is sometimes said to have

154 Marble funerary relief carved with the portrait heads of two freedmen (former slaves). To the left are the rod and staffs used in the ceremony of freeing a slave, to the right the tools of a smith or moneyer and a carpenter. About 20–1 BC. Ht 69 cm.

attempted a blend of Classical idealism with traditional realism. Many of the later emperors from Vespasian (AD 69–79) onwards were of provincial or relatively humble origin, and while continuing to manipulate their official portraits as seemed advantageous at the time, they tended to favour a more naturalistic approach; to some extent they were reviving the more austere and realistic styles of the Republic. Many imperial portraits are very impressively and powerfully carved; the finest succeed both as images of power and authority and as evocations of particular individuals.

The official portraits of the emperor and his family had an enormous effect on the way that well-to-do Romans themselves either looked or chose to have themselves portrayed. In the reign of Augustus everyone was clean-shaven and tended to look rather calm and Classical; in the reign of Domitian, women's portraits display the elaborate, high-piled hairstyles pioneered by the emperor's wife, Julia Titi; when Hadrian introduced a fashion for beards in the early second century AD, beards became obligatory, until the reign of Constantine heralded the return of the clean-shaven, Augustan look.

Much of the large-scale free-standing sculpture set up in public

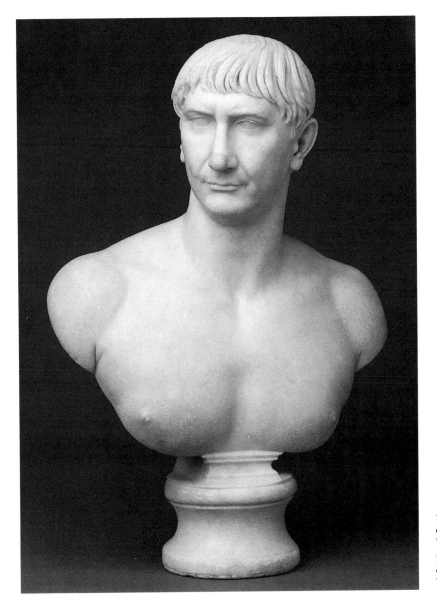

155 Marble bust of the emperor Trajan (AD 98–117). The hairstyle and prominent pectoral muscles are characteristic features of Trajan's portraits. Ht 76 cm.

places celebrated the reigning emperor; statues of the emperor on horseback were perennially popular, as were over-life-size representations of him standing in full armour with an elaborately decorated cuirass rich in pictorial symbolism. In the provinces, statues of local benefactors or government officials were also common. Relief sculpture could be used to decorate buildings and monuments; for the emperors, prominently positioned sculptural scenes commemorating their military or political achievements were an impressive and lasting form of publicity. The emperor Trajan, for example, chose to celebrate his early-second-century victories over the Dacians (the inhabitants of present-day Romania) by erecting a colossal column, its shaft decor-

156 RIGHT Gold aureus bearing a frontal portrait of the Gallic emperor Postumus, who reigned in France, Germany, Britain and Spain between AD 260 and 269. The portrait, dated to AD 263–4, is one of the finest extant on Roman coins. D 2.2 cm.

157 BELOW Roman emperors as seen on their coins, all shown at 1.5 × life-size. (**a**) Silver denarius of the youthful Augustus, about 30 BC. (**b**) Gold aureus of the mature, more classically portrayed Augustus, about 10 BC. (**c**) Silver denarius of the young Nero with his mother Agrippina, AD 54. (**d**) Silver denarius of Severus, with the head of his young son Caracalla, AD 201–6. (**e**) Brass sestertius of Vitellius, AD 69. (**f**) Silver denarius of the mature Caracalla, AD 213–17.

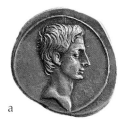

a

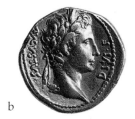

b

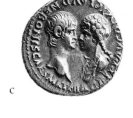

c

d

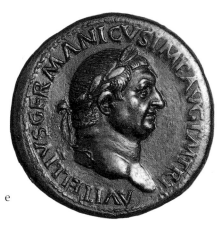

e

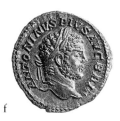

f

ated with a spiral frieze carved with a continuous pictorial narrative of the Dacian campaigns. This column still stands in Rome, but a small relief in the British Museum, decorated with a heap of Roman and Dacian armour, is probably based on the decoration of the column-base.

Inhabitants of the furthest corners of the Empire learned what their emperor looked like from the coins they used in daily life. The basic unit of the Roman silver coinage, the denarius, was introduced shortly before 213 BC, and from the early Empire onwards well-regulated series of coins were struck in gold, silver and bronze. Coins of all denominations struck at the major imperial mints, principally that of Rome, almost always bore the head of the reigning emperor, with his name and titles, on the obverse; sometimes other members of the im-perial family were shown instead. Some of the dies are masterpieces of
156 portraiture; the brilliant frontal portrait of the Gallic usurper Postumus is one such, produced, it is interesting to recall, at a time when the for-tunes of the Empire are generally reckoned to have been at a very low ebb. Individual eccentricities too can be recorded in coin portraits; Commodus, for example, who believed himself to be the reincarnation of Hercules, issued several series on which he appears with the hero's lion-skin helmet. It can be intriguing to observe how an emperor's
157 appearance changes over successive issues of his coinage. Sometimes, as is the case with Marcus Aurelius (AD 161–80), who appears first on the coins of Antoninus Pius and then on his own over a period of forty-two years, it is simply a matter of witnessing a normal ageing process; Caracalla also ages spectacularly over the twenty years of his reign

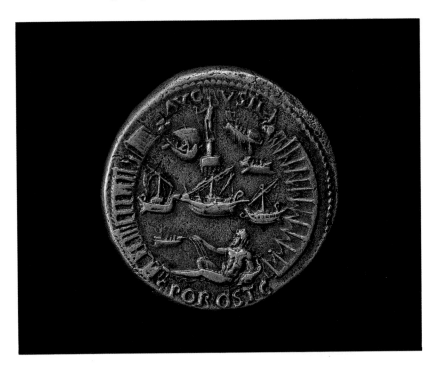

158 Brass sestertius showing a schematic view of the harbour at Ostia, the port of Rome, with its wharves, ships and statues. Issued by the emperor Nero, AD 64–6. D 3.4 cm.

[187]

(AD 198–217). With the emperor Nero (AD 54–68), on the other hand, development of character is clearly visible, too. Nero produced an extensive and constantly changing coinage in which he evidently took a great deal of interest. He first appears as a normal-looking youth with a typically Classical profile alongside his mother; by about AD 58 he has matured into a plump but reasonably amiable young man; between AD 58 and 68 successive issues show his face filling out, his chins doubling, and his expression becoming increasingly savage.

The reverses of the coins were decorated with a huge variety of subjects, many illustrating the emperor's aspirations and achievements. Personifications of such concepts as Virtus (Courage), Pax (Peace), Concordia (Concord) or Fortuna (Fortune) were perennially popular; there might also be references to the legendary origins of Rome or to contemporary events, such as military victories, triumphs or popular legislation. The most interesting designs tend to appear on the larger brass denominations, the sestertii: a bird's-eye view of the port of Ostia, elegantly designed if topographically inaccurate, decorated one 158 of Nero's issues, while Titus chose to record his construction of the Colosseum with a detailed view of the new building. The reverse types 159 of coins minted in the eastern part of the Empire, especially in the Greek cities of Asia Minor, are extremely varied, offering views of local monuments, gateways, harbours and even entire cities, alongside references to local myths and literature; several issues of the local

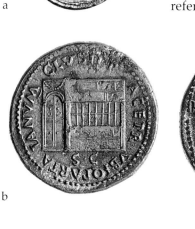

a

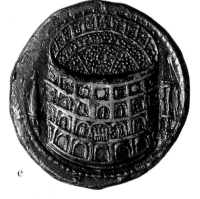

b

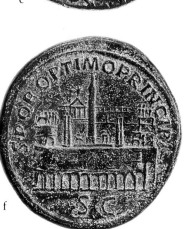

c

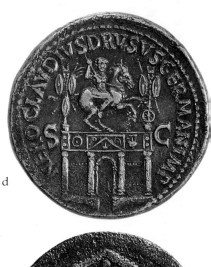

d

e

f

g

coinage of Ephesus, for example, offer quite detailed views of the temple of Artemis, complete with its cult-image and its sculptured column-drums.

Like the columns of the temple of Artemis, much Greek sculpture was still in existence in the period of the Roman Empire, both in Greece and transplanted to Rome or elsewhere. Those who could not acquire original Greek works had to be content with copies, which survive in large numbers; many, along with other free-standing figures of various types, were probably commissioned for private or imperial houses and villas. A large proportion of the British Museum's Roman sculpture of this sort was once the property of Charles Townley, an eighteenth-century Lancashire gentleman most of whose collection was formed in Rome. Townley was a voracious and discerning collector, who devoted a considerable part of his life to the restoration, display, documentation and study of his sculptures. His collection is interesting

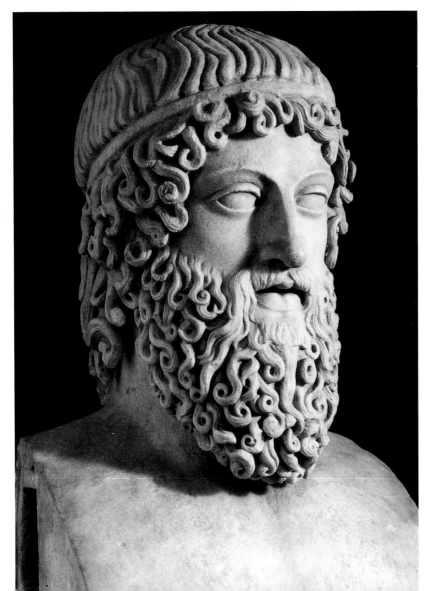

159 OPPOSITE The reverse designs of Roman imperial coins might illustrate contemporary events, buildings or monuments erected by the emperor, or places of local significance to the cities where the coins were minted. (**a**) Silver denarius of Augustus, the crocodile celebrating the battle of Actium, issued in 28 BC. (**b**) Brass dupondius of Nero marking the ceremonial closure of the doors of the temple of Janus at Rome, AD 64–6 (these doors were never closed when Rome was at war). (**c**) Brass sestertius of Hadrian, showing the emperor addressing his troops, represented by three soldiers carrying eagle standards, AD 134–8. (**d**) Brass sestertius of Claudius issued in AD 41–54 to commemorate his father's German victories of 12–9 BC; his father appears on horseback, spearing a fallen enemy, on the summit of a triumphal arch. (**e**) Brass sestertius of Titus, showing the newly built Colosseum with its tiers of seats, statuary and thronging crowds, AD 80–81. (**f**) Brass sestertius of Trajan, with a detailed view of the Circus Maximus, which he had recently restored, with adjacent buildings and monuments, AD 104–11. (**g**) Bronze coin of Maximinus minted at Ephesus, showing the temple and cult-statue of Artemis, AD 235–8.

160 LEFT Marble head of the wine-god Dionysos from a terminal figure; Roman, first or early second century AD, but carved in the Classical Greek style of the fifth century BC. Found near Naples in 1771; formerly in the Townley collection. Ht (of head) 40 cm.

[189]

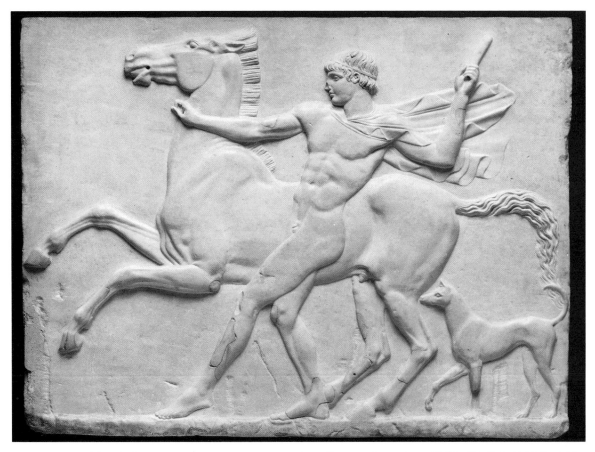

161 ABOVE Marble relief showing a youth restraining a horse. Although the style recalls such Classical Greek works as the Parthenon frieze, the relief was made in the early second century AD, very probably for the adornment of Hadrian's villa at Tivoli, where it was found. Formerly in the Townley collection. Ht 75 cm.

162 RIGHT The Townley greyhounds, a marble group found at Montecagnolo ('Dog Mountain') near Rome. Roman; probably second century AD. Ht 67 cm.

both as a uniquely well-documented instance of eighteenth-century taste and collecting opportunities, and as a remarkably representative cross-section of the types, styles and periods of Roman sculpture. Among Townley's many copies of Greek originals are his Discobolus; the 'Townley Venus'; another small-scale and rather finer naked Aphrodite, stooping to fasten her sandal; a figure of Cupid stringing a bow; and a fine herm, the hair and beard of which are thought to reflect the style of the Riace bronzes of the fifth century BC; one marble relief, finely carved in a style reminiscent of the Parthenon frieze with the figure of a boy restraining a rearing horse, was found at the site of the emperor Hadrian's villa at Tivoli, for which it was probably made. The Townley Collection also includes many fine portraits, including impressive busts of the emperors Trajan and Hadrian. A pair of seated dogs of greyhound type, one chewing the ear of the other in a friendly manner, is both appealing in its subject-matter and finely executed. A number of pieces in the collection were perhaps acquired more for their curiosity value than for any aesthetic considerations: examples are two large marble feet (not a pair), an African boy-acrobat balancing rather improbably upside-down on the tail of a crocodile, and a seated boy biting a human arm, once identified as a cannibal but soon recognised as the remains of a group of two boys quarrelling over a game of knucklebones. The numerous images of Bacchus and his satyr followers may have inspired some of the more mystical interpretations of Roman art current in Townley's circle.

Townley's own favourite piece was the one he christened 'Clytie', a marble bust of a woman emerging from a calyx of leaves. The nymph Clytie was turned into a flower while pining for the love of the sun-god, Helios. The identification is not generally accepted by modern scholars, although the name has stuck. 'Clytie' is certainly a most attractive figure, with her Classically featured face cast down, her finely carved hair flowing in curling ringlets over her neck and shoulders, and her transparent drapery slipping off her breast. Some critics have condemned her as an eighteenth-century invention, but the current consensus is that while she may have been reworked in that period, she is basically ancient and may well be a portrait of a member of the Julio-Claudian imperial family, possibly Antonia, daughter of Mark Antony and mother of the emperor Claudius.

Marble cinerary urns and elaborately carved sarcophagi (coffins) were also included in Townley's collection. These survive in large numbers throughout the Roman Empire, reflecting the stress laid by traditional Roman morality on the importance of the family; the dead had to be treated with almost as much respect as the living. Until the second century AD cremation was the normal practice, with the ashes placed in urns or chests that were then set in niches in family tombs. These tombs could be extremely large monuments, lavishly embellished with sculpture; many still survive on the outskirts of ancient Roman cities. The ash-chests themselves were often very finely decorated; sometimes they took the form of miniature shrines, complete

163 This fine marble bust of a woman, christened 'Clytie' by Townley and his friends, is thought by some to represent a member of the Julio-Claudian imperial family, perhaps Antonia, daughter of Mark Antony and mother of the emperor Claudius. An alternative theory represents her as one of the peoples conquered by Augustus. About AD 30. Ht 68.5 cm.

with gabled roofs and architectural ornament. One ornate marble chest ¹⁶⁴ dated to the early years of the second century AD bears an inscription recording that it was dedicated by Marcus Iunius Hamillus, a former slave, to his own spirit and that of his 'dearest wife' Iunia Pieris; in the pediment, which is supported by columns entwined with vines, a mother bird feeds her young, perhaps a sentimental allusion to the matronly duties of the deceased, while below the inscription two griffins flank a roundel containing a portrait of a woman, presumably Iunia Pieris herself. The sculptural emphasis on Iunia Pieris combines with the form of the dedication to suggest that she died first, with her husband's ashes added to the chest at a later date.

The inscription on this chest is finely cut, like much Roman lettering.

164 Marble cinerary urn of Marcus Iunius Hamillus and his wife Iunia Pieris. First or early second century AD; formerly in the Townley collection. Ht 42 cm.

This was an art at which the Romans excelled; beautiful inscriptions, some from funerary monuments, others recording imperial edicts or visits, benefactions, restorations of buildings or dedications, survive from throughout the Empire.

In the course of the second century AD, marble sarcophagi, decorated in a variety of styles, became the fashionable means of burial for well-to-do Romans in Italy, Greece and Asia Minor, and by the third century the custom had become widespread for people of most social classes in most areas of the Empire. The marble quarries of Carrara (in Tuscany) were exploited to provide many of the sarcophagi required in Rome in the second century AD, and the island of Thasos supplied the city in the third century AD. Otherwise, most sarcophagi originated in one of three marble quarries in the eastern provinces of the Empire: Mount Pentelicus near Athens, the island of Proconnesus in the Sea of Marmara, and Docimeum in Phrygia (west central Turkey). Some sarcophagi were carved at or near the quarries, while others were simply roughly hollowed out (to save unnecessary weight) and then shipped to Rome or elsewhere to be finished. Characteristic of the Docimeum quarries were large and very ornate sarcophagi decorated with figures set between projecting columns. Versions of these were also made in Rome from imported marble; on one example, suitable perhaps for a

165 The nine Muses are arranged in a decorative arcade on this relief, one side of a large sarcophagus. Made in Rome from imported Proconnesian marble about AD 250–300; formerly in the Townley collection.
Ht 72.5 cm.

poet, a series of Muses holding different attributes stand between 165 columns decorated with dramatic masks.

Many of the most striking sarcophagi of the second and third century AD were carved in high relief along the front with scenes from Greek mythology; the battles between the Greeks and Amazons or Centaurs were popular, as were the deeds of Herakles, episodes from the story of Troy or the legend of Meleager and the Calydonian boar. Especially in the case of those sarcophagi carved at Rome, one of the mythological characters might be given a head that is clearly intended as a portrait of the dead person; at other times the portrait might be set in a separate medallion. The mythological subjects do not always seem particularly appropriate for the tomb; their chief function was probably to display the taste and erudition of the deceased person and his family. Small sarcophagi were made for children, and many bear poignant inscriptions expressing the grief of the parents and recording the child's age in years, months and days. Some children's sarcophagi were decorated with appropriate scenes such as small figures of Cupids mimicking the rites of the wine-god Dionysos, or children fishing or playing various games with nuts.

12

THE ROMAN WORLD:
THE DECORATIVE AND
MINOR ARTS

Far more is known about the private lives of the Romans than those of the Greeks. Both civilisations have left written accounts of various aspects of daily life, and the ground-plans and some architectural details of Greek houses of various periods can be traced at such sites as Delos, Olynthos or Priene. When it comes to the materials used, however, and the decoration of walls, floors and ceilings, these Greek sites can scarcely be compared with the evidence provided by the town houses and country villas overwhelmed in the great eruption of Mount Vesuvius in AD 79. Preserved for centuries under layers of solidified pumice, ash, and mud, the houses of Pompeii and Hercula-neum, along with great villas such as that at Oplontis, have added depth and colour to our understanding of the way people lived in the early Empire; more recently this information has been extended by the excavation of well-preserved houses both at Ephesus and at various Roman sites in north Africa. Houses such as these can form a back-ground against which to set the mass of small and apparently mis-cellaneous objects that survive from all over the Roman world, and in this way some progress can be made towards reconstructing the ma-terial lives of at least the wealthier citizens of the Empire.

The houses of wealthy Romans were rarely used simply as comfort-able private homes. Providing accommodation for the family was obviously one of their functions, but houses were also places in which large numbers of clients were entertained, and business in general was conducted; because of this public aspect of their usage, the construc-tion, furnishing and decoration of Roman houses might all be vehicles for the assertion of the family's wealth and status. Furniture appears to have been fairly sparse and does not survive in large quantities. Its appearance must be reconstructed from the evidence of paintings and from the occasional survival of such items as stone table-legs, some-times modelled in the form of lion's heads that taper into lion's paws,

or the more numerous scroll-shaped couch-ends with fine horse-head terminals, generally made of bronze but occasionally either cast entirely in silver or decorated with panels of silver and ivory inlay. Considerable use was also made of brightly coloured and richly patterned textiles for curtains, cushions or coverings for couches; some portions of these do survive, especially from Roman Egypt, but the rich effect they promoted may more readily be glimpsed in contemporary paintings of interiors.

After dark, the Roman house was lit by means of oil-lamps, sometimes set on or suspended from tall lamp-stands. A few gold and silver lamps are known; one silver lamp found in Switzerland is shaped like a boat on which sits the infant Hercules, strangling his two snakes. Bronze lamps do survive in large quantities, although many thousands ¹⁶⁶ must have been melted down for re-use in antiquity and later; they were made in a variety of shapes, including human heads, animals, birds or dolphins (at times ridden by figures of Eros). The vast majority of the Roman lamps that survive today are made of terracotta; at various times they were manufactured in several different centres of the Empire and shipped in large numbers from one area to another. The earliest were made on the wheel, but from the first century BC onwards most were produced from moulds. At first the finest examples were Italian, but from the second and third centuries AD well-modelled and distinctively shaped lamps were made elsewhere, too. One distinctive Italian type, introduced by the innovative lamp-makers of the

166 Bronze lamp in the form of the head of a hound with a hare in its mouth. Roman, first century AD; from Nocera. Ht 7 cm.

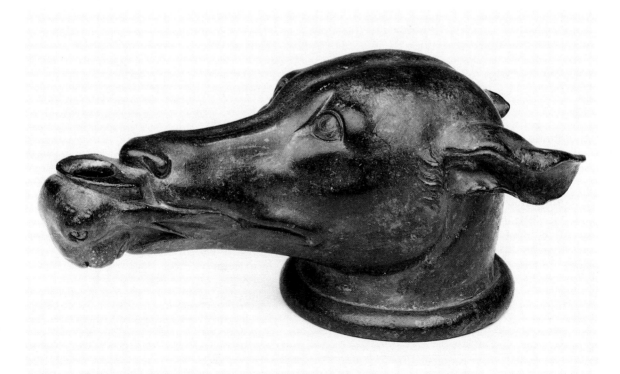

early Empire, is the volute-lamp, distinguished by two prominent curling volutes framing the nozzle in which floated the wick. Athens and Corinth produced some of the finest of all terracotta lamps in the late second and third centuries AD, often decorated with beautifully modelled scenes in high relief. An enormous variety of designs appear on lamps of all types: they include vignettes of rural life, incidents from Greek mythology, animals, gladiatorial combats, erotic encounters or representations of gods and goddesses.

Considerable attention was lavished on the appearance of the walls, floors, and ceilings of the Roman house; these might be decorated with paintings, mosaics and stucco, or occasionally with decorative terracotta panels. Both wall-painting and mosaics derived from the Greek world, but survive in quantity only from the Roman period. Many of the best-preserved paintings have been found in or near Pompeii and Herculaneum. They were executed in the fresco technique, with the colours applied when the carefully prepared lime-and-marble plaster of the walls was still damp; sometimes details might be added later when the surface was dry, in which case a binding agent was used to prevent the colours peeling off. Several distinct styles and a wide range of subjects have been identified; at some periods there was a preference for complex architectural vistas, while at others naturalistic garden scenes or imaginary landscapes, still-life paintings of glass bowls of fruit or flowers, theatrical scenes or episodes from Greek mythology were favoured.

[167] Two small wall-paintings in the British Museum were recovered from one villa near Pompeii in the mid-nineteenth century; they were perhaps originally part of a larger series of scenes representing well-known incidents of Greek myth. One shows Odysseus sailing past the island of the Sirens, where whitened skeletons of former victims lie among the rocks; on the other, Icarus plummets towards the sea after flying too near the sun on the wax-joined wings made for him by his father Daedalus. The paintings share a horizon set at the top of the panel, a feature which allows the artist to include more landscape elements than would otherwise have been possible. The mythical subjects of the scenes are, in fact, totally subordinated to the landscapes in which they appear; the seas, the towering cliffs, the trees and buildings, the people going about their daily lives or the adventurous goats clambering about the rocks are in each case far more absorbing than the principal actors in the drama. The colours used in the two paintings are very much the same, a dark grey-blue for the sea and a rusty-red for the figures, with the cliffs and buildings rendered in a range of greys, whites and yellows. The technique of the paintings is extremely sketchy and impressionistic, and their success lies in the evocation of remote and fantastic worlds rather than in the precise delineation of detail.

Fragments of painting also survive from the Golden House of Nero in Rome, a vast imperial palace constructed at great speed in the years immediately following the great fire of AD 64. The fragments now in

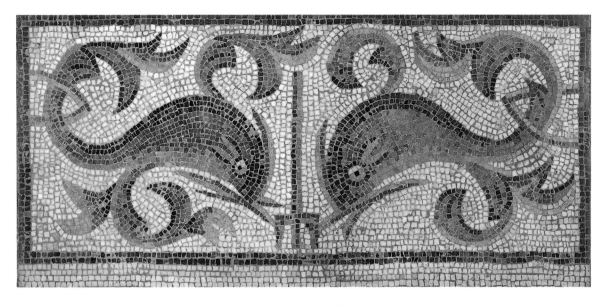

168 Detail from the border of a large mosaic found at Carthage; the two dolphins are separated by a trident, attribute of the sea-god Neptune. Fourth century AD. Ht 50 cm.

flowing around his head like waves while the curls of his moustache branch out in seaweed fronds. Another very large but now fragmentary mosaic from Carthage is interesting for the elaborate way in which it was organised into main and subsidiary panels and borders. The central panel portrayed the four seasons, but especially attractive are parts of the border designs, including two narrow vertical panels, each bearing an acanthus-like pot-plant, framing the left- and right-hand margins of the central scene. A pair of plunging dolphins from a 168 frieze at the lower edge is particularly well preserved; they are executed in a beautiful range of colours, shading from light khaki on the underbelly up through pale green and turquoise to a dark blue stripe on the back, with their fins highlighted in pink and red. A vivid impression of movement is conveyed by the way the tesserae are laid in lines that follow the curving outlines of each dolphin's arching back.

Much of the best-preserved stucco decoration survives, not surprisingly, *in situ*, but the British Museum does possess a series of stucco panels that originally decorated ornamental niches or the ceilings of various tombs at Pozzuoli on the Bay of Naples. Some stucco decoration is believed to copy famous works of art: the panel showing Perseus, Andromeda and the sea-monster, for example, may be copied from a well-known painting. Other panels in the series bear conventional decorative motifs, including Erotes and sea-monsters.

Terracotta was used for the decoration of both public and private Roman buildings; terracotta water-spouts in the form of animal heads are frequently found, as are the antefixes, decorated with designs in relief, which could be used as a decorative border at the lower edge of roof tiles. One antefix in the British Museum shows Victory standing on a globe and brandishing a trophy, flanked by two figures of Capricorn, the sign of the zodiac associated with the emperor Augustus; the motif most probably commemorates Augustus's victory at Actium,

and the piece is an interesting example of the typically Roman habit of applying imperial motifs to the most mundane of objects. Like almost all terracotta artefacts, such antefixes were mould-made and mass-produced, and identical or very similar examples have been found at both Rome and Ostia. Both interior and exterior walls could be decor-ated with the terracotta plaques known as Campana reliefs, named after the nineteenth-century Marchese Campana, who owned an extensive collection of them. These were a cheaper alternative to mar-ble reliefs and were produced in large numbers in the first centuries BC and AD. They are decorated, sometimes very finely, with a range of subjects taken from Greek mythology, religious ritual and important public events, such as games or other spectacles; many of them are exe-cuted in a style reminiscent of Classical Greek art.

The table set for a dinner-party in a wealthy Roman household at any period from the first century BC onwards would have presented an elegant and sumptuous appearance, with a selection of plates, bowls, cups and jugs made from gold, silver or bronze, pottery or glass. Very few gold vessels have survived: a gold jar found in the sea off Cnidus in Asia Minor is a very rare survivor. Silver plate too now exists only in limited quantities, but literary sources, combined with the archaeolog-ical evidence of such sites as Pompeii, suggest that a great many wealthy families from the period of the late Republic onwards would have possessed a set of silver vessels for dining. Plate was regularly

169 Terracotta relief plaque ('Campana plaque') bearing a scene from the Roman circus: a racing chariot rounds the turning posts, at the foot of which crouches a fallen charioteer; the *jubilator* (a horseman who rode in front to encourage the contestants) has already turned. About AD 60–100. Ht 30.5 cm.

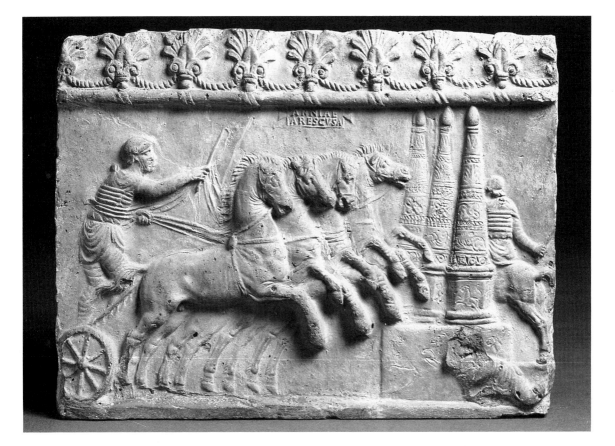

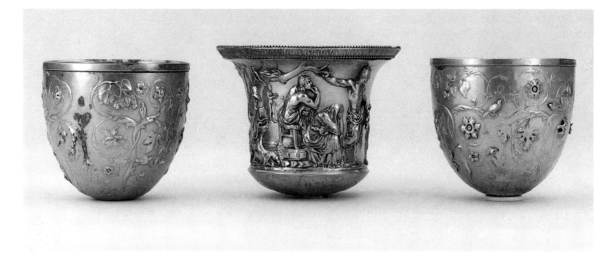

170 ABOVE Three silver cups, two with floral decoration and the third bearing a scene which may derive from a lost Sophoclean tragedy. Late first century BC or early first century AD. Ht (of central cup) 10 cm.

172 OPPOSITE BELOW Bronze mask of the wine-god Bacchus, the handle-ornament of a bronze pail. Roman, first century AD, perhaps deriving from a Hellenistic original. The mask was formerly in the collections of Dr Richard Mead (1673–1754) and Sir Paul Methuen (1672–1757). Ht 21.4 cm.

bestowed on important officials by the emperors to mark their succession or significant anniversaries; it has also been found outside the Roman Empire, suggesting that its exchange might have played a role in trade and diplomatic contacts.

Three fine drinking-cups are among the few examples of silver vessels to have survived from the late first century BC. Two of them form a pair, richly ornamented with delicate floral scrolls enlivened with occasional birds and insects; the simultaneously disciplined and realistic vegetation recalls that of the floral borders of the monumental 'Altar of Peace' erected by Augustus (the *Ara Pacis*). The third cup is decorated with a figured scene representing Iphigeneia, Orestes and Pylades on the island of Sminthe, where they have taken refuge after stealing a statue of Artemis from Thoas, king of the Tauri, who is about to be killed by Chryses, the priest of Apollo on Sminthe. The scenes may illustrate *Chryses*, a lost play by Sophocles; quite apart from the beauty of their execution, they are of considerable importance as a reminder of the degree of contemporary interest in and familiarity with Greek culture. 170

Most Roman silver plate has been found in hoards, buried for safe-keeping at times of political crisis in the third and fourth centuries AD. More than fifty hoards are known from Roman Gaul, for example, most of them buried after about AD 260, when Gaul was threatened from outside by barbarian invaders and internally disrupted by imperial usurpers. One of the largest and most spectacular of these late-third-century Gallic hoards is the Chaourse Treasure, named after the village near Montcornet in north-eastern France where it was discovered in 1883. The treasure may very well represent the complete silver service of a well-to-do family. Both for the sheer quantity of silver it contains and for the superlative quality of many of the pieces, it is an extremely impressive collection. The hoard comprises some thirty-nine objects, all silver apart from five small plates and a mirror of silvered bronze. There are enormous serving plates, some with contrast- 171

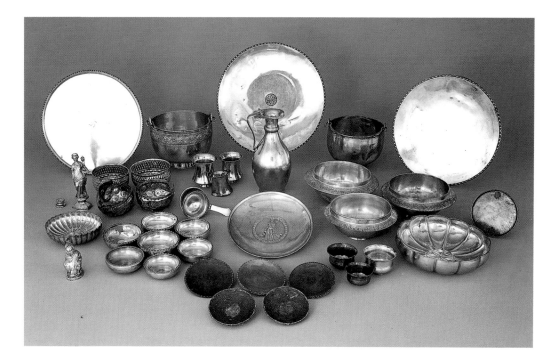

ing niello (silver sulphide) decoration including one with a central roundel containing the figure of Mercury; there are jugs, and cups fitted with elegant projecting collars finely decorated with scrolling designs of leaves and heads; there are plain and decorated cups and bowls including one for washing the hands; a fluted bowl; a statuette of Fortuna; a pail decorated with a magnificent acanthus-scroll frieze between heavy beaded borders; an ingeniously designed and beautifully made combination funnel and strainer; and a pepper-pot in the shape of a squatting black slave-boy. The Chaourse Treasure is unusual in containing silver drinking-cups; at this period glass was the preferred material for drinking vessels, for it was recognised that glass imparted no taste to the contents. Some of the decorated Chaourse cups do in fact appear to imitate the shapes and patterns of glass cups.

Bronze jugs, pails and bowls of various shapes were also popular. The handle ornament of one large bronze pail, perhaps used for mixing
172 wine, takes the form of a beautifully worked mask of the wine-god, Bacchus. The god's curling hair and beard are meticulously worked, and details of his features and head-band are inlaid with silver, copper and iron.

Glass vessels, produced in a variety of ways, were extremely popular throughout the Roman world. During the late Republic and early Empire, the production of high-quality decorative glass spread from Syria, which remained an important production centre, to Italy and the Rhineland, while plain wares were made in numerous local centres. Glass-blowing, which was the quickest and so the cheapest method of production, was perfected in the first century BC, and gradually came to supersede the old method of casting, which had originated in the Hellenistic period. Up until the second century AD, however, a range of cast-glass vessels continued to be produced, mostly drinking-cups

171 ABOVE The Chaourse Treasure, perhaps the complete silver service of a wealthy Roman family, who buried it for safe-keeping at a time of crisis about AD 260 and never returned to reclaim it. D (of the Mercury plate) 23.4 cm.

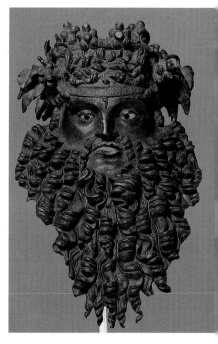

or bowls. At first they were made in polychrome or brightly coloured opaque or translucent glass, but from the mid-first century AD onwards colourless glass was preferred: in the later first century the Elder Pliny wrote that 'the most highly valued glass is colourless and transparent, resembling rock-crystal as closely as possible'.

The technique of blowing glass into a mould, invented in the early first century AD, produced an effect not unlike that of casting; the best mould-blown vessels were produced in Syria, where some makers such as Ennion left their signatures on their wares. Drinking-cups, small jugs and amphoras were produced in this way, their decoration often appearing to imitate their more expensive metal counterparts. In this respect free-blown vessels differ from both cast and mould-blown specimens, for in both shape and decoration their makers were not constrained to imitate other materials but free to exploit the natural properties and advantages of the medium. Most of the glass in daily use was plain and undecorated, though often carefully and attractively shaped and coloured. More expensive products could be decorated in various ways; applied blobs and trails of glass in contrasting colours were popular and relatively simple to produce, while cutting patterns or even entire figured scenes into the surface of the glass with a cutting wheel was a more delicate and skilful operation. The vessels with the most spectacular wheel-cut decoration are the fourth-century cage-cups, which were made by cutting away a thick-walled blank, often made from two contrastingly coloured layers of glass, until an almost free-standing network of interlocking rings was left, attached to the body of the vessel only by a series of fine bridges; some cage-cups substituted figure scenes for the usual cage effect.

The Portland Vase, named after the Dukes of Portland who owned it 173 from 1785 to 1945, was produced by a similar technique at a much earlier date, in the Augustan period. It is made up of an inner layer of dark blue glass cased in an outer layer of opaque white glass; the white surface is partially cut away, in the technique used for cameos, to produce white figures set against a dark blue background. The lower part of the vase is missing; originally it may have ended in a base-knob, like a larger contemporary cameo-glass vessel, the 'Blue Vase' from Pompeii. Few cameo-glass vessels survive, presumably because they were extremely difficult to make. The cameo-cutting process was fraught with possibilities for disaster, and even the production of the original white-encased blue blank was a complex process. To obtain such a blank, it is believed that a mass of hot blue glass, gathered together on a rod, was dipped into a crucible of molten white glass, and the two layers were then blown together into the required shape. The handles would have been added separately. Interpretations of the subject-matter of the scenes on the Portland Vase are legion. Currently there are two principle theories: one is that the scenes refer to the marriage of Peleus and Thetis, and the other that they allude to the union of Atia, the mother of Augustus, and the god Apollo. Whoever they may represent, the figures are beautifully designed and cut, with shading,

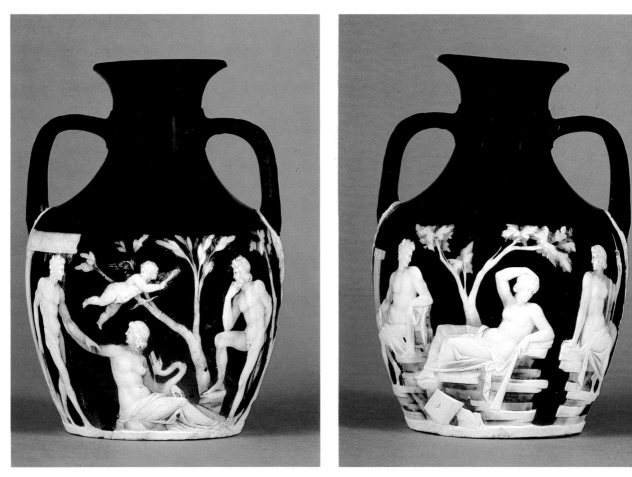

depth and the effects of drapery all represented with the utmost skill by subtle variations in the thickness of the layer of white glass; as finely rendered as the figures are the ruins they lounge upon or around, the building one character steps out from, and the spreading trees above.

Alongside the silver and glass on the rich man's table would be examples of fine pottery. The best-known Roman pottery types are the mould-made red-gloss wares known collectively as 'terra sigillata' ('stamped clay'). Their development was perhaps influenced partly by the moulded 'Megarian bowls' produced in various cities and regions of the Greek world, including Athens, Corinth, the islands and the coast of Asia Minor from the mid-third to the first century BC, and partly by the glossy black wares current in Campania at much the same time. The earliest red wares were made in Pergamon from the mid-second century BC. Their manufacture in the western part of the Empire started in the town of Arretium (Arezzo) in Etruria in the mid-first century BC. The earliest Arretine plates and bowls were undecorated; the more typical relief-moulded decorated bowls seem to start around 30 BC. Some of the shapes of the vessels, such as the mixing-bowls (*kraters*), and many of the designs they bear, which include

173 The Portland Vase is the most spectacular cameo glass vessel to have survived. The iconography of the scenes it bears has taxed the ingenuity of scores of scholars; in general terms, the appearance and activities of the characters suggest themes of love and loss. Made in the late first century BC or the early first century AD. Ht 24.5 cm.

174 A group of Roman samian vessels made in northern Italy and southern Gaul in the first or early second century AD. Ht (of the large bowl at the back) 13.7 cm.

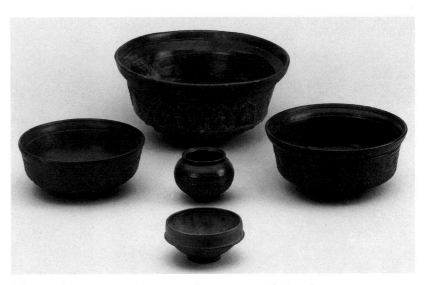

Muses, dancers, erotic scenes, banquets and vine harvests, are very Greek in inspiration; more purely Roman are the decorative borders of naturalistic leaves, flowers and tendrils. One bowl is decorated with figures of the seasons, each equipped with characteristic attributes; inside the bowl is the stamp of the potter Cn.Ateius, who seems to have left Arezzo to set up workshops in Pisa and as far north as Lyons, from where he was able to supply the large military markets of Gaul and the Rhineland. Soon, however, these workshops were in competition with major new south Gaulish potteries, most notably at La Graufesenque, which were producing their own versions of red-gloss wares (sometimes known as 'samian' ware), and by the end of the first 174 century AD production had ceased altogether at Arezzo. The new Gaulish wares were less artistically refined than the original Arretine, but commercially they were an enormous success, reaching every corner of the Empire. From the early second century, central and east Gaulish wares took the place of south Gaulish in the northern prov-

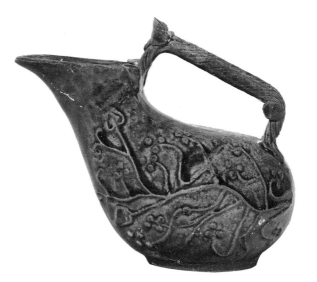

175 Green-glazed *askos* (oil-flask), decorated with a relief design of olive twigs and fruits. Roman; first century AD. Ht 11.5 cm.

[206]

inces; by the late second century, the Mediterranean basin was largely supplied with pottery from north African workshops. African Red Slip Ware, made in Tunisia, was the finest and most important fabric; it was produced in a wide range of shapes, often without decoration but occasionally enlivened with moulded or appliqué human or animal figures, or stylised plant motifs.

In addition to the red wares, various types of colour-coated and painted pottery were produced, including the brown and black colour-coated beakers decorated in the barbotine technique by laying trails of slip over the finished surface of the pot. Attractive green, yellow or
175 brown lead-glazed vessels were also produced in several centres and at various periods, usually small cups and bowls moulded with relief decoration in the form of leaves and flowers.

Figurines in silver, bronze and terracotta have been found in large quantities throughout the Roman Empire. Many represent gods and goddesses, either the Olympian deities whom the Romans had taken over in modified form from the Greeks, or local divinities, who were sometimes partially assimilated with the Olympians. Many of the figurines may have been produced for dedication in sanctuaries; others are thought to have occupied the domestic shrines, Lararia, which would have been present in many households.

The silver statuettes from the Mâcon hoard may have originated in either a public or a domestic shrine in southern Gaul in the later third century AD. The hoard was discovered in 1764, and early accounts refer to some thirty thousand gold and silver coins, jewellery, five pieces of plate and an unspecified number of statuettes; today, apart from eight statuettes, only one large plate can be attributed to the hoard. Four of the eight statuettes represent the god Mercury, whose worship was widespread in Gaul; another shows Luna, the moon-goddess, who was also very popular there. Two other statuettes are of Jupiter, whose worship was officially encouraged throughout the Empire, and of a Genius, a local protective deity. The most striking
176 figure has been identified as that of a pantheistic Tutela: she appears to be a local Gallic deity, who combines the attributes of a goddess protecting a particular city with those of the more widely venerated pantheistic goddess Isis-Fortuna. She is shown as a winged figure, standing by an altar holding an offering dish in her right hand; her role as city-goddess is indicated by the crown she wears, which takes the form of a miniature city-wall with seven towers and three gates. The pantheistic aspects of her character are indicated by the numerous busts of gods and goddesses that she carries; Apollo and Diana spring from the double cornucopia in her left hand, the Dioscuri are set halfway up her wings, while on a bar fastened between her wing-tips are placed images of the gods of the days of the week: Saturn, Sol (the sun), Luna, Mars, Mercury, Jupiter and Venus.

Bronze statuettes were made in a wide range of styles and sizes. Occasionally they too appear to form sets, as is the case with a group found at Paramythia in Epirus (northern Greece); these large and finely

176 Silver figurine from the Mâcon Hoard, representing the pantheistic goddess Tutela, a protective deity popular in southern France and elsewhere. The small heads set on the yoke above her head represent the days of the week. Roman; about AD 260. Ht 14 cm.

177 Terracotta figurines from the Roman provinces. The smaller white pipe-clay representations of the goddess Fortuna and a bird were made in Gaul in the second century AD, while the larger figurine of the goddess Isis and the model of the sacred couch of Isis, decorated with figures of Greek and Egyptian gods, were made in Egypt, the figurine in the first century BC or AD, the couch in the first or second century AD. Ht (of the couch) 10.3 cm.

178 OPPOSITE A group of Roman jewellery produced in various parts of the Empire at different periods: a pair of gold earrings with pendants in the form of miniature clubs of Hercules, second century AD, from Antaradus, Syria; a gold double finger-ring with a cornelian setting, fourth century AD, from Marathus, Amrit; a silver finger-ring with snake's-head terminals, the eyes made from pellets of gold, first century AD; a gold hair-ornament, thickly encrusted with pearls and precious stones (some now missing), second or third century AD, from Tunis, north Africa; a brooch in the form of a bronze dog with spots of coloured enamel, made in the north-west provinces of the Empire, about AD 50–150; a gold pendant with a gold aureus of the emperor Gallienus (AD 253–68), minted at Rome in AD 260–61; a necklace made up of emeralds threaded on gold rods, interlinked with gold quatrefoils, second or third century AD. L (of hair-ornament) 10.8 cm.

made figures are thought to be Roman copies of larger-scale Greek originals of various dates, and may represent the contents of a single Lararium. Like their bronze and silver counterparts, most terracotta figurines were produced for dedication in shrines and sanctuaries, although it seems likely that some were made as toys or even souvenirs. At most periods there were strong stylistic distinctions between terracottas produced in different parts of the Empire. In some of the Greek cities of Asia Minor, notably Smyrna and Myrina, there is no very obvious stylistic distinction to be made between the products of the Hellenistic period and those of the first centuries BC and AD, which continued in much the same tradition. Very different are the figurines of Roman Egypt, produced in the rather coarse, dark brown Egyptian clay; here an enormous variety of types was produced, ranging from conventional classical gods and goddesses to Egyptian deities including Isis, Sarapis and Harpocrates, fertility figures, model shrines and animals of all description. In areas of the Empire such as Gaul, where there was no established tradition of manufacturing terracotta figurines, workshops for extremely large-scale production were set up between about AD 100 and 150. Most Gaulish figurines were made from white iron-free clay (sometimes known as pipe-clay) in a range of subjects and styles; curvaceous figures of Venus were popular, as were horses, cocks and doves, along with local Celtic gods and goddesses.

There was, therefore, no shortage of luxury items available for those Romans wishing to display their wealth and taste. They might also spend money on their personal appearance, principally on gold and silver jewellery. In the Republic, the wearing of jewellery had been limited to certain classes of people; there had also been strict regulations concerning both the amount of jewellery a woman might wear on any one occasion, and the amount that might be buried with the dead. In the Empire, these restrictions were lifted, and wearing jewellery became a fashionable way of displaying wealth. At most periods men would generally wear no more than one finger-ring; this might incor-

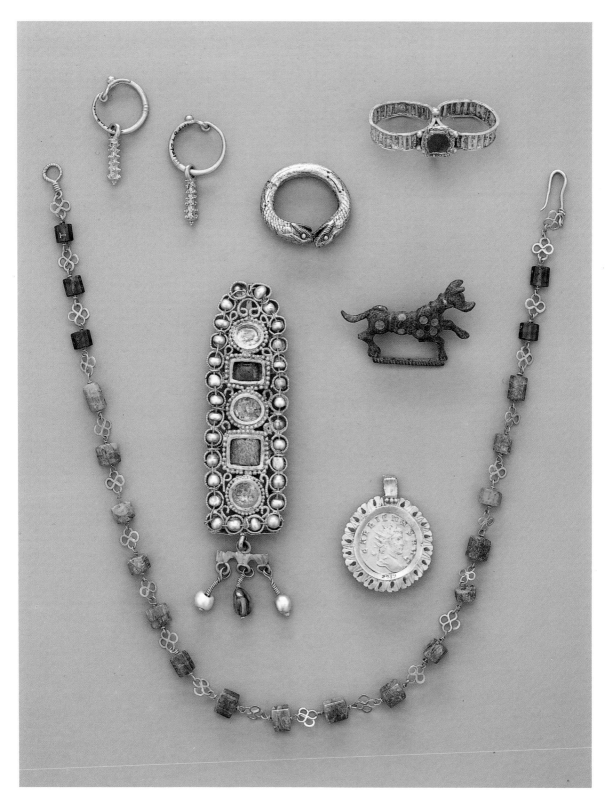

179 Five Roman gems illustrating fashions in women's dress and hairstyle from the early Empire to the later second century AD. (*top left*) Sard intaglio; the head may be that of Augustus's sister Octavia or a contemporary in the period of about 30–10 BC. (*centre*) Sardonyx cameo; the head recalls that of Nero's mother Agrippina; about AD 38. (*top right*) Onyx cameo bust of a woman wearing the *stola*, an over-tunic worn by Roman matrons of high status; about AD 90. (*lower left*) Sardonyx cameo; the woman's hairstyle belongs to the Hadrianic period, about AD 120–40. (*lower right*) A woman with the crimped and curled hairstyle popular in the Antonine period, about AD 160–70. Ht (of the last) 2 cm.

porate a seal, cut either in gold, or in a semi-precious stone. Women, on the other hand, could – and did – adorn themselves with a wide variety of rings, necklaces, earrings, bracelets and hair-ornaments. Lollia [179] Paulina, for example, wife of the Emperor Caligula, is reported by the Elder Pliny to have appeared 'at an ordinary betrothal banquet, covered with emeralds and pearls interlaced alternately and shining all over her head, hair, ears, neck, arms and fingers, the sum total amounting to the value of 40,000,000 sestertii'; to put this sum in perspective, the pay of one of Caligula's soldiers would have been around 900 sestertii per year.

The principal centres for the production of jewellery were the old Hellenistic capitals of Alexandria and Antioch, and Rome; few techniques that had not already been current in the Hellenistic era were developed. One stylistic innovation of the second century AD was the practice of piercing gold to produce an attractive fretwork effect, known as *opus interrasile*; another was the fashion for setting gold coins or medallions of the reigning emperor or members of his family into rings, pendants or brooches. During most periods precious and

semi-precious stones were popular, especially in the northern parts of the Empire, so that Roman jewellery is often extremely colourful. An example of this is provided by a second- or third-century hair-ornament and matching bracelet found in Tunis. The hair-ornament is composed of a row of oval and rectangular bezel settings, some filled with emeralds, surrounded by a row of pearls; suspended below is a horizontal gold bar from which hang two pearls and a sapphire. The bracelet has a central medallion adorned with similar bezels, now empty; the strap is formed out of an interlocking openwork design in the form of ivy leaves set with pearls.

The Romans themselves appear to have felt that their own art could not match that of the Greeks whom they had conquered. So the Augustan poet Horace wrote that 'captive Greece led her proud conqueror captive', while Aeneas, the Trojan hero of Virgil's epic poem, the *Aeneid*, and one of the legendary founders of Rome, is told by his father Anchises:

> Others, for so I can well believe, will hammer forth more softly breathing likenesses of bronze, draw living faces from the marble, plead causes with more skill, plot with their instruments the movements of the sky, and predict the rising of the stars. But you, Roman, must remember that you have to guide the nations by your authority, for these shall be your arts, to graft tradition on to peace, to spare the conquered, and to crush the proud.

It is true that the military and political achievements of the Romans were of paramount importance, but recognition of their prowess in these fields should not detract from a proper appreciation of their artistic accomplishments. The Romans harnessed their native talents and ambitions to the Greek tradition that they had absorbed, and the monuments resulting from this fusion continue to provide inspiration for successive generations.

SUGGESTIONS FOR FURTHER READING

Current excavation and research are continually refining and modifying the picture of **Bronze Age Greece**, so that it is usually advisable to go first to fairly recent works such as P. Warren's *The Aegean Civilisations from Ancient Crete to Mycenae* (2nd edn, Oxford 1989); for a more detailed account, there is M.S.F. Hood's *The Arts in Prehistoric Greece* (London 1978). For the Cyclades, see J.L. Fitton, *Cycladic Art* (London 1989), with up-to-date bibliography.

The quantity of literature devoted to Greek art from the **Geometric to Hellenistic** periods is vast. The best introduction to the history, archaeology and art of the Geometric period is J.N. Coldstream's *Geometric Greece* (London 1977). The most comprehensive and thoughtful overview of the whole period is provided by C.M. Robertson in his *History of Greek Art* (Cambridge 1975); rather less daunting in size and more attractively illustrated is the same author's *A Shorter History of Greek Art* (Cambridge 1981). For students and teachers in particular, S. Woodford's *An Introduction to Greek Art* (London 1986) provides much helpful and accessible guidance. A useful survey of current trends in scholarship and detailed (English) bibliography covering the last ten years is B. Sparkes's *Greek Art*, no. 22 in the series *Greece and Rome: New Surveys in the Classics* (Oxford 1991).

After the general works, books on Greek art tend to focus either on a particular period or on one category of object. In the **Archaic and Classical** periods, where the material remains are at their richest, it is advisable to turn to some of the books that deal with smaller divisions of the subject. A pioneer in the provision of easily obtainable, relatively cheap, straightforwardly written and copiously illustrated handbooks in the fields of vase-painting and sculpture is J. Boardman: his *Athenian Black Figure Vases*, *Athenian Red Figure Vases: The Archaic Period*, *Athenian Red Figure Vases: The Classical Period*, *Greek Sculpture: The Archaic Period*, and *Greek Sculpture: The Classical Period* (London 1974, 1975, 1989, 1978 and 1985) may all be recommended both to students and to the general reader. D. Williams's *Greek Vases* (London 1985) offers a well-illustrated introduction to its subject. B.S. Ridgway's three volumes on Greek sculpture are also very lively and thought-provoking: *The Archaic Style in Greek Sculpture*, *The Severe Style in Greek Sculpture*, and *Fifth-Century Styles in Greek Sculpture* (Princeton 1977, 1970 and 1981).

The **Parthenon** is a subject in its own right; good brief introductions are B.F. Cook's *The Elgin Marbles* (London 1984) (especially informative on the history and acquisition) and S. Woodford's *The Parthenon* (Cambridge 1981) (very helpful on how to understand the structure of the building and arrangement of the sculpture). For fine illustrations and a

good overview of the sculpture, there is F. Brommer's *The Sculptures of the Parthenon* (London 1979).

Turning to other branches of Greek art, **terracotta figurines** from the Bronze Age to the Hellenistic period are covered in R.A. Higgins's *Greek Terracottas* (London 1967); the same author's definitive *Greek and Roman Jewellery* (2nd edn, London 1980) has not been superseded. Gems and finger-rings are beautifully illustrated and discussed by J. Boardman in *Greek Gems and Finger-Rings* (London 1970). For the types and development of **Greek coins**, see C.M. Kraay, *Archaic and Classical Greek Coins* (London 1976) and G.K. Jenkins, *Ancient Greek Coins* (London 1972); also I. Carradice and M.J. Price, *Coinage in the Greek World* (London 1988).

The **South Italian and Sicilian Greeks** are included in the general books, but for a more detailed introduction see A.G. Woodhead, *The Greeks in the West* (London 1962). A new series of well-researched, up-to-date and finely illustrated books on particular sites has recently started to appear; the first is J. Griffiths Pedley, *Paestum: Greeks and Romans in Southern Italy* (London 1990). For south Italian vase-painting the best starting point is A.D. Trendall's compact volume on *Red-Figure Vases of South Italy and Sicily* (London 1989).

The **Hellenistic** period has recently attracted much well-researched and generally readable scholarship, notably J. Onians's *Art and Thought in the Hellenistic Age: The Greek World View 350–50 BC* (London 1979) and J.J. Pollit's *Art in the Hellenistic Age* (Cambridge 1986).

The **Mausoleum** of Halicarnassos is discussed in most of the general art books, but the best short, scholarly and readable introduction to the subject is G.B. Waywell's in P. Clayton and M. Price (eds), *The Seven Wonders of the Ancient World* (London 1988). For an excellent account of the history, territory and sites of Lycia, the best starting point is G. Bean's *Lycian Turkey* (2nd edn, London 1989).

For **Cyprus**, V. Tatton-Brown's *Ancient Cyprus* (London 1987) offers a concise, thematically arranged introduction to the subject, while V. Karageorghis in his *Cyprus from the Stone Age to the Romans* (London 1982) pursues a more traditional chronological approach; both books are well illustrated and very informative, as is Sir D. Hunt (ed.), *Footprints in Cyprus* (rev. edn, London 1990). D. Morris's *The Art of Ancient Cyprus* (Oxford 1985) offers a rather uncanonical and idiosyncratic view of Cypriot culture, with numerous beautiful illustrations.

In the field of **Etruscan** studies, M. Pallottino's *The Etruscans* (English translation, London 1975) remains a classic, as does O.J. Brendel's *Etruscan Art* (Harmondsworth 1978). Written with elegance and authority, and finely illustrated, is E. Macnamara's *Etruscan Art* (London 1990). N. Spivey and S. Stoddart in their *Etruscan Italy* (London 1990) offer a new and stimulating approach to the whole question of the Etruscan civilisation.

For the **Romans**, J.M.C. Toynbee's *The Art of the Romans* (London 1965) and D. Strong's *Roman Art* (Harmondsworth 1976) remain essential reading. Among more recent works, M. Henig (ed.), *A Handbook of*

Roman Art (Oxford 1983) provides an excellent starting point; the chapters on various aspects of the subject from sculpture to glass, pots and jewellery are contributed by a range of distinguished scholars, who provide extensive bibliographies. A shorter, very readable and beautifully illustrated introduction is S. Walker's *Roman Art* (London 1991). Among recent monographs P. Zanker's (recently translated) fascinating and highly convincing account of the interweaving of art and politics in the early Empire, *The Power of Images in the Age of Augustus* (trans. A. Shapiro, Michigan 1988), is highly recommended. Roman coins are beautifully illustrated in J.P.C. Kent's *Roman Coins* (London 1978); for a discussion of their development, types and historical significance see A. Burnett, *Coinage in the Roman World* (London 1987).

The Greek World

BLACK SEA

SEA OF MARMARA

THRACE

MACEDON

LEMNOS

AEGEAN SEA

Troy

Pergamon

Myrina
Kyme
Smyrna
Cesme
Clazomenae

CHIOS

Satala

LYDIA

Ephesus
Priene
Miletus
Didyma

Halicarnassos
Theangela
Cnidus

CARIA

RHODES

Camirus

LYCIA

Zakro

DELOS
KEROS
NAXOS
PAROS
ANTIPAROS
SYROS

THERA

Akrotiri

Mallia
Knossos
Phaistos

CRETE

Phylakopi
MELOS

KYTHNOS

Chalkis
Eretria
Tanagra
Thebes

EUBOEA

Eleusis
Athens

BOEOTIA

Plataea

Delphi

SALAMIS
AEGINA

Corinth
Tiryns
Mycenae

Bassae
Sparta

ELIS

Olympia

Pylos

ZAKYNTHOS

IONIAN SEA

100 m
150 km

0

LYCIA

SYRIA

Al Mina

Orontes

PHOENICIA

Jordan

PHOENICIAN SEA

Enkomi
Tamassos
Salamis
Kition
Kourion
Amathus

CYPRUS

MEDITERRANEAN SEA

LYCIA

Pinara
Xanthos

LYCIAN SEA

Naukratis

EGYPT

Nile

150 m
250 km

0

[215]

Greeks and Etruscans in Italy and Sicily

- Villanova

Pisa
Arno

Arezzo
Volterra
Cortona
Populonia
Chiusi
Perugia
Vetulonia
Orvieto
Bolsena
Tiber

CORSICA

Vulci
Tarquinia
Cerveteri
Rome
Praeneste
Ostia

ADRIATIC SEA

APULIA

Capua
Canosa
CAMPANIA
Cumae
Herculaneum
Pithekoussai
Egnazia
Pompeii

SARDINIA

LUCANIA
Paestum
Metaponto
Taranto
Armentum

TYRRHENIAN SEA

Sybaris

Croton

Locri
Reggio

Selinous
SICILY
Agrigento
Gela
Syracuse

NORTH AFRICA

100 m

0 150 km

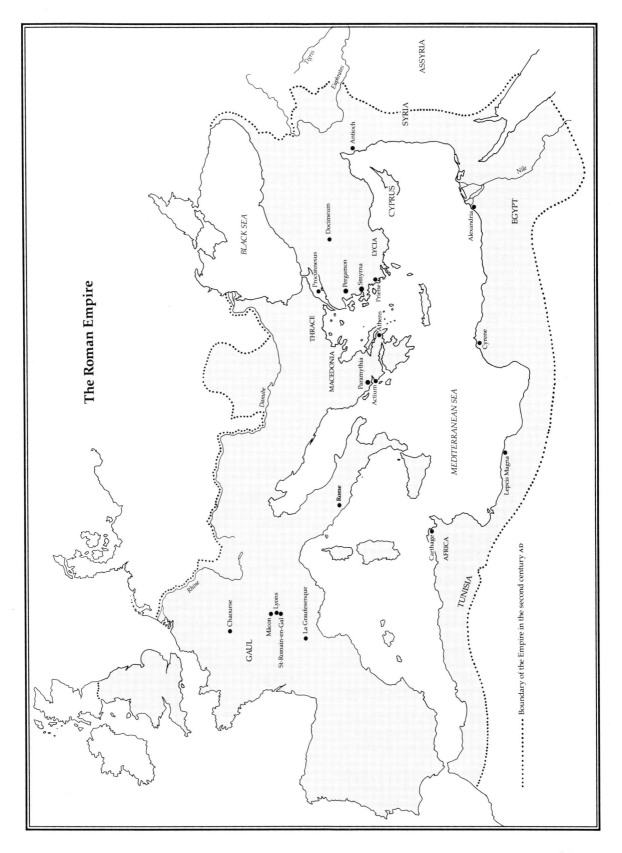

The Roman Empire

ASSYRIA

SYRIA

Tigris

Euphrates

Antioch

Nile

CYPRUS

BLACK SEA

EGYPT

Alexandria

Docimeum

LYCIA

Procomnesus

Pergamon

Smyrna

Priene

Cyrene

THRACE

Athens

MACEDONIA

Paramythia

Actium

MEDITERRANEAN SEA

Danube

Lepcis Magna

Rome

Carthage

AFRICA

Rhine

TUNISIA

Chaourse

Mâcon Lyons

St-Romain-en-Gal

La Graufesenque

GAUL

Boundary of the Empire in the second century AD

[217]

ILLUSTRATION REFERENCES

Illustrations have been provided by the British Museum Photographic Service except where noted otherwise.

Frontispiece: Vase D13
1 Vase A 301
2 GR 1890.1–10.5,1843.5–7.76, 1889.12–12.1, 1890.1–10.8
3 GR 1842.7–28.614
4 Sculpture A 17
5 Photograph L. Schofield
6 GR 1966.3–28.1
7 Gem 79
8 Jewellery 762, 763, 765
9 Vase C 16
10 GR 1963.7–5.1
11 Terracottas B 11, B 12
12 GR 1910.4–23.1
13 GR 1861.4–25.51
14 GR 1912.5–22.1
15 GR 1899.2–19.1
16 GR 1925.4–22.1, 1966.3–28.5
17 GR 1960.11–1.18, 19,46,47
18 GR 1864.10–7.676,671, 1004,562,604
19 GR 1873.8–20.385
20 GR 1860.2–1.1
21 GR 1936.10–17.1
22 GR 1860.2–1.30, 1889.4–18.1
23 GR 1923.2–12.1,58,8,83, 214,165,164
24 GR 1870.3–15.16
25/26 Bronze 3205, drawing by S. Bird
27 Jewellery 1128–30
28 Sculpture B 474
29 After the Society of Dilettanti's *Antiquities of Ionia* vol. i (London 1821)
30 Sculpture B 89
31 Sculpture B 285
32 GR 1864.10–7.358, 1861.4–25.46
33 GR 1888.6–1.456
34 GR 1860.4–4.1
35/36 GR 1971.11–1.1
37 Vase B 471
38 Vase B 210
39 Terracottas 774, 769, 783
40 Terracottas 1621, 1646, 1648, GR 1861.4–25.24, 27
41 GR 1954.10–18.1
42 CM PCG I A 9
43 CM BMC Athens 23; BMC Aegina 1; 1891.4–8.2 (PCG I B 18)
44 Gems 465, 489, 445
45 Sculpture B 475
46 GR 1958.4–18.1
47 Sculpture 1754

48 Sculpture 549
49 Photograph B.F. Cook
50 Parthenon S. Metope 27
51 Parthenon S. Metope 28
52 Parthenon S. Frieze 40
53 Parthenon E. Pediment KLM
54 Sculpture 424
55 Sculpture 409
56 Sculpture 541
57 Sculpture 628
58 Sculpture 1206
59 Sculpture 1300
60 Sculpture 1600
61 GR 1980.10–29.1
62/63 Vase E 3
64 Vase E 468
65 Vase E 697
66 Vases D 62, D 61, D 73
67 Vase D 5
68 GR 1871.7–22.8,11,13
69 Terracottas 804–808
70 Terracotta 616
71 Bronze 242
72 GR 1816.6–10.115, 1960.11–1.48
73 Bronze 289
74 Jewellery 1672–3
75 CM BMC Elis 73 (PCG III B 43); BMC Corinth 131; 1971.5–13.1; BMC Thebes 103; 1940.10–1.3
76 Gem 531
77 Photograph L. Burn
78 GR 1950.1–24.1,2
79 Vase F 157
80 Vase F 279
81 Vase F 284
82 Vase F 149
83 Vase F 189
84 Vase F 560
85 Terracotta D 161
86 GR 1988.2–1.1, 1988.3–8.1
87 GR 1904.7–3.1
88 Bronze 285
89 Bronze 491
90 Jewellery 2626–7
91 Jewellery 1952
92 Silver 1
93 CM BMC Poseidonia 5 (PCG I C 9); BMC Metaponto 11 (PCG I C 8); 1929.12–3.11
94 CM 1946.1–1.1410
95 CM 1946.1–1.817
96 Photograph L. Burn
97 Scharf drawing in Dept of Greek and Roman Antiquities, British Museum
98 Sculpture B 287

99 Sculpture 950
100 Sculpture 850 etc
101 Sculpture 910
102 Sculpture 869
103 Photograph I.D. Jenkins
104 Drawing by S. Bird, in collaboration with G. B. Waywell
105 Sculptures 1000–01
106 Sculpture 1075
107 Sculptures 1013–14
108 Photograph L. Burn
109 Inscription 399
110 CM BMC Alexander 3038a; PCG IV A 16
111 Bronze 1453
112 CM BMC Alexandria 23 (PCG IV A 20); BMC Alexandria 9; PCG V A 4; BMC Bactria 1 (PCG V A 20)
113 Gem 1184
114 Bronze 847
115 Bronze 268
116 Terracottas C 295, C 324, GR 1875.10–12.2
117 Terracotta C 536
118 Sculpture 2191
119 Vase K 77
120 GR 1926.7–13.2
121 GR 1871.5–18.2
122 Jewellery 1607
123 Photograph B. Kapadia
124 Bronzes 111, 107, 112
125 GR 1946.10–17.1
126 Vase C 252, GR 1925.11–1.1, Vase C 134
127 Vase C 974
128 GR 1929.2–11.2
129 GR 1929.10–14.1, Terracotta A 15
130 GR 1866.1–2.298, 9
131 Sculpture C 40
132 Sculpture C 154
133 GR 1897.4–1.872
134 GR 1897.4–1.996
135 Jewellery 1987
136 Photograph T. Rasmussen
137 Vases H 159, H 171, H 165, H 198
138 Terracotta D 219
139 Jewellery 1358–9
140 Jewellery 1376
141 Painting 5c–e
142 Bronze 542
143 Sculpture D 18
144 Vase G 151
145 Bronzes 651, 655, GR 1868.6–6.4
146 Bronze 640
147 Terracotta D 786

148 Bronze 444
149 GR 1912.12–20.5
150 Bronze 2857
151 Photograph H. Walda
152 GR 1911.9 – 1.1
153 Gem 3577
154 GR 1954.12–14.1
155 Sculpture 1893
156 CM PCR 914
157 CM BMC Augustus 599; BMC Augustus 489; BMC Nero 3; BMC Severus and Caracalla 271; BMC Vitellius 57; 1946.10–4.918
158 CM BMC Nero 132
159 CM BMC Augustus 653; BMC Nero 203; BMC Hadrian 1688; BMC Claudius 188; BMC Titus 190; BMC Trajan 854; 1970.9–9.83
160 Sculpture 1608
161 Sculpture 2206
162 Sculpture 2131
163 Sculpture 1874
164 Sculpture 2367
165 Sarcophagus 24
166 GR 1865.7–12.10
167 Paintings 28,27
168 Mosaic 29
169 Terracotta D 627
170 GR 1960.1–1.1,2,3
171 Silver 144–82
172 GR 1989.1–30.1
173 Gem 4036
174 Vases M 5, L 138, M 4, M 78, M 125
175 Vase K 25
176 Silver 33
177 GR 1936.9–3.3, 1986.10–6.3, 1931.4–15.105, 1904.2–4.410
178 GR 1917.6–1.2421,2422, 1983.6–4.1, Ring 1135, Jewellery 2866, 1904.6–2.3, Jewellery 2939, 2731
179 Gems 1975, 3593, 1987.7–28.1, Gems 3611, 2016

INDEX

References to illustration numbers are in bold; gods, heroes and events of mythology are only indexed where illustrated.

Aberdeen Head 72, **60**
Acheloos, River **44**
Achilles 38, **64**
Actium, battle of 143, 179
Aegina, coinage of **43b**
Aegina Treasure 16–17, **8**
Aemilius Paullus 143
Africa 132, 144, 163, 178, 181, 191, 195, 199, 207
African Head 132, **115**
Agrigento 91, 92, 111, **95**
Agrippina **157c**, **179b**
Akragas *see* Agrigento
Alashiya 146–7
Alexander the Great 72, 90, 127, 129, 141, 146, **110**, **111**
Alexander Mosaic 130
Alexandria 138–41, 210
Alkestis **58**
Alkmene **82**
Al Mina 30
Amazons 38, 56, 88, **107**
Amphitryon **82**
Andokides (potter) 75–6, **61**
Antimachos **112d**
Antioch 127, 136, 210
Antiochos III 143
Antonia 191
Antoninus Pius 187
Aphrodite 53, **65**, **71**, **73**
Apollo 45, 46, 64, **132**
Apotheosis of Homer 137–8, **118**
Apulian vase-painting 95–7, **80, 81**
Ara Pacis 202
Archaic Greek art 40–55
Archelaos of Priene (sculptor) 137
Ares **92**
Arethusa **94**
Armentum Rider 102–3, **87**
Arretine pottery 205–6
Arezzo 161, 205
Arsinoe II 140, **112b, 119**
Arsinoe III 138, **118**
Artemis **27** (*see also* Ephesus)
Artemis Orthia, sanctuary of 35–6, **23**
Artemisia 120, 123
Artemisium Zeus 58
ash chests 191–2
Athena **64, 92**
Athens 25, 29, 31, 42, 43, 46–50, 53, 56, 60–67, 69, 74–82, 83, 84, 89, 93, 112, 127, 133, 168, 181, 197, 205
Attalus III 143
Augustus 178–9, 181, 182–3, 184, **152, 153, 157a,b**

Aurelian 179

Bacchus **172**
Baltimore Painter **81**
Base Ring Ware 149–50, **126**
Bassae, Temple of Apollo at 68, **56**
Beazley, Sir John 48
Bellerophon **70**, **146**
Bent, James Theodore 9
Berlin Painter 76, 78, **64**
Bichrome Ware 152, **128**
bilingual vases 76, **62, 63**
Blacas cameo 183, **153**
black-figure vases
 Athenian 46–50, **37, 38, 61, 62**
 Corinthian 43–4, **32**
 Etruscan 169
black-glazed vases 82, **68**
Black-on-Red Ware 151, **127**
Boccanera plaques 166–7, **141**
Bodrum **103** (*see also* Mausoleum)
Boeotian *fibulae* 38, **26**
Boeotian terracottas 50, 82–4, 133–4, **39, 69, 116**
Boreas **43c**
Bryaxis (sculptor) 120, 125
Brygos Tomb at Capua 78
bucchero, Etruscan 163, 168, **137**
bull-leaping 14, **6**

Caligula 183, 210
cameo-glass 204–5, **173**
Camirus
 gold jewellery from 39, **27**
 ivory from **18**
Campana reliefs 201, **169**
Campania 93, 97, 159, 162, 169, 175, 177, 205
Campanian vase-painting 97
Canning, Sir Stratford 120
'Canopic' jars 165
Canosan vases 99–100
Capua 78, 177
Caracalla 186–7, **157d,f**
Carrara 193
Carrey, Jacques 62
Carthage 200
Cato the Elder 181
centaurs 36, **50, 51**
Cerveteri **136**
Çeşme 52
Chaourse Treasure 202–3, **171**
Chares 42
Charon **66**
Chatsworth Head 58, **46**

Cheiron **36**
Chimaira **70**
Chiot vases 45
Chiusi 161, 169
Chryses 202, **170**
Circus Maximus **159f**
Classical Greek art 56–90
Claudius 183
Clazomenian sarcophagi 45–6
Cleopatra 179, 181
Clytie 191, **163**
Cn. Ateius (potter) 206
Cnidus 72, 203
Cnidus, Demeter of 72, **59**
coins
 Archaic Greek 53–4, **42–3**
 Classical Greek 89–90, **75**
 Cypriot 158
 Etruscan 172
 Roman 186–9, **156, 157, 158, 159**
 Sicilian 109–11, **94, 95**
 south Italian 108–9, **93**
Colosseum 188, **159e**
Commodus 179, 187
Constantine 179, 184
Constantinople 179
Corinth 34–5, 43–4, 46, 50, 54, 86, 89, 92–3, 143, 162, 163, 165, 180, 197, 205
Corinthian vase-painting 43–4, **32**
Cortona 161
Croesus 43, 56
Cumae 91, 92, 177
 battle of 103, 169
Cycladic culture 8–12
 figurines 12, **4**
 marble vessels 10–11, **2, 3**
 pots 9, **1**
Cyprus 19, 58, 144–58

Dacians 185
Darius Painter **80**
Daunian(s) 174–5
 pottery 174–5, **149**
Deianeira **44**
Delian League and Treasury 60, 112
Delos 60, 195
Demarateion 110–11
Demaratus 162
Demeter of Cnidus 72, **59**
denarius 186–7
Didyma 42, **29**
Diocletian 179
Diomedes **79, 94**
Dionysos 36, **61, 75e, 92, 160**
Discobolos 59, 191
Docimeum 193
Dolon **79**

Dolon Painter 94, **79**
Domitian 184

Egypt 13, 21, 29, 40, 42, 51, 54, 82, 126, 127, 130, 138, 139, 140, 141, 143, 144, 146, 147, 154, 155, 158, 165, 178, 196, 208
Elgin, Lord 62, 66, 86
Elgin jewellery 29, **17**
Enkomi 147, 155
Enkomi hoard 148, **124**
Ennion (glass-blower) 204
Ephesus, Temple of Artemis at 69–72, 128, 189, 195, **30, 58, 159g**
Epiktetos (vase-painter) 76, **62, 63**
Erechtheion 67, **55**
Eros **65, 71, 73, 74, 117**
Etruscan language 159, 162
Etruscans 103, 159–77, 180
Eukleidas (die-engraver) 111, **94**
Euphorbos **34**
Evans, Sir Arthur 12
Exekias (vase-painter) 50, **38**
Èze 108

faience 51, 139–40, 162, 167, **40, 119**
Faliscans 174
Fellows, Charles 112, 116
Fikellura style 45
Fortuna **177**

Gallic Empire 179, 202
Gallienus **178**
Gaul 179, 202, 206–7, 208
Gela 106
Geometric period 24–9
 vases 25–8, **13, 14, 15**
Geryon **30**
glass
 Hellenistic 141, **121**
 Roman 203–5, **173**
 sandwich gold 141, **121**
Glaukos 67
Gnathia vases 99, **84**
gorgons **32, 37** (*see also* Medusa)
Gravisca 162
griffins 31, **19, 24, 133**
grotesques 133

Hadra cemetery 141
Hadra vases 140–41, **120**
Hadrian 179, 181, 191
Halicarnassos *see* Mausoleum
Hannibal 142–3
Harpokrates 208

Harpy Tomb 114–15, **97, 98**
Hebe **36**
Hector **34, 64**
Hellenistic period 127–43, 169–72
Hera, Tarantine priestess of 106
Heracleia under Latmus **96**
Herakles **25, 26, 44, 56, 75, 92, 110a, 142**
 knot of 141, 142, **122**
Herculaneum 195
Hermes **37, 58, 60, 92**
Herodotos 159
Hinton St Mary 199
Hippolytos **80**
Homer and the Homeric poems 22–3, 26–8, 44, 137–8
 apotheosis of 137–8, **118**
Horace 211

Icarus **167a**
Iktinos (architect) 61, 68
Io **91**
Ionian Revolt 56
Isis **177**
Isis Tomb at Vulci 162–3, 167
Iunia Pieris 192, **164**

Janus, Temple of **159b**
Jeppesen, Kristian 122
Judgement of Paris **141**
Julia Titi 184
Julius Caesar 178

Kairos 137
Kallikrates (architect) 61
Kition 145, 149
korai 40–42, 56
Kourion **123**
kouroi 40–42, 56–7, **28, 45**
Kyme jewellery 88–9, **74**
Kyniskos 60

Laconian vase-painting 44
La Graufesenque 206
lamps, Roman 196–7, **166**
Lapiths **50, 51**
Lararia 207, 208
Laris Havrenie 170, **145**
Latins 174
Leochares 72, 120, 125
Leptis Magna **151**
Linear B 22, **12**
Lion Tomb 114
Locri 92, 102
Locrian plaques 102
Lokroi *see* Locri
Lollia Paulina 210
Lucania 93, 95, 177
Lucanian vase-painting 93–5, **79**
Lucius Mummius 143
Lucumo (Lucius Tarquinius) 162

Lycia 112, 113–18
Lydia 43, 56, 112
Lyons 206
Lysippos (sculptor) 130, 136–7

Mâcon Hoard 207, **176**
Marcus Aurelius 179, 187
Marcus Iunius Hamillus 192, **164**
Mark Antony 179, 181
master of animals **8**
Mausoleum 112, 118–26, **104, 105, 106, 107**
Mausolos 112, 118, 123
Medusa **37**
Meidias Painter 78–9, **65**
Melian reliefs 84, **70**
Menelaos **34, 92**
Merehi, Tomb of 116–17
Messapians 174
Metaponto 92, 93, 101
Metrodoros 143
Micali Painter 169
Miletus 128
Minoan civilisation 12–17
mirrors, bronze 86–7, 167, **71, 73, 142**
mistress of animals **27**
Mlakuch **142**
Montcornet 202
Morosini 62
mosaics 199–200, **168**
Muses **118, 165**
Mycenaean civilisation 18–23
Mycenaeans on Cyprus 145
Myrina figurines 134–5, **117**

Naukratis 45, 162
Nereid **101**
Nereid Monument 113, 117–18, 126, **100, 101, 102**
Nero 181, 183–4, 188, **157c**
 Golden House of 197, 199
Newton, Charles 42, 72, 120–22
Nike (Victory) **89, 92, 94**
Nike, Temple of Athena 66–7, **54**

Octavia(?) **179**
Octavian *see* Augustus
Odysseus **79, 167b**
Olynthos 195
Oplontis 195
opus interrasile 210
Orientalising period 29–39
 in Etruria 162–6
Orvieto 161
Ostia 188, 199, **158**

Paestan vase-painting 97, **82, 83**
Paestum 91, 177
Pan **73**
Panathenaic procession 63–4, **52**

Paramythia bronzes 207–8
Paris, Judgement of **141**
Parthenon 60–66, **49, 50, 51, 52, 53**
Pausanias 60, 64, 68, 72
Payava, Tomb of 116–17, **99**
Pegasus **75b, 146**
Peloponnesian War 66, 74, 78–9
Penthesileia **38**
Peparethos, coinage of **43c**
Pergamon 108, 138, 143
Pericles 60, 66, 74, 129, **48**
Perseus (Greek hero) **37**
Perseus (King of Macedon) 143
Persian Wars 56, 57, 60
Perugia 161
Peucetians 174
Phaistos 12, **5**
Phanes **42**
Pheidias (sculptor) 62
Philetairos 131, **112c, 113**
Philip II of Macedon 127
Philip V of Macedon 142–3
Phlyax vases 97, **83**
Phoenicia(ns) 29, 30, 51, 54, 108, 144, 145, 146, 149, 150, 151, 154, 158
Pisa 206
Pithekoussai 91, 92, 162
plank figurines 153, **129**
plastic *lekythoi* 84–5
Pliny the Elder 162, 204, 210
Polybius 182
Polyeidos **67**
Polykleitos (sculptor) 59–60
Pompeii 199, 201, 204
Populonia 172–3
Portland Vase 204–5, **173**
portraiture 42, 60, 123, 126, 129–32, 182–4, 186–8
Poseidon **93a**
Poseidonia *see* Paestum
Postumus 186–7, **156**
Pozzuoli 200
Praenestine *cistae* 172, **146**
Praxiteles 72
Priene 128, 199, **108**
Probus 179
Proconnesus 193
Proto-Attic vase-painting 33–4, 35
Proto-Corinthian vase-painting 34–5, 93, **22, 78**
Ptolemies 127, 138, 146
Ptolemy I 130, 138, **112a**
Ptolemy II 139
Ptolemy IV 138, **118**
Python (vase-painter) 97, **82, 83**

red-figure vases
 Athenian 74–9, **63, 64, 65**
 Etruscan 170, **144**
 south Italian 93–7, **79, 80, 81, 82, 83**

Red Polished Ware 149, **126, 129**
red wares (Roman) *see* terra sigillata
Reed Painter 66
reef-knots (in jewellery) 141, 142, **122**
Reggio di Calabria 93
Republic, the Roman 178–9
Riace Bronzes 58, 191
Roman art 178–211
Rome 162, 169, 174, 177, 178–9, 180, 181
 Circus Maximus **159f**
 Colosseum **159e**
 Temple of Janus **159b**

Sabina **151**
Sabouroff Painter **66**
St-Romain-en-Gal 199
Salamis (Cyprus) 146
samian ware *see* terra sigillata
Samnite(s) 177
 belts 177, **150**
Santa Eufemia Treasure 106
Saqqara 82
Sarapis 208
sarcophagi 169, 173–4, 191, 193–4, **147, 165**
Satala 128–9
satyrs 61, 63
Schliemann, Heinrich 22–3
Seianti Hanunia Tlesnasa 173–4, **147**
Selinous 91
Selinunte *see* Selinous
silver, Roman 201–3, **170, 171**
Sirens **167b**
Six Technique 75
Skopas (sculptor) 120, 125
Sophilos *dinos* 46–8, **35, 36**
Sophocles 131–2, 202, **114**
Sotades Painter 81–2, **67**
Strangford Apollo 57, **45**
stucco decoration 200
Syracuse 91, 92, 109–11, 180, **77**
Syria 13, 127, 143, 144, 146, 150, 153, 163, 178, 203, 204

Tanagra figurines 133–4, **116**
Taranto 91, 92, 93, 101, 102, 104, 105, 106, 109, 174, 180
Tarquinia 161, 162
terra sigillata 205–7, **174**
Thanatos **58**
Thasos 193
Thurioi 93
Tiberius 183
 sword of 183
Timotheos 120, 125
Titus 188

Tivoli 191
Townley, Charles 189–91
 Greyhounds 191, **162**
 Venus 191
Trajan 185, 191, **155**
Treasury of Atreus 18
Troy 22–3
Tunis 211
Tutela **207**

Tyche of Antioch 136–7

Umbrians 174, **148**
Urartu 37

Vespasian 184
Villanovan culture 161–2
Virgil 211
Vitellius **157e**

Vulci 161, 162, 167, 169

wall paintings
 Etruscan 166–7
 Roman 197–9
Westmacott Athlete 59–60,
 47
white-ground vases 79–82,
 66, **67**

White Painted Ware 151, 153
White Slip Ware 150, **126**
Wild Goat style 44, **33**
Wooden Horse of Troy **25**, **26**

Xanthippos, stele of 69, **57**
Xanthos 113–18, **97**

Zeus **75a**